MAKING ARTIST'S TOOLS

MAKING

ARTIST'S TOOLS

Vance Studley

VNR VAN NOSTRAND REINHOLD COMPANY

NEW YORK CINCINNATI TORONTO LONDON MELBOURNE

For Walter Durian and Henry Lion

Acknowledgments

I would like to express my appreciation to the following individuals who assisted me in the preparation of this book. They have given not only their time but something of themselves, and their contributions are greatly appreciated: Norton Simon and the Norton Simon Museum Staff, Andrea Clark, Toshi Sekiyama of Yasutomo & Co., Hans Christian Krake, Sue Mossman, Al Fiori, Lee Wexler, Robert Fiedler, Walter Askin, Garabed Mardirossian, Frances Kinman, and my wife, Margo Studley.

Printed in the United States of America
Designed by Loudan Enterprises

Published in 1979 by Van Nostrand Reinhold Company
A division of Litton Educational Publishing, Inc.
135 West 50th Street, New York, N.Y. 10020, U.S.A.

Van Nostrand Reinhold Limited
1410 Birchmount Road, Scarborough, Ontario M1P 2E7, Canada

Van Nostrand Reinhold Australia Pty. Limited
17 Queen Street, Mitcham, Victoria 3132, Australia

Van Nostrand Reinhold Company Limited
Molly Millars Lane, Wokingham, Berkshire, England

16 15 14 13 12 11 10 9 8 7 6 5 4 3 2 1

Library of Congress Cataloging in Publication Data

Studley, Vance.
 Making artist's tools.

 Bibliography: p.
 Includes index.
 1. Artists' tools—Handbooks, manuals, etc.
 I. Title
N8543.S88 702'.8 78-18233
ISBN 0-442-27903-5

Contents

Foreword
by Walter Askin

. . . for many artists the weeds between the fields of the media have become more nourishing than all the tame potatoes within the boundaries.
—Fred Martin

If the only tool you have is a hammer, you tend to see every problem as a nail.—Abraham Maslow
. . . On a large scale, and in work determinable by line and rule, it is indeed possible and necessary that the thoughts of one man should be carried out by the labour of others . . . But on a smaller scale, and if a design cannot be mathematically defined, one man's thoughts can never be expressed by another: and the difference between the spirit of touch of the man who is inventing, and to the man who is obeying directions, is often all the difference between a great and a common work of art.
—John Ruskin

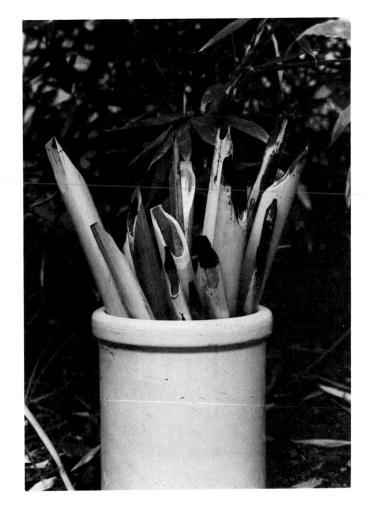

In our age the technical realm is sometimes thought to have its own rational and intellectual order divorced from intuition, conjecture, and feeling. It is presumed to be factual. But because our technology is changing so fast, its operations have become more visible. "Facts" are constantly changing: the new ones are "true," and the old ones are "false." Technical "facts" are seen more and more as the products of ethical decisions. The form and character of tools are seen increasingly to have an implicit moral order.

An American firm sent a model of a teacup to Japan, where it could be mass-produced less expensively. In transit the model was broken, and the Japanese manufacturer faithfully produced thousands of teacups with broken handles. Where no ethical standard is present, quality cannot exist. One can imagine an Orwellian czar of artist's implements who dictates their form and thus their expression. A change in means almost inevitably becomes a change in content.

Style involves many factors, not the least of which is the creative potential of the tools employed. Artist's ready-made tools are drenched in an aura of "fundamentals," with an air of "rightness" and "proper use." But how many paintings owe their creation more to the Grumbacher Company (or any other artist's supply house) than to the artist in front of the easel? How many would-be artists sell their psychic stock to parameters set by a manufacturing concern? To stay within the boundaries dictated by ready-made materials is to deny an entire facet of experimentation, to make art that is less acceptable, less real, less true.

There is magic in the artist's box of tools and materials. If one is enthusiastic about modern life, one is almost certain to be engaged in the great synthesis—the confluence of spirit and matter. For many artists this encounter requires the development of their own extraordinarily expressive means, tools that bring forth a harvest of imagination. It involves the impure act of bringing together a reverence and an irreverence for materials, tools, and techniques; for forms and colors; for images, associations, and illusions; for concepts; and, finally, for the creative process.

The creative being simply does not accept traditional limitations. Boundaries describe the ordinary, the complacent and accepting—a world that makes no demands, accepts no challenges, reveals no mysteries. In other words, a place not worth the visit. The artists who inspire us are transforming energies. They are the self-starting wheels who create challenges and demonstrate a clear commitment. Their works are hybrid, transitional, impure, and magically alive. They are the least neutral, the most focused, and the most accomplished.

All materials are the products of necessity. Collapsible paint tubes did not exist until artists needed to work *en plein air*. Possibilities presented during the heat of creative fervor inevitably define the form, nature, and use of the means employed. Tools that can never be found in the art-materials store may be needed to realize a particular creative dream. Any innovator eventually extends and refines his medium to suit his own ends. Even the mastery of a medium frequently requires alteration of the tools involved in order to direct them toward uniquely personal ends. Artists need new media whenever the cultural map becomes unreadable, whenever there is intense cultural distortion, whenever the path is unclear. What is found in the supply shop is generally the product of various artists' searches—long after those searches are over.

Life is greater than art. If artists are to achieve in art the infectious and persuasive thrills of life, they must force everything possible out of the means. In our science-oriented society (which has proliferated an unprecedented number of materials, tools, compounds, formulas, processes, and recipes) the artist is not far behind in using and extending every process and material toward a new art. Artists have indeed frequently led the way in the development of new technology, but even so we have today almost too many means rather than too few. If anything, we need to refine the creative tools that we now have so that we can realize our potential more fully and render those tools rather as a path to our ends than as a dictator of our expression.

Even to talk about means and ends as two separate concerns in art is absurd. They are both part of one and the same thing—the creative process. It follows that, if the creative act is to be liberating, there must be an expansiveness of concept to match an expansiveness of means—and vice versa.

Introduction

The purpose of *Making Artist's Tools* is twofold: to assist the artist in developing original methods of making stimulating and imaginative tools and equipment by hand—each tool can be used for specific projects and is relatively easy to make—and to explore a wide range of techniques made possible by new, handmade tools. With tools fashioned by one's own hands drawing, painting, and printmaking become more expressive, images more dynamic or subtle. Brushes, lettering quills, bamboo calligraphy pens, printmaking brayers, drawing inks, and many other useful items can be made by anyone willing to analyze needs and create solutions to meet those needs. This book is a guide to finding the right solution and thereby allowing the creation of personal and customized tools, which, frankly, can be as much fun to make as they are to use.

The student of art is exposed at an early age to painting, drawing with pencils and charcoal, and working with clay. The medium is the material that gives form to the artist's imagination. It is through the introduction and continued use of the material that familiarity and confidence develop to the degree that the young artist controls the medium. This is a vital component upon which creativity rests. Creativity and skill with the material grow simultaneously; they are certainly mutually supportive. Image making at this early stage is usually limited to the use of crayons, caked watercolors, tempera, and other expendable items. As a youngster I was fascinated by rulers, messy fountain pens, soft crayons, and large sheets of blotter-paper remnants supplied by my grandfather, who was the local printer. Together we made crayons from hopeless candles, added linseed oil and thinner to cans of dried printer's ink, fashioned primitive pens from thin garden stakes. An airbrush was made from an exhausted cologne bottle with an attached bulb. We tortured more than enough materials, hoping that each experiment would evince heretofore undiscovered magic in our pictures. This early, nascent interest bred in me a healthy respect for the well-made tool.

Artists with enough patience and resourcefulness have improvised many methods to bring about desired results. The relationship between image and tool is one of compatibility—delicate brushes for delicate work. But the natural limits of the materials' workability must be considered, and for this reason I have provided examples of artist's work along with tools created for specific purposes.

I have often shopped at an artist's supply store and been surprised and outraged at the same time. Surprised that there is a brush, pencil, burnisher, new, bright color of ink, or measuring device that will predictably be highly useful for my creative work. Outraged that it is too expensive and not so ingenious that someone with dexterity and imagination could not fashion the item by himself at home or in the classroom. The artist is conditioned to rely heavily on the availability of supplies carried by the local store, and there are indeed many manufactured products that require advanced technology, specialized tooling, and access to scarce raw materials beyond the reach of most people. There have been many occasions, however, when I have exhausted my material or found that items were no longer stocked. Simple improvisation was the answer. I have made many tools with better, more serviceable results and for far less money. In most instances I no longer buy the equivalent in a store.

My students, in a short period of time, have made their own brushes, pigments, crayons, lettering tools, proportional devices, pens, and even paper for their expressive needs. Once this has been done several

times, what becomes more obvious than the tool itself (and more far-reaching) is the respect for the tool and for what it can do in skillful hands. As an indirect result of making an item out of raw material a new device is often made that, because of its unique properties, shape, or feel, brings about unexpected results, heightening the experience of painting and drawing. These discoveries are included here.

In the following pages I have set forth some basic methods for making various tools and implements. Included are step-by-step illustrations and suggestions on materials to be used for unusual results. I have purposefully avoided cumbersome technological procedures that might obscure the concepts involved and strain the reader's patience and have concentrated my remarks and observations on information that for the most part is not available in other books on artist's materials.

You may ask, "Why all the trouble and time to make a simple device that can handily be bought?" I suppose that the answer to this question falls into the dichotomy of conservation versus consumption. I feel that making one's own tools for creative use follows an urge that is deep within all of us. That urge is also twofold: wanting to make something with one's own hands and wanting to own something of worth. To own what you make or even to give what you make to someone else who recognizes the meaningfulness of your handcrafted tool is a pleasure that is very difficult to deny oneself.

The imagination of the reader should be considered his greatest asset. The ideas and projects suggested here can be used to augment the search for rewarding results. It is hoped that you will find some spiritual satisfaction as your tools take shape and that you will quickly realize how one tool begets another. You will soon be inventing your own tools, as I have. As you manipulate materials to fit your own expressive character, you will find yourself making artist's items as earnestly and enthusiastically as you make your images.

1 Historical Precedents

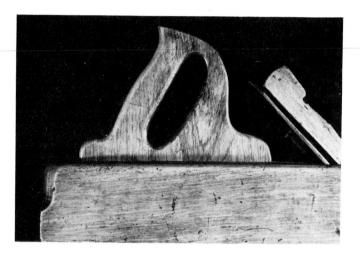

Detail of a late-19th-century carpenter's plane. Notice that the contour of the handle conforms to the shape of the hand. Although this tool is industrially produced, it still reflects fine workmanship.

THE ROLE OF THE DESIGNER

If a design is to be considered as an object, it is in effect a statement of the ideal form of the thing to be made. Careful drawings are made in precise and exacting detail and spell out to the workman exactly what is called for and how the object is to be put together. The designer can also become the maker of his design. If the designer is careful and reasonably well acquainted with his tools and their limitations, he usually finds himself in the enviable position of having wrought from raw material something of his own creation. This can be a satisfying experience. Observe the child molding clay and transforming it into a recognizable shape. The custom-furniture maker slowly and lovingly rubs rich oils into the surface of a walnut table, hoping to bring forth an internal luster impossible to obtain by any other means. Handmade objects often bring with them the veneration that they so deserve. This is true to the degree that many people admire and use or encourage the use of materials that they themselves could make.

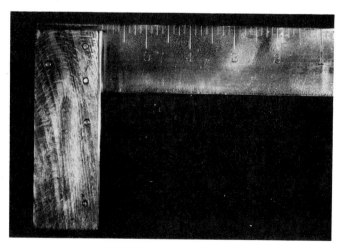

A carpenter's square, revealing a close marriage between metal and wood.

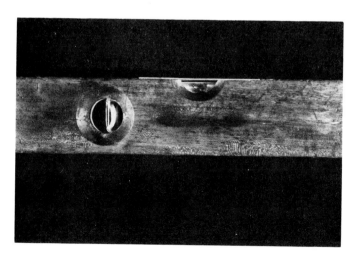

A spirit level made in 1878. The relationship between the function and the form of this object was closely adhered to during the manufacturing process.

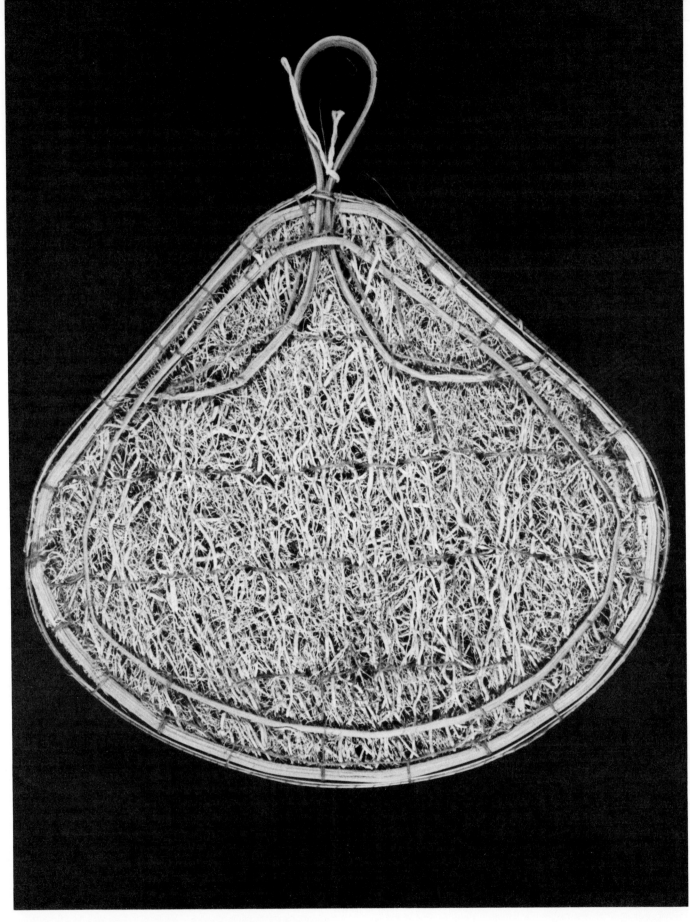

An East Indian fan made of grass and coarse straw. Items such
as these are made from plastics and materials indigenous to
the area.

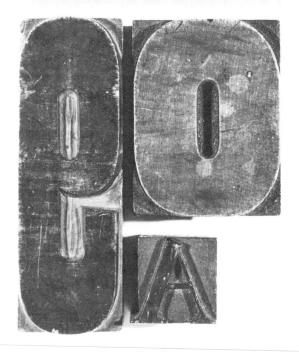

Late-19th-century wood type. Usually made from maple wood, type was used for large posters and announcements. The fine detail is an obvious reflection of the care and crafting of these items.

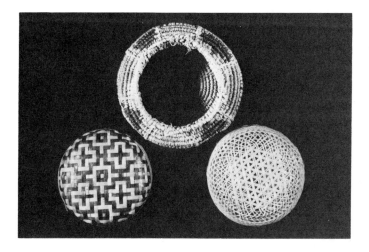

Oriental baskets made from cane and bamboo without benefit of tools or machinery. The detail reveals the painstaking attention paid to the making of each basket.

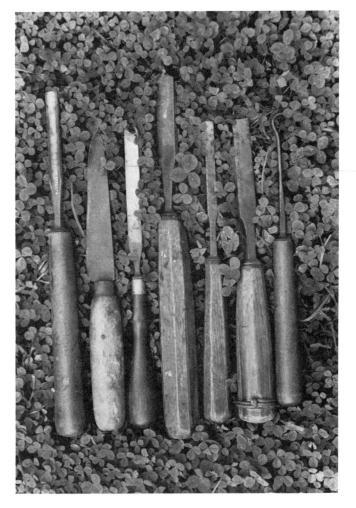

Hand wood-carving tools from the late 19th century. Tools such as these were instrumental in the making of fine-quality furniture.

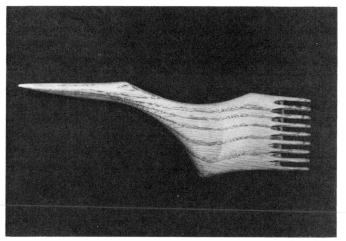

Contemporary weaver's comb made of oak. The handle conforms to the shape of the palm, giving it balance and useful symmetry.

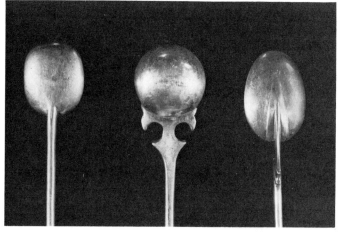

19th-century demitasse spoons. The fusion between handle and scoop is masterfully achieved by blending the art of hand tooling and rare metal.

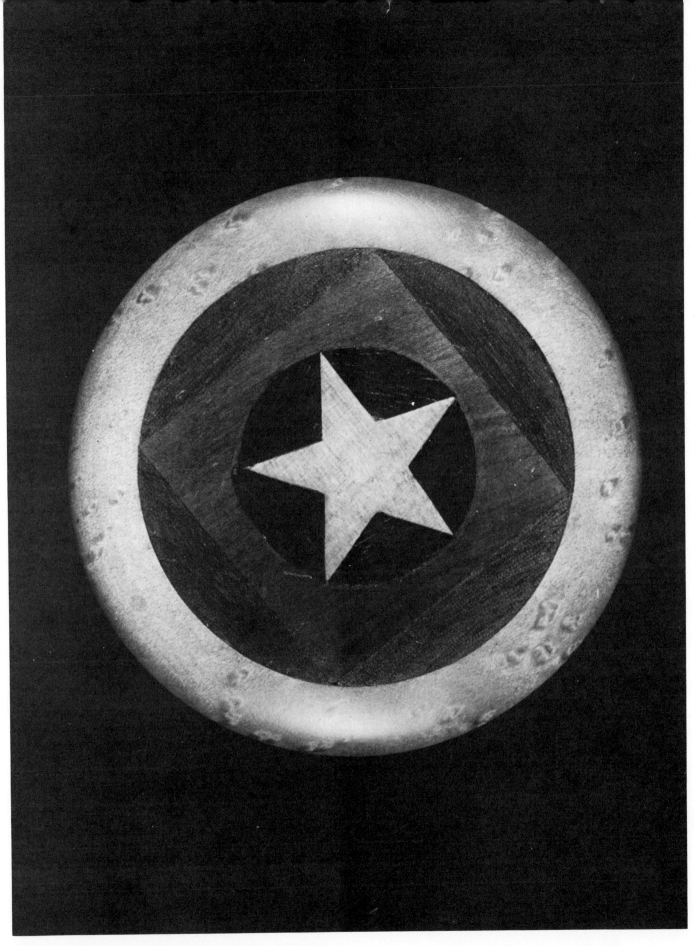

Early-19th-century grain-storage cylinder. Various woods are
inlaid to create an interesting and subtle design.

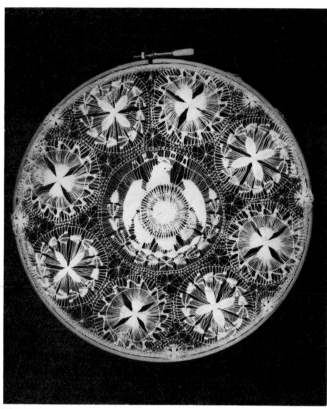

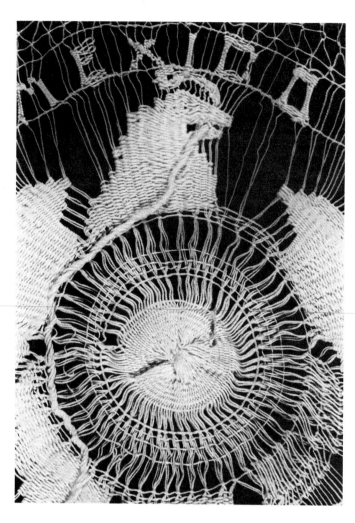

Mid-19th-century handwoven piece showing exquisite and minute detail.

Japanese *hishaku* (bamboo water ladle). This graceful implement, used in the Japanese tea ceremony, is an intrinsically simple object. The refinements that have arisen within its framework are numerous and baffling to the western mind.

Early man formed his tools by chiseling flint and shale into shapes resembling spears, hatchets, and knives. These primitive weapons were used for cutting, chopping, and hunting.

Two flint weapons revealing simplicity and sharpness of purpose.

EARLY CONTRIBUTIONS

It is openly acknowledged and believed that objects created by early man have from the most ancient and prehistoric times constituted an extension of himself, a manifestation of his physical and emotional makeup. The early and naive utensil, such as a sharpened flint, hand ax, wooden spoon, or hunting spear, and the most sophisticated and refined item, such as a watch, telescope, or computer, both possess two characteristics: that of having a specific function—i.e., to subdue, to chop, to hold, to perform an operation—and that of summing up the state of technology or "know-how" for the particular period in which the object was made. It is with the artifacts of earlier times that we measure and attempt to know what took place thousands of years ago. Self-conscious stylization of goods and materials is a relatively new contribution to the man-made object compared to the primitive's feeble yet functionally adequate tool.

ARTIST AND ENVIRONMENT

At one point in history there could have been little discussion as to what objects might have been placed in a time vault for future generations to see—a metal knife, a clay bowl, exotic and rare jeweled handicrafts, a few sculptural figurines, but not much else. Today things are different. Artists make art *for* the environment and make it part *of* the environment as well. Art objects are more visible on city streets than ever before. Sculpture is large, architectonic, abstract, and monolithic. Paintings, graphics, and weavings adorn the walls of hotels, civic structures, and public theaters and become part of the structural fabric in which art is no longer relegated to surface decoration.

But regardless of his place in history an artist uses his hands, his eyes, his imagination to improvise tools and objects to serve his creative needs. The industrially produced tool is as resourceful and functional as the very matrix used to make the prototype. It is for this reason that I find it particularly uplifting to remind myself that we are not totally dominated by a cookie-cutter approach to the manufacture of artist's tools. Many of the following devices reflect my own experience of having to reach for materials that were non-existent or that existed in another form. With a bit of conjuring and some deft handling of tools all the projects illustrated and discussed can be made by anyone who enjoys making tools.

Pre-Columbian figurine approximately 1″ tall. Sculptural objects such as these became an extension of the cultural worship of gods and deities. Many of these figurines are scattered throughout Mexico and Central America.

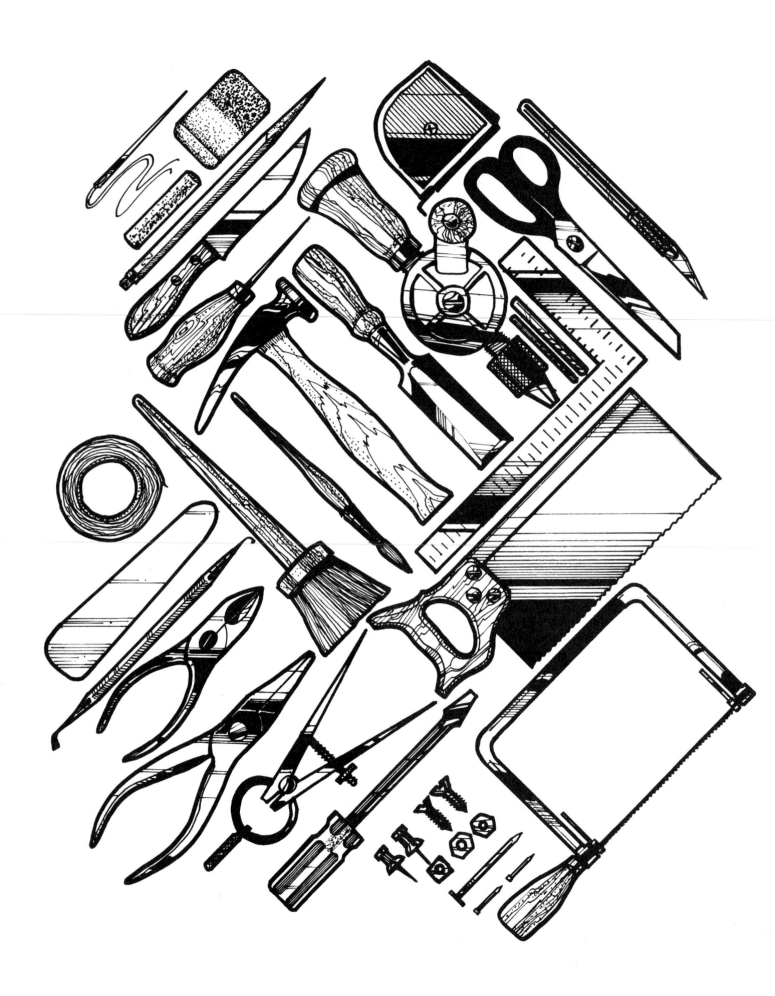

2 Tools & Their Characteristics

The equipment used in making tools varies, depending on the tool and on the extent to which the artist intends to execute his work. Many simple tools can be produced with a limited number of materials. Some projects require very little in the way of specialized equipment and can easily be adapted to classroom situations or to studio space within the home. The artist who is a veteran in the use of artist's tools but at the same time a beginner in tool making can often substitute or improvise in various ways to accomplish results within his limitations. Lack of expensive or sophisticated equipment need not prevent anyone from experiencing the pleasure of making artist's tools. The dedicated craftsman who catches the tool-making "bug" will slowly, out of personal need, acquire more elaborate tools to extend his abilities.

TOOLS, EQUIPMENT, AND MATERIALS
You need tools to make tools. This fact need not intimidate the beginner, for he can start simply and add extra materials as he goes along to facilitate the design and construction of desired tools. A list of basic tools and equipment includes many items that may already be at hand or may be easily obtained.

An assortment of hand tools used in the making of artist's tools. Many of these items can be found around the home and in the classroom.

Hand tools
The following hand tools should be procured:
 hammer
 wooden mallet
 pliers
 needle-nose pliers
 tin snips
 steel square
 metal ruler
 sailmaker's needle
 shears
 mat cutting knife
 diagonal wire cutters
 punch
 awl
 chisel
 C-clamps
 hacksaw
 steel straightedge
 pocket knife
 spring dividers
 drill with assorted drill bits
 small scissors
 large scissors
 coping saw
 Arkansas stone
 Carborundum stone
 X-acto knife with #11 blades
 kitchen scale
 wood file
 screwdrivers
 staple gun
 coarse ½" to 1½" brushes
 mason jars

An X-Acto knife with an #11 blade. The X-Acto knife is a multipurpose tool for quill and bamboo cutting, among many other uses. The blades are inexpensive and readily available.

A common claw hammer.

A kitchen scale is used to weigh pigments and other powdered substances. It need not be elaborate—merely functional and easily accessible.

A hand drill is indispensable to the tool maker. An assortment of drill bits is also necessary for making various projects in each chapter.

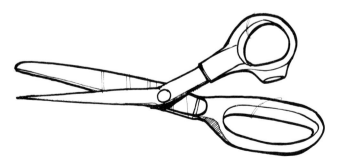

Sharp scissors are a must for cutting cloth, paper, and leather. The scissors are also employed to cut thin pieces of brass shim stock.

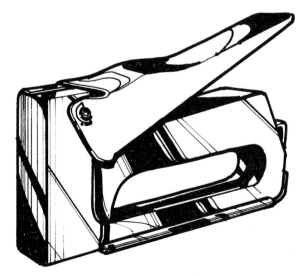

A heavy-duty staple gun is used to prepare molds for papermaking. Recommended staple length is no less than ¼″.

Mason jars are used to store liquids and powdered pigments. Keep assorted sizes within reach. A few of these jars have a resealable clamping device for an airtight fit.

Small medicine and tablet bottles are convenient for storing pigments and inks. By soaking the bottle the label can be removed and a new one put in its place to identify the contents.

Swan, turkey, goose, or raven feathers are essential for making quills. Quills remain to this day one of the finest lettering implements.

Equipment
You need the following in the way of equipment:
 electric hand drill
 vise
 pressing iron
 electric blender for papermaking
 hot plate
 band saw (optional)
 drill press (optional)
 jig saw (optional)
 grinding wheel (optional)
 radial-arm saw (optional)
 buffing wheel (optional)

Materials
These materials should be on hand:
 sandpaper
 assorted pieces of wood
 plastic scraps
 brass shim stock
 aluminum tubing
 bamboo
 small bottles
 swan, turkey, goose, or raven feathers
 smooth stones
 string
 thread
 brass wire
 fiberglass-screen cloth
 coarse fabrics
 brass brads
 assorted finishing nails
 steel wool
 chipboard
 butcher wrap
 hair and bristle fibers
 reeds
 plastic tubing
 straws
 mortar and pestle
 measuring cup
 tablespoon
 graph paper
 weights

Adhesives

These adhesives are necessary:
- white glue
- epoxy
- resin sealer
- ground-hide glue (optional)
- masking tape
- plastic tape
- waterproof carpenter's glue
- rubber cement
- applicators

A large quantity of white glue is used for a number of projects in this book. The bottle should have an attached resealable collar for convenience.

Rubber cement is available in cans and bottles. The volume of cement to be used warrants purchase of the larger size.

Worktables

The worktable should be sturdy, well built, and on a sound flat surface. A flimsy table is irritating and does more to undermine good work habits than almost anything else. The worktable surface should be clean, hard, and smooth. It may be covered with formica, linoleum, or plastic material that resists warping or chipping and can easily be cleaned. Wood surfaces should be sealed with a heavy-duty varnish to withstand the rigors of tool-making activities. If possible, the table should be about 30" wide and not less than 5' to 6' long.

Shelving

If there is sufficient space accessible, freestanding or wall-hung shelves are ideal. If shelves are too wide, things tend to be mislaid or hidden. It is useful to have some wide shelves for storing paper and other large items. Shelves may be fitted under the worktable, especially if space is limited. Make sure to allow comfortable foot room at the front.

Lighting

To make the best use of available natural light, consider placing the worktable under or near a window. Electric lighting must be adequate and should be adjustable to provide good illumination exactly where it is needed.

Drying Area

It seems that, whenever tool-making activities are underway, there is something that requires drying space and time. I have found by trial and error that drying surfaces should be located away from the main tool-making area and close to a source of circulating air for ventilation. Airborne particles, sawdust, metal filings, or droplets of oil and water always seem to be present at the wrong time on the wrong project. To prevent this, use a waist-high flat table and place it on the opposite side of the classroom or studio. Whenever possible, drape a piece of fabric from overhead to curtain off the drying area. This need not be an elaborate arrangement—merely something functional and simple. It will contribute to your peace of mind as you work on other projects during the waiting-drying time.

Miscellaneous Necessities

A metal storage bin is necessary to house flammable solvents and soiled rags. The bin also makes a handy storage area for liquids, adhesives, and measuring cups. Electric receptacles and a source of clean water must also be provided, and a large trash can is an obvious necessity. Many tool-making procedures require a standing position, but the wise craftsman keeps stools around and uses them whenever possible.

ASSESSING YOUR NEEDS

Of the panoply of tools and materials at your disposal in the studio and classroom, which ones do you continually seek out and use? Which make the best lines, apply the broadest strokes of color, feel the most comfortable in the hand? These most frequently used tools tend to provide a certain amount of aesthetic pleasure in themselves while they are involved in the creation of art objects and art images.

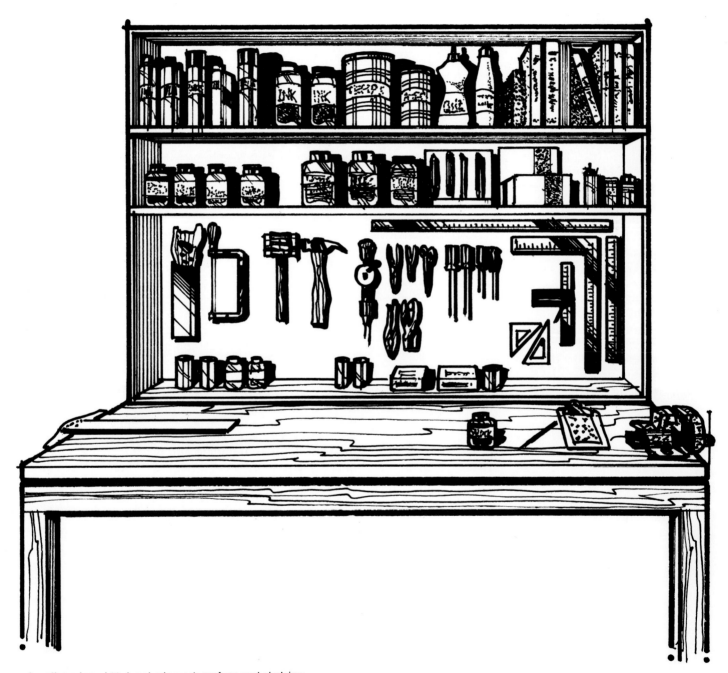

A well-equipped tool maker's work surface and shelving arrangement. It is essential that the work surface be kept clean and free of debris. Bottles and other containers should be kept in plain view. Flammable materials should be stored in a metal bin or locker.

The aesthetic characteristics of a handmade brush, pen, or brayer result from use itself and in this way are created by the "touch" of the artist. Every aesthetic consideration of a commercially produced tool, on the other hand, is already implicit in its design or in the prototype that will serve as the matrix for the successive forms of the series. Mass-produced items are designed to be bought and sold in large quantities in order to support the manufacturer's endeavors. The manufacturer also strives for "perfect" workmanship in the sense that the item attempts to mirror the popular concept of ideal form.

Examine commercial tools and supplies closely. How much of the "eyewash" can you do without? Need the handles of red-sable brushes be coated with hard enamel paint, hiding the natural color of the wood; can the pseudogold stamping be omitted and the packaging graphics made less expensive to reduce the cost? These features are undeniably added to products in order to equate them with our current notions of identity and quality. This quality is unfortunately shortlived, because an industrially produced object, which is subject to accelerated consumption on the part of the masses, loses its formal validity at a much faster rate than a hand-produced item. The changes that we see in brushes, rulers, inks, pens, paper, and other artist's goods are often dictated by fashion rather than by the criteria of a good brush or lead sharpener, for example, which we are already aware of. Advertising, sales, promotional literature, and the phenomenon of competition lead us to believe we need what we see.

I believe that, if you take a hard look at your studio and your materials, you can find a way to circumvent your dependency on store-purchased items by making your own tools at home and by designing them in terms of performance and reliability. The following elements are important in planning your projects.

Function

A handmade object is not meant to last for thousands of years, nor is it predisposed to die an early death. It follows the appointed round of days; it drifts with us as the current carries us along; it wears away little by little; it dies in a natural and predictable manner. In time, it can be replaced. While it is used, its function may well be its most important characteristic. But while an object must fulfill its intended function, it need not be austere and aseptic in appearance. A handmade object can be beautiful and give pleasure through its ability to perform its function well. Neglect of function combined with meaningless decoration lead to the production of cheap souvenirs. Material, function, and the harmony between beauty and form should be related.

Material

The materials used in making artist's tools should be taken at face value. All woods need not be painted. The natural grain and inherent color of the wood are in themselves attractive. Aluminum is reliable, cheap, and readily available, and it does not corrode easily. It is not the same as brass, which is more expensive, but it can perform many of the same jobs. Plastic offers a unique surface for engraving. It can be experimented with to elicit new and different modes of expression. Its more precious counterparts, copper and boxwood, are not the only materials to attract the engraver's burin.

If you are willing to accept the clear and natural form of raw materials, then you have taken a giant stride towards understanding their nature and limitations. For these reasons keep a variety of miscellaneous materials around you and, whenever an idea surfaces, be prepared to draw from your stockpile of supplies the one that is most able to give visible form to your mental concept.

Form and Decoration

An object's function determines its form. The form should always be in harmony with the material, or the object will appear forced or unnatural. If you want a certain form, choose a suitable material; if you have the material in hand, choose an appropriate form. Do not use flimsy and weak materials to support heavy weights; delicate materials should be used for lightness, rigidity, and scale. Common materials should be imbued with the integrity often assigned to more exotic and precious materials.

An affection for ornament is evident in many cultures; it can itself form an organic and logical part of the object, emphasize certain elements, or divert the eye from them. But if it is not done well, it can damage and obscure the form and, by overloading it, even destroy it entirely.

It is true that decorative patterns in a handcrafted object generally have no function whatsoever, yet there can be a close connection between form and ornament as long as the chosen decoration is adapted to the form. The persistence and proliferation of purely decorative motifs in handcrafted tools reveal an intermediate zone between usefulness and aesthetic contemplation. Decoration violates the principle of efficiency, but it is essential to the manifestation of pleasure in the object-making experience.

3 Tools For Drawing

HISTORY

The world, as Norbert Wiener once remarked, may be viewed as a myriad of "to whom it may concern" messages. The import of this comment becomes obvious when one realizes that everything that exists and happens in the world, every object and event, every plant and animal, almost continuously emits its own characteristic identifying signal. Messages take unique forms, forms that are patently clear or imbued with mystical signs and symbols that elude the viewer at every turn. It is an undeniable fact that man has shown a strong penchant for making images. He makes images of himself, images of the world around him. This world encloses him like an envelope of space, much of it known, charted, and predictable. Much more, however, remains unknown and mysterious and fills his mind and imagination with awe.

Man has gradually and increasingly gained some understanding of the activations underlying objects that he venerates, such as the role of light in the growth processes of life. With this knowledge grew the desire to record simple and complex discoveries. Various forms of expression developed. Words were written, charts made, pictures taken, messages encoded, entire systems of storage and retrieval developed, creative artifacts for future generations to discuss, analyze, and probe. When looked at from a historical perspective, this is simply—business as usual. Man, the image maker, translates incoming signals from his peripheral space into outgoing signs that say something about the way in which he is being affected by constant sensorial bombardment.

Early man drew out of necessity. It abated his anxieties about food, clothing, fertility, and shelter. As Paul Klee once said, "The secretly perceived is made visible." Man's oldest drawn forms are seen in cave pictures from the Stone Age, in rock inscriptions and scratchings executed by primitive peoples in many parts of the world. The cave wall gave way to clay,

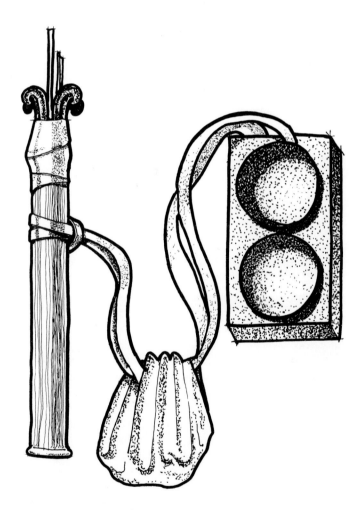

Egyptian writing utensils—reed brush holder, ink bag, and palette. The Egyptian scribe used an assortment of materials and tools for writing on papyrus.

tortoiseshell, bone, ivory, papyrus, parchment, and, eventually, paper. The tools with which man recorded his studies of worldly investigations took the form of reeds, pens, brushes, graphite, and mixtures of black and earthen-colored charcoallike substances.

It is not known precisely when man began to apply conscious decisions to matters involving taste, form, balance, and harmony. Most historians would regard the Greeks as the most instrumental in establishing dictates of classical beauty. Witness the magnificent vases and urns of the Greek period. These designs are not haphazard or random: they show a pronounced and obvious attempt at a harmonious division of space. Symmetry, pattern (the repetition of a motif), and early ornamentation became a logical and organic part of the object. Much of the subject matter for these stylizations came from nature: floral patterns, the divisions of a leaf, palmettes, shoots, and other forms of vegetation and animal life. It is from nature that simple and workable tools were derived, which came to serve the artist in his daily routine of making objects with great care and exacting beauty.

ARTIST AND MEDIUM

The artist traditionally applies pigment to a surface or ground. In most cases the ground must be somewhat rough or coarse. On this surface pictures are made with media that leave a small amount of residual material in the wake of the stroke. The very coarseness of the surface abrades the media to an extent depending on the force with which the tool makes contact. This is characteristic of all abrasive media, as opposed to aqueous media, which impregnate the paper or board. Tonalities are achieved with pressure, the softness or hardness of the tool, and rubbing of the surface with the finger or palm of the hand. Stick charcoal, chalks, pastels, and crayons permit a wide range of drawing experiences. Paper with a moderate tooth can bring out the hidden qualities of the material used for drawing purposes. There are many improvisational items that can be made from materials which leave satisfactory lines on your chosen surface.

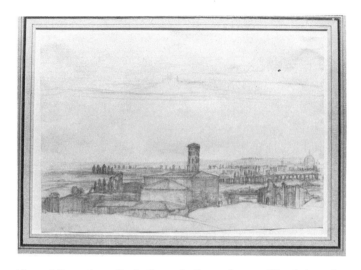

View of Rome from Santa Croce in Gerusalemme. Claude Lorrain, c. 1638. Black chalk. (Courtesy of the Norton Simon Museum.) The artist uses abrasive media to portray a distant landscape. Paper with a moderate tooth can bring out the hidden qualities of the drawing material. Charcoal was often used for sketching and brief notation.

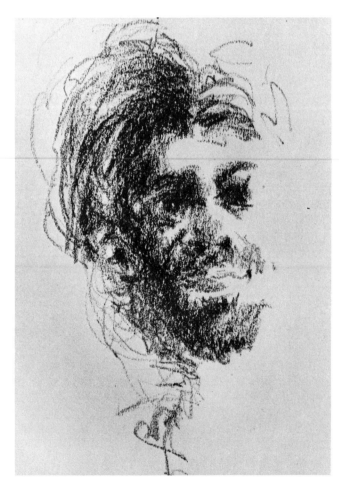

Head study. Lee Wexler, 1978. Gesture drawing is facilitated by the use of chalklike tools, as they can be smeared, rubbed, and drawn into for greater detail.

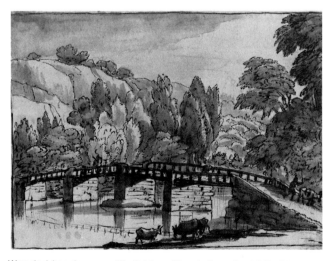

Wooded Landscape with Bridge. Claude Lorrain, 1640. Black chalk, pen, brown wash. (Courtesy of the Norton Simon Museum.) Lorrain was a sensitive and gifted chronicler of the moods and colors of nature.

24

Metamorphosis. Vance Studley, 1975. This oversized drawing combines a variety of homemade charcoals made from charred woods, lampblack, and ivory black. Handmade charcoal can surpass its industrially made counterpart.

CHARCOAL

Charcoal pastels can be made from earthen pigments or powdered tempera. These ingredients are combined with a simple binder, rolled into desirable shapes, and left to dry naturally or in a warm oven. They are strong, can make deep and rich marks, and offer the artist a wide choice of pastel values.

The term "pastel" has come to be associated with a large variety of colored chalks, but black pastel is generally made of ivory-black pigment and gum arabic, ball clay, or other materials often found in other types of black chalk. In place of gum arabic it is possible to use other binders for a variety of results. Gum arabic is available in either powdered or liquid form. It must be mixed in different strengths for different pigments, as their molecular natures require different physical properties. A true colloidal mixture requires the right binder strength for the particular pigment. This invariably requires some experimentation.

Ivory black is an impure carbon and is the type most widely used by artists. It can be safely said that most if not all ivory black sold on a commercial basis is in reality merely high-grade bone black. True ivory black is made by incinerating ivory scraps and has the same properties as bone black, but it is finer, more intense, and higher in carbon content. This is probably so because it is made with greater care, due to the value of the raw material. Other acceptable blacks are iron-oxide or Mars black, carbon black, and lampblack. Compressed black charcoals can easily be made from these materials, and each has a different complexion and intensity. It is also possible to reconstitute short pieces of charcoal, reform them, and create altogether new charcoal sticks from old remnants. Instead of going to waste charcoals that are too small to hold in the fingers can be used as raw material to make new sticks. The bits and pieces are ground in a mortar and pestle and kept sealed in small marked jars until needed.

The built-up charcoal and pastel kits sold in stores always seduce the eye with the full color spectrum, but what artist uses the full gamut of colors and without using one color more than another? He would do better to purchase the more intense high-chroma pastels and black and white.

The earthen pigments do not have the permanency or staying power that synthetic colors made in the color chemist's laboratory have. Colors such as emerald green and those containing traces of arsenic or lead should be altogether avoided. They are toxic and are better left to the professional color chemist. If in doubt, consult Ralph Mayer's *The Artist's Handbook of Materials and Techniques*. He has provided the reader with an exhaustive list of pigments that includes descriptions of their properties.

Making Charcoal Pastels

The charcoal that is used as a drawing tool is derived from charred vine, willow, and other twigs prepared especially for this purpose. The pigments in this type of drawing implement are members of a group of impure forms of carbon made by burning selected materials. For color density and saturation charcoal is inferior to lampblack but is suitable for purposes of sketching and other forms of drawing. It is ideal for making faint lines on the drawing paper and is easily erased, with little evidence of the line or shaded area remaining.

Charcoal is very light and fragile and should be encased in a rigid container when not in use. To increase the density of the charcoal line, add a small amount of lampblack to the charcoal powder as you begin to make the sticks. To prevent the charcoal from dusting off the paper surface, it is sprayed with a light fixative. This may be done with an atomizer and a very dilute solution of mastic or shellac mixed in alcohol. The proportion of the fixative is approximately 2 parts resinous material to 98 parts of solvent, which in this case is alcohol.

Most drawings made by the Old Masters were made with forms of charcoal, natural red chalks, or ink applied with a reed, quill, or brush. Vine charcoal is still a popular tool with artists, and, because of its obvious characteristics, it is essential to the studio and classroom.

Making Charcoal Sticks

Select several dry branches of hardwood such as ash, alder, maple, or birch and allow to burn completely in a fireplace or pit. The wood must be thoroughly incinerated. Gather a few small fragments of the charred wood measuring no larger than 2" square and place on a glass plate or in a large mortar or mixing bowl. With the aid of the pestle completely grind the contents as finely as possible until a light powder results.

Prepare a gum-arabic binder, an age-old formula in use long before commercial binders were developed, according to the following recipe. Add 1 tablespoon powdered gum arabic to 1 cup of water. Mix the gum arabic with the water and boil the contents in a saucepan at a low temperature for 5 minutes. Pour the solution into a jar with a resealable lid.

To 3 ounces of charcoal powder add 1 teaspoon of the gum-arabic mix. This is done in the mortar while you slowly grind the contents together with the pestle. The mixture should have a pastelike consistency that is somewhat stiff in feel and texture. Remove the paste and place on a plastic sheet or cookie tin. Gently shape the stick into a long rectangle by running the fingers over the top and sides until the entire stick is smooth. Set the stick aside to dry for a few hours. Do not hasten the drying process: the curing must take place gradually. The sticks, because of their very fragile nature, should be stored in boxes for best protection.

A small amount of lampblack may be mixed in with the powdered charcoal to deepen the black if, after drawing with the original charcoal, you want a deeper shade. You can also make charcoal exclusively with lampblack. Use the same proportions as with the charred pwder. This will provide a deep, lustrous drawing tool.

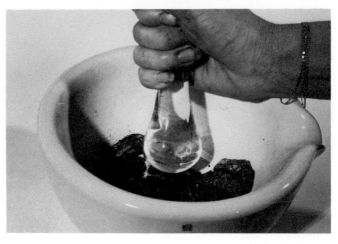

The charred fragments are being ground up and pulverized into fine powder. Grinding this material is a slow process. Be sure to bear down with the pestle while turning the fragments in a swirling motion.

A glass pestle and slab. These items are used in the preparation of handmade charcoals and pastels.

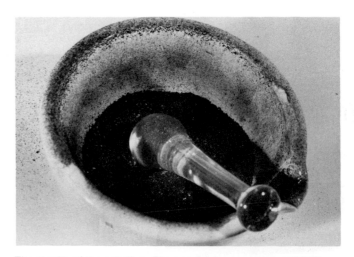

The results of the grinding. The powder is very black and light. Caution should be taken to prevent the particles from becoming airborne, as they settle on everything in sight.

A glass mortar and pestle, used to make charcoals and pastels. Mortars and pestles are available in a variety of sizes and can be ordered from scientific-instrument-supply houses of chemical-products companies.

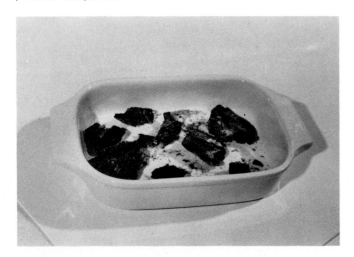

Small fragments of charred maple, which are ground up to make sticks of charcoal. The fragments must be fully incinerated before use.

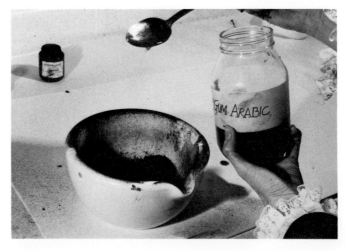

To the charcoal powder add the gum-arabic binder. Use 1 teaspoon of the gum-arabic mix to 3 ounces of dry powder. If the blend becomes too thick with stirring, add ½ teaspoon of water.

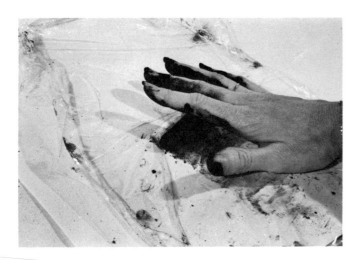

When the mixture has a pastelike consistency, remove and place on a plastic sheet or cookie tin. Shape the substance with the fingers by carefully rolling the stick into a long rectangle.

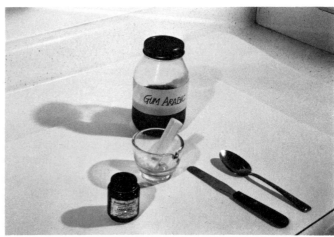

Charcoal can also be made with lampblack and the gum-arabic solution. The results will resemble a black pastel. Lampblack is a heavier and denser form of carbon, ideal for charcoal-making purposes.

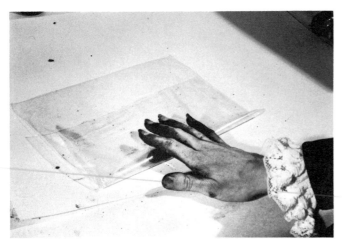

Even out the stick with a continued rubbing motion. Be careful not to bear down as you roll the stick. Continue until it is smooth on all sides.

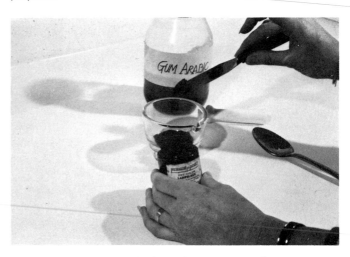

Proportions for the lampblack are three parts powder to one part binder solution.

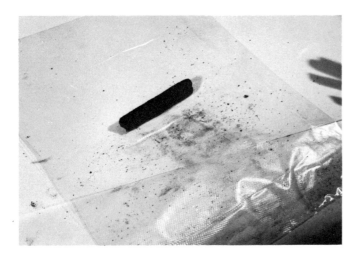

The finished charcoal resembles an even stick like the one pictured here. Flatten the ends by pushing with the thumb.

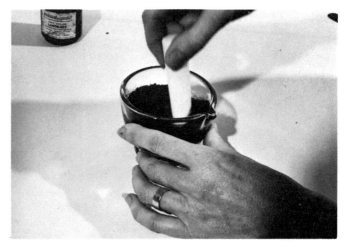

Stir in the mortar with the pestle until a proper mixture is achieved. Roll out the stick following the same procedure as for incinerated wood.

STICKS, TWIGS, AND DRIED PLANTS

New techniques of drawing can be achieved by using natural materials, which produce unique qualities of line. This is an effective way of introducing students to the almost limitless variety of "tools" at their disposal. Plant materials can inspire the sensitive hand. The advantage is that such a unique instrument—a twig, sharp stick, or dried stem—can impart something special to the drawing that another, more commercial tool cannot.

Every community offers an extensive variety of shrubs, trees, grasses, shoots, and fibrils, all capable of being used for investigative drawing. Prior to the refinement of pencils, pens, and other drawing and writing accessories, organic materials were the sole means of applying pigment to drawing surfaces, so their use is by no means unprecedented.

I have found that many of these items, which I have gathered during long forays and walks, are very personal and quite comfortable to work with. Like a pair of well-worn slippers, they fit me well and I return to them time and again. Near my studio there is a large arboretum where plants from all over the world are cultivated. On occasions one of my students, an employee at the arboretum, brings me the dried remnants of plants such as Chinese bamboo (very dark and brittle) ornamental papyrus stems, hardened grass shoots, and sackfuls of small, thin pine branches from around the world. I place them in a small corner of my cellar to dry, and, when the mood is upon me, I select a few, dip them into handmade inks, and sketch away on handmade paper that I have developed over the last few years. No art school or art-supply store prepares one for the personal and unique manner of drawing that these items afford.

I have observed the impact of nature, compounded of the seen and the known, and how it passes visual signals into the mysterious workings of the artist's mind. These experiences and insights are stored and often regenerated to mix and merge with feelings, intuitions, and receptivity, making visualization interact with the work of the hand to enhance disciplined control. Drawing is an experience. It helps to mold and sharpen purpose and develops above all a keen perception of shifting and transient moods in the world around us. Responsive drawing asks that the artist continually push toward a closer examination of phenomena—subject matter—which may or may not be tangible.

On my studio shelf I have an assortment of painted coffee cans that contain a wide variety of different natural drawing tools. Many of them look quite primitive and unsophisticated. Others are odd in shape: pieces are lashed, glued, or held together with small pegs. Not all have a single stylus: several contain three, four, and five points.

One can use many plant stems for various purposes and for different rough and smooth surfaces. I often use stems of elder, ash, and liquidambar for drawing on extremely coarse papers or woods. Drawing on Masonite panels prepared with several thin coats of gesso proves to be an interesting experiment. Hardwood stems work best if they have first been soaked in water for no less than several minutes. They are then much easier to cut into assorted points, and they retain more ink when wet. Stay with lightweight materials. Heavy and cumbersome tools slow down the hand and wrist and become tiring.

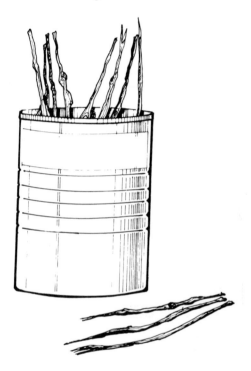

Sticks, twigs, and small branches can be effectively transformed into unique drawing tools. Each has its own character and feel.

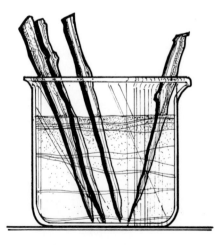

The sticks and twigs should be soaked in water for a few minutes before using. This helps to open the pores and fibers of the wood, assisting the absorption of ink and other aqueous media.

To shape the point, use a small pocketknife or penknife and cut thin shavings from the end of the stick. The sharper and more pointed the tool, the finer the line. You will soon find that the harder woods such as maple, oak, and ash survive longer. Softwoods do not fare as well but can be used for scumble drawing or for shading.

It is refreshing to relieve a rather uniform picture made with conventional tools with free subjective forms. The spontaneity and freshness of a drawing will never lose their power to put across a message in convincing human terms. In a drawing abstract ideas can be made visible in a manner that no other medium can rival.

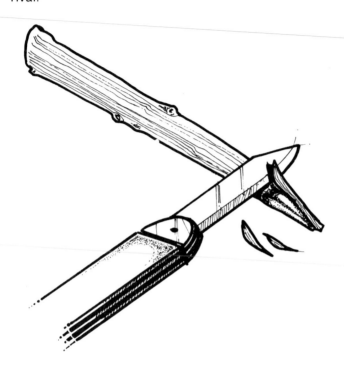

Sticks and twigs can be shaped and sharpened with a pocket knife to meet the needs of the artist.

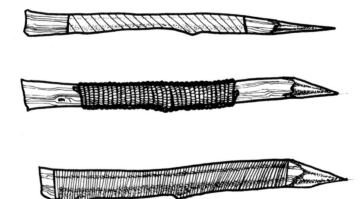

The newly made writing and drawing tool can be wrapped in string, yarn, or leather for a more comfortable grip.

BAMBOO PENS

In the Orient the bamboo pen is common. It can be carved in several ways, each for a specific purpose. In the first method a point is carved on one or both ends of a piece of bamboo approximately 6″ long. A second pen has only one carved point: the other end conceals a small *sumi-e* brush within the cap. Either end may be dipped into ink, offering the convenience of both pen and brush within the same tool. The pen portion usually does not contain a reservoir to hold ink, but one can be added in order to retain more ink at a time. This will not interfere with the stylus, nor does it take great skill to make. Thin strips of brass or aluminum are all that is needed.

It is recommended that you lightly spray-seal or brush-seal the inside of a pen nib that has been freshly cut. Use a thin coat of wood sealer or plastic resin. Both are impervious to water. Sealing the inner hollow helps to preserve a frequently used pen. Even the hardest bamboo soaks up moisture, and ink is no exception. The pen will be easier to clean, and your handiwork will be preserved. Although bamboo is an ideal material, you may want to consider making drawing pens from reed, cane, or other suitable hollow-core plants.

A pocket drawing pen is quite simple to make. It contains a self-sealing cap and can be clipped to the shirt pocket as with an ordinary fountain or ballpoint pen. You will need to locate a bamboo stem with several jointed sections. Cut the sections apart and find one that easily fits into another one. The fit should be snug but not forced. Carve a point, slit the nib if desired for better ink flow, and add the reservoir. On the larger bamboo section add the thin metal or brass clip as shown and cap the pen. Experiment with a few different sizes and carry one with you on outings. It is handy, inexpensive, and your own design. The use of this type of pen necessitates an available source of ink. A small plastic 35mm film canister will hold a large amount of ink and can be filled prior to use. It is airtight and will not leak. Ask for them at film stores. They are usually discarded, and, once rescued, make ideal storage containers. Coffee cans and small jars can be employed to mix larger quantities of washes, inks, and watercolors.

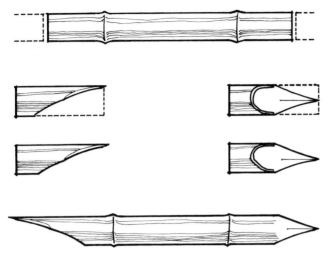

All types of bamboo can be used to make drawing tools. The points can be made with a thin slit down the center for better ink flow. This tool is lightweight, highly absorbent, and extremely easy to carve. Add a reservoir for better ink retention.

A series of sketches made by the author using an assortment of sticks, twigs, and bamboo. Notice the variety of lines and shapes acheived with these relatively simple implements.

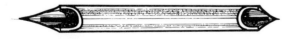

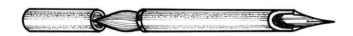

A pen-and-brush combination made with a single piece of bamboo. You may wish to form a bamboo cap to fit over the bristled end.

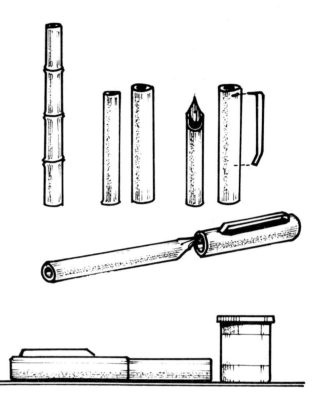

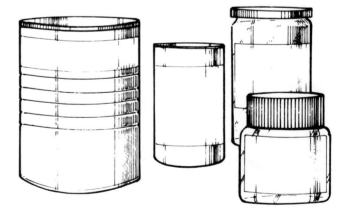

A pocket drawing pen made of bamboo. The pen is made first by sharpening the tip as shown in the illustration. The cap and clip are made after the width of the shaft has been determined. The cap can be made from the same bamboo shoot. The clip is made of brass or aluminum, one end of which is sharpened to a point, bent to a right angle, and forced into the bamboo. The other end of the clip slips over the shirt pocket.

Coffee cans and small jars should be saved rather than discarded. They are useful for mixing inks, pigments, and paints.

PASTEL, CHARCOAL, AND LEAD HOLDERS

Several tools for the draughtsman are very fragile and will benefit from the use of a holder, which provides strength and convenience. A device of this nature not only holds the material but extends it to its full measure. Make several out of tin or—much simpler—bamboo. Bamboo, as you will notice, is mentioned throughout this book as a very useful material for making artist's accessories. Its availability, pliancy, and fibril nature make it an ideal substance for a variety of uses. It is always necessary to allow the bamboo to dry before using it in your projects. The drying process can be facilitated by cutting the bamboo strip into several sections and storing in a warm, dry area of the studio.

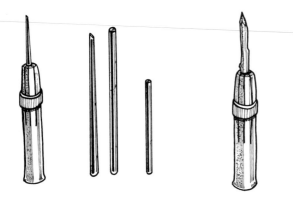

An adjustable lead holder can be made from bamboo and a small metal ring. One end of the bamboo is split into several long pieces to accommodate the stick, pastel, or charcoal. The ring is then slipped down to tighten the holder and the lead.

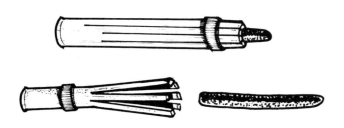

If the slits of bamboo are made longer, they can accommodate wider pieces of graphite and charcoal.

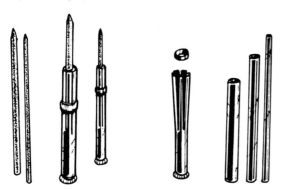

A tin lead holder is fashioned from an aluminum television aerial. One end of the aluminum is slit, and the other is flared and flattened to prevent the ring from slipping off the holder.

Making a Bamboo Lead Holder

The bamboo lead holder is an adjustable device: one holder can accommodate thin and thick pieces of charcoal, graphite, pastel, crayon, pencil lead, and vine charcoal. It grips thin twigs for very delicate drawings well and prevents them from snapping.

In addition to a few jointed sections of bamboo it is necessary to have a brass or metal (plastic will do) ring to slide up and down the shaft for tightening purposes. The ring must travel freely as it slides, and the thickness should not interfere with the fingers as the holder is used. Hardware stores, particularly those specializing in plumbing supplies, stock a large assortment of odd couplings and fittings, of which small rings and washers are a major part. Look for rings or bands that meet the above requirements. You will also need a sharp knife to split the bamboo.

In one hand hold the bamboo so that the joint of the shaft is away from you or facing the floor. Slowly make several short slits, evenly spaced around the tip, with the knife. Make between six and eight, depending on the width of the lead: if it is very thin, make more slits. Insert the small end of a brush handle into the bamboo tube and pull it up gradually until the bamboo splits another 1½" to 2". Assuming that the holder is 4" to 6" in length, 2" splits are sufficient. Slip the ring onto the shaft and move it up and down. If there is slight friction, sand the bamboo to eliminate raised spots. Insert the drawing material and slide it into the shaft so that there is a sufficient amount for the holder to grab. Tighten the ring. If you have carefully cut the bamboo just above the joint, the ring will not slip off the opposite end.

Making a Tin Lead Holder

The procedure for making a lightweight tin lead holder is the same as for making a bamboo holder with the following exceptions. Use thin aluminum tubing, which is easily cut with wire cutters or tin snips. Old television aerials will supply you with enough lead holders to stock an entire classroom. A television aerial is made up of thin tubes in a variety of widths. A television-repair specialist often has discarded antennas around the shop and shouldn't mind parting with a few feet of the material. Use a hacksaw to cut the tubes to the required lengths. The tin snips will crimp the tube, which may be desirable at one end to prevent the ring from sliding off the holder but renders the opposite end useless for slitting. Slit the end as described above, slip on the ring, insert the material, and tighten. Adjust if necessary. Instead of crimping the top end of the tube consider nipping the lip of the metal, making many small ⅛" slits. With needle-nose pliers bend the little flange out and under itself. This flares the end and also prevents the ring from coming off. Be sure that no sharp edges remain, as they can cut the skin. Dress with a file if necessary in order to re-

move undesirable edges. You will quickly find that the obvious advantage of the aluminum holder is its pronounced lightness. It is easily handled and capable of considerable extension.

SILVERPOINT

One of the more ancient drawing media is silverpoint. When metallic silver is drawn across paper coated with a thin layer of white paint, small, dark particles of the metal are left on the porous or granular surface. This process is no different than that in which small bits of charcoal or lead are held on the paper. Silverpoint drawings evince great subtlety due to the extremely fine line made with the material. In time the lines tarnish, producing the slightly darker surface typical of silver. Although silverpoint is not so widely advocated today as in the past few centuries, there is something to be said for its unique line quality. It does not require wet media, is self-contained, and should be experienced by artists as a welcome change from more traditional modes of rendering.

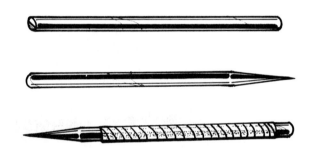

Silverpoint tools were employed by the Old Masters to draw on gessoed surfaces due to their outstanding line, character, and sensitivity.

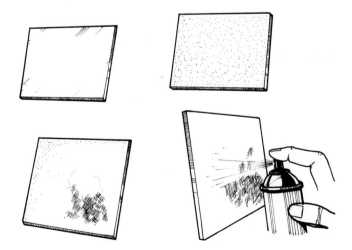

Once the silverpoint drawing has been made on the coated panel, further tarnishing can be avoided by the use of an appropriate fixative.

If silverpoint paper is not available, you can easily make your own by painting a thin layer of Chinese white or gesso on Masonite panels or thick watercolor paper with a fine, wide camelhair brush. Too textured an application of the paint interferes with the subtle silverpoint line. For best results the paper should be soaked and stretched and its edges taped to a drawing board to prevent buckling or rippling as the paint is applied.

While silver is considered to be a precious metal, the amount needed to make the silverpoint tool is nominal. The usefulness of silverpoint outweighs the marginal cost of the material. There are two methods for making the silverpoint instrument. The simplest and least expensive requires a short length of silver wire and an etching-needle holder (or a homemade holder as described above). Silver wire may be purchased from a jeweler. It is flimsy and soft and is best sharpened by lightly pulling the wire across a medium-surface Arkansas stone. Carborundum paper (#600) may be substituted for the stone. Pull the wire towards you in repeated identical motions while slowly turning the wire. The degree of sharpness is a personal matter: the finer the tip, the finer the line. Insert the other end into the holder and tighten. The act of drawing on the textured coating helps to keep the point sharpened, provided that the holder is slowly rotated while drawing. If tarnishing is not desired, spray with the appropriate fixative, usually a plastic sealer. Use the fixative sparingly.

The second method utilizes a sharpened silver rod, which is considerably thicker than the wire. A silver rod half the thickness of a pencil will last a long time. Although silver is soft, it does not wear down easily. I have used the same instrument for many years, and it has a long way to go before it will need to be replaced. The method of sharpening is the same as above. A coarser surface will hasten the process. Polish the tapered portion of the silverpoint on crocus cloth.

ALUMINUM CIGAR CONTAINER

Save the aluminum humidors used to preserve the freshness of cigars. They make excellent containers for storing lead, pencil, and charcoal holders when not in use. A tobacco or pipe shop may have a surplus, and they may often be had for the asking.

An aluminum cigar humidor serves as a handy pencil and lead container.

PIGMENTS

Inks

Very little is definitely known of the composition of ancient inks. The black liquid of the cuttlefish was once employed as a writing fluid. As ancient civilizations used the stylus, they must have had carbon inks similar to those employed by Asiatic peoples. Carbon in the form of soot was the principal ingredient of early inks. The soot was mixed with a mucilaginous or adhesive fluid, and an acid was sometimes added to make it bite or sink into the papyrus. The use of iron salts seems also to date from a remote period.

At the turn of the century the common ingredients of black ink were nutgalls, iron sulphate, and gum arabic. The galls were first crushed, then extracted with hot water and cloth filters in vats made for the purpose. These filters separated the clear solution from the woody and gummy residue. The liquid was then mixed with several other chemicals and with indigo and aniline blues. The gum arabic kept the ink from spreading on the paper and enabled the artist to make fine lines with the pen. An antiseptic solution was added to keep the ink from molding.

True fluid inks containing a blue coloring material were first made in 1856 by Stephens of London. Only indigo was employed, as aniline blue was not known at that time. The color of the ink was at first a deep blue, turning to black after writing. Inks are now manufactured in almost every conceivable color. Modern-day chemistry has provided numerous ways of concocting rich and varied shades of all colors of the spectrum. The introduction of coal-tar or aniline dyes

has added greatly to the existing stable of inks now used by artists.

India ink contains the same ingredients as did the ancient inks and is still made and used in China and Japan. In these countries it is used with a brush for both painting and writing. It is made from lampblack and a glutinous substance. The lampblack powder is gathered on the underside on a thin metal tin positioned above an oil-burning flame. The fine powder is then removed with a light, feathery tool and mixed with the appropriate binders. In india ink the carbon is held suspended in the fluid and is not dissolved or chemically combined, as are the iron compounds in writing inks. A perfume, such as a mixture of Borneo camphor and musk, is occasionally added to the finer varieties. This ink is prepared in the form of cakes or sticks, which are rubbed down in distilled water held by an ink stone. Various shades or depths of black can be obtained, according to the degree of dilution. India ink is blacker than other inks and is largely employed in cases requiring the densest coverage possible. It is considered a high ritual in the Orient to artfully rub down the ink prior to its use. The manner in which this is done is said to influence the quality of the lines made with the brush and ink.

It should be mentioned that most colored inks invariably lose their intensity or brilliance over a period of years. Fading is accelerated if the artwork is placed near ultraviolet light such as sunlight. The refining of lightproof pigments is continually being researched, but if permanency is required, these inks should be regarded with some suspicion until their long-range effects can be established.

Making Inks in the Studio

It is possible to make a selection of inks in many colors and shades in the studio with a few miscellaneous items. Obtain a mortar and pestle (glass or porcelain), some powdered pigment, a cup of water, an eyedropper, gum arabic, and a stirring apparatus. To test the color, use a pen fitted with a nib and a wide brush. The wide brush imparts a band of the color to the paper, which will reveal the overall density of the ink.

Mixing the Ink

Organic colors can be derived from plants, vegetables, and fruit such as pomegranate, blueberries, and other varieties. Inorganic materials such as earthen pigments may be finely ground and mixed with a binder to make earth tones for drawing and painting. In many of the desert and canyon areas of the West Coast it is possible to find deep, rich shades of red, brown, yellow, and black in rocks and clumps of dirt.

In order to use the pigment, it must be finely ground and mixed in a liquid vehicle to form ink. Colored substances that dissolve in liquid and impart their color to materials by staining or absorption are classified as

Ink sticks are unrivaled for their density, opacity, and lustrous qualities. The artist controls the thickness of the ink by the amount of rubbing on the ink stone. In the Orient the stick and stone are an integral part of scrolls, *sumi-e* paintings, and other works of art.

A portable table used for grinding ink. This Japanese instrument dates from the middle 1800s.

A man-made *suzuri* grinding stone for making *sumi* ink from *sumi* sticks. These stones are made of genuine powdered Amabata stone, which is considered the best quality. It is combined with a cementing compound and compressed tightly in molding to form its traditional shape.

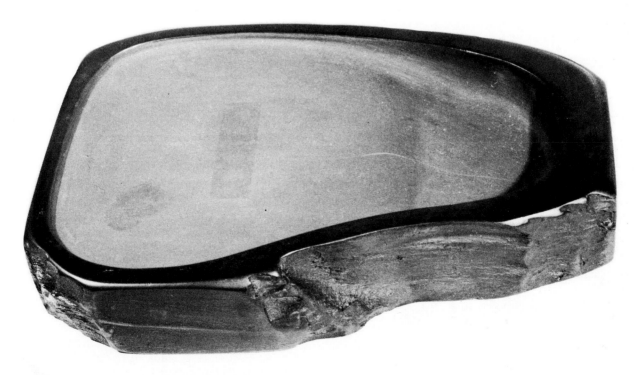

A Japanese *suzuri* stone made from selected Amabata stone. This ink stone was hand-carved to utilize the natural grain of the stone in order to facilitate fast, smooth, even, fine grinding of the ink. Each stone is selected by a trained and skillful stone maker.

dyes. The inks described here fall into this category, although they may be modified to the degree that they develop a surface opacity when applied to the support. The opacity is achieved by adding a greater amount of dry pigment to the binder or vehicle. When the vehicle has evaporated, as in the case of aqueous media, it will leave the residual pigment.

The most direct and immediate ink substance can probably be made from a small amount of powdered pigment, a few drops of thinned gum arabic, and distilled water. These ingredients are blended in the mortar with the grinding action of the pestle. All ingredients are stirred together until they have been sufficiently homogenized for their intended use. If the mixture is too viscous or sticky, add small amounts of water with an eyedropper until the ink is thin enough to use.

Inorganic Native Earths

Permanent Pigments manufactures an extensive line of powdered pigments that are available in art stores. They vary in price according to supply and demand. There are other pigments that are more precious and not so easily obtainable. These substances also vary with location, but pigment of some type abounds everywhere. Colors are as accessible and as near as the backyard or local quarry. Colors may be gathered from tundra and forest, canyon and river, peak and glacier or from some secluded corner of the hills where weathering has brought its own particular palette to the crust of the earth, as seen in the upended rocks and the mulch of the autumn leaves. Each fragment and particle of earthen substance contains within its own sphere a unique, characteristic color property. Find these spectral differences and use them in your experiments.

Small plastic bags can be of immense help in your forages for earth colors. Label them and draw from your own color collection to make inks and thinned media for drawing and painting. The homemade drawing implements described above create an ideal marriage between pen and ink, for the intent here is not one of permanency but of the pursuit of pleasure. To paraphrase a noted oriental-art historian, our minds are the canvas on which the artist lays his color; his pigments are our emotions; his chiaroscuro the light of joy, the shadow of sadness. The masterpiece is of ourselves, as we are in the masterpiece.

A sensitive calligraphic statement by Susan Honda using traditional Japanese haiku poetry. This student project utilized hand-ground ink and dyes. The oriental characters were made with the Japanese bristle brush.

Some water, a dash of color, and a pen or brush are all that are necessary to make marks and trails on the blank surface. Your endeavors will reveal that handmade inks and dyes are prime elements in the continuing search for personal expression and individual creativity.

Ink study. Vance Studley, 1968. Multicolored inks can be used for color washes as well as for line drawings. A combination of the two techniques can make a pleasing complement to the artist's idea.

Solvent cans are useful for storing and dispensing ink. They can be purchased in auto-supply stores. The thin resealable spout can be used to fill small mechanical-pen cartridges.

4 Tools For Painting

TYPES OF BRUSHES

Of all the items contained in the artist's box of supplies the brush would have to be considered the most important and useful. Each painting discipline carries with it the need for an appropriate brush to match the medium used by the painter. The success of a work often depends on the quality and character of the brush, whether new, used, or so completely worn down that only the owner of that particular pet brush could keep it alive. Brushes are made of hair, bristles, nylon, and in rare instances the shredded fibrils of bamboo. A brief description of each of these categories of brushes is offered for background information.

Hair

The tips or points of hair paintbrushes are the natural ends of the hair—they are rarely cut or trimmed. All shaping and trimming is done at the root end by careful and skillful manipulation.

The finest red-sable hair comes from the tail of a weasellike animal called the kolinsky mink, also known as the Siberian mink or the red tartar marten. No other hair has the same spring, durability, and other desirable properties. Only the tail hair, which is pale red in color, is used. Skilled brush makers dress the hair and carefully insert it into the ferrule of the brush, which is then fastened to the wooden handle. Each handle is crimped tightly to assure the proper fit.

Other hairs may be used in the manufacture of brushes. For example, deer hair (from the animal's back or outer body) is generally selected to give the brush a firm standing. For various qualities of elasticity and pigment absorption brushes may incorporate portions of squirrel, horsetail, badger, weasel, sheep, goat, ox, and even cat hair.

Hair brushes, depending on shape and size, have the following classifications: bright, flat, round, and long. They are manufactured as red-sable oil brushes and red-sable watercolor brushes.

Bristle

Bristle brushes are made from high grades of bleached white hog bristles, which are carefully selected for brush-making purposes. The natural bristle has a split end, which is forked and branched like a small twig: this is called the flag. Bristle brushes fall into the following categories: round, flat, and bright. The quality of bristle brushes may vary according to the manufacturer's requirements, so the only real test of a brush's quality is to paint with it.

Nylon

To meet the growing popularity of polymer paints, manufacturers have developed and refined a brush that is more able to cope with the strain put upon it by this relatively new medium. The use of nylon bristles is, particularly in the last decade, an ever-present reminder that it is entirely possible to use new and untried experimental fibers in brush making. In the last few years an even finer, more sophisticated nylon brush has been introduced to the market, which, according to some experienced painters, is close in quality to that of the kolinsky sable. I am afraid that at this time I can offer little information to support this claim. But I have tried the finer-grade nylon painting brushes and found them to be excellent for gouache and watercolors.

Shredded Fibril

Bamboo brushes are made of selected pieces of bamboo. Their durability and distinctive texture impart a special crispness to calligraphy, painting, and drawing. Their method of manufacture is covered later in this chapter.

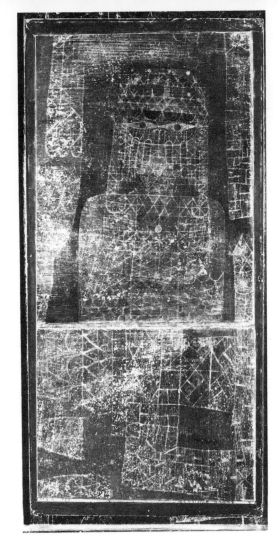

Arabian Bride. Paul Klee, watercolor, 13⅜″ × 6½″. (Courtesy of the Norton Simon Museum. The Blue Four. Galka Scheyer Collection.) Klee was a master of painting in many media. Naive images often conceal a richer, more profound message within the work. Brushes become an extension of the artist's hands and his visually rich and fertile imagination.

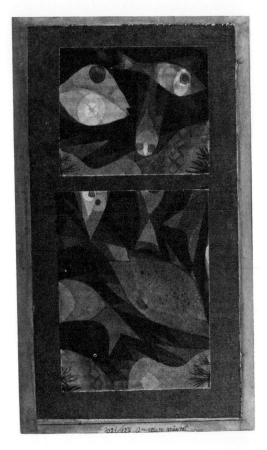

Aquarium Green/Red (*Two Small Scenes*. . .). Paul Klee, watercolor and ink on paper, 8⅞″ × 4¾″. (Courtesy of the Norton Simon Museum. The Blue Four. Galka Scheyer Collection.) Klee frequently used watercolors and inks on an assortment of highly textured papers to give surface richness and textural appeal.

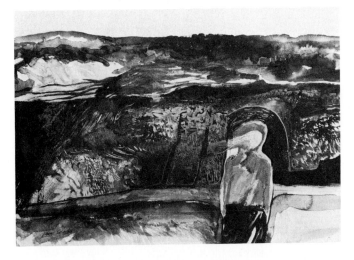

Tunisian Landscape. Vance Studley, 1971. All colors used in this work were derived from earthen pigments. Brushes used to apply the pigment were also handmade. Handmade brushes can rival and are often superior to their commercial counterparts. The handmade brush embodies unusual materials for expressive purposes.

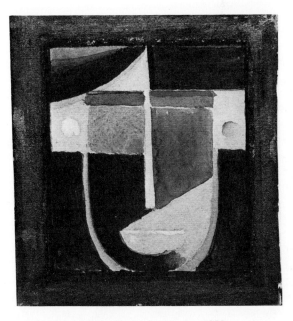

Little Head, Red-Black. Alexei Jawlensky, 1928, 3 5/8″ x 3 7/16″. (Courtesy of the Norton Simon Museum. The Blue Four. Galka Scheyer Collection.) Watercolor and gold pigment were applied in small, discrete patches with diminutive brushes to form this arresting work of art.

39

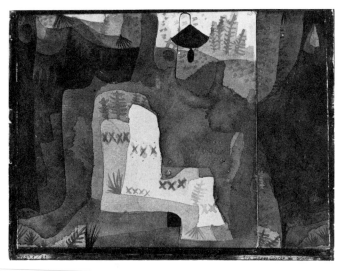

Black Bell in the Forest. Paul Klee, 6⅛″ × 7¾″. (Courtesy of the Norton Simon Museum. The Blue Four. Galka Scheyer Collection.)

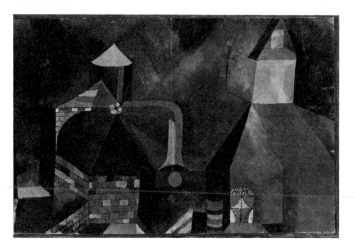

New Houses. Paul Klee, 7″ ×10⅞″. (Courtesy of the Norton Simon Museum. The Blue Four. Galka Scheyer Collection.)

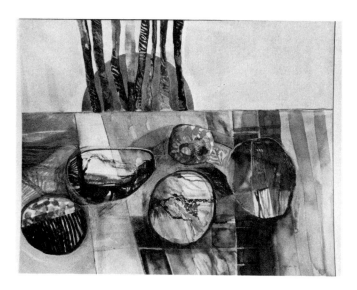

Rising moon. Vance Studley, watercolor, 1974. The success of a work often depends on the quality and character of the tools. An assortment of large and small brushes made of animal fur and bristles was used in this work.

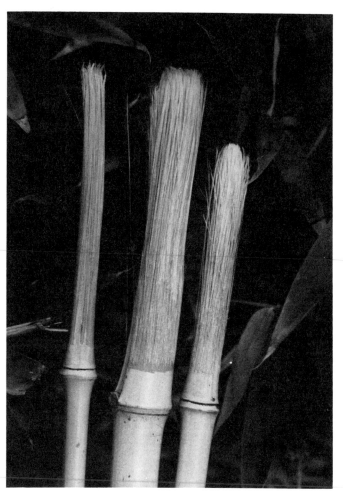

Shredded-fibril-bamboo brushes made by inserting the ends of the bamboo in the ground and allowing biodegrading action to form the strands seen here.

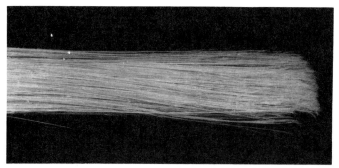

MAKING YOUR OWN BRUSHES

By combining interesting and unusual hairs with an assortment of ferrules and handles it is altogether possible to devise brushes for painting with a variety of media, such as watercolor, colored ink, acrylic, oil, tempera, gouache, and casein. It must be stressed that these homemade brushes are not meant to compete with superior-grade commercial brushes but are instead offered as refreshing diversions to the more traditional tools. The procedures set forth here have all been tried and found to work surprisingly well.

Hair

I was recently the recipient of an old fur stole from a distant relative. The stole, not exactly an heirloom, was precisely what I needed to test my hypothesis that good-quality animal hair could be used to make brushes in the studio. By carefully removing small clumps of fur with strong tweezers I was able to stock a dozen plastic bags with potential brush material. In addition to the fur I obtained some aluminum and brass shim for constructing the ferrules and a few feet of ¼" and ⅜" doweling for brush handles. My method of making the brushes is outlined here.

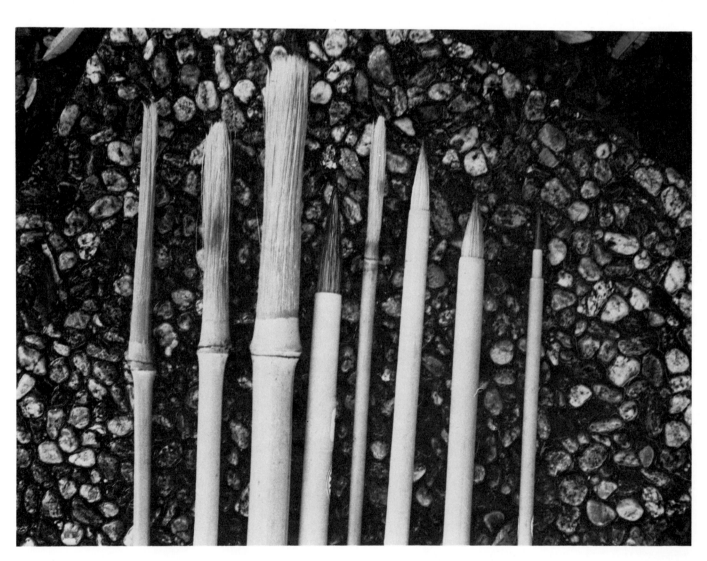

Bamboo is a universal plant and a useful raw material for artist's brushes. Notice the variety of shapes and sizes obtainable from this unique plant.

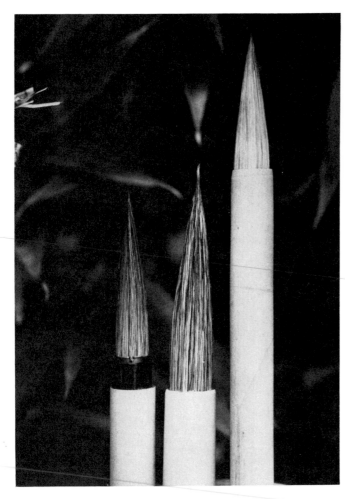

Three brushes made by the author using, from left to right, deer, fox, and goat hair.

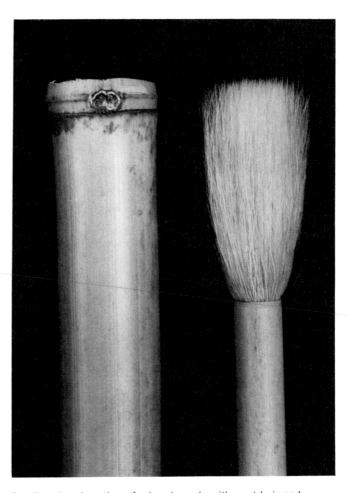

Detail and end section of a brush made with goat hair and bamboo.

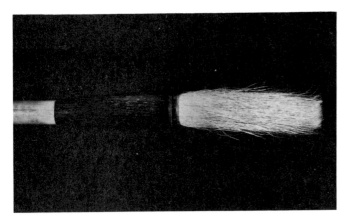

A brush made with badger hair, a bone ferrule, and bamboo for the handle.

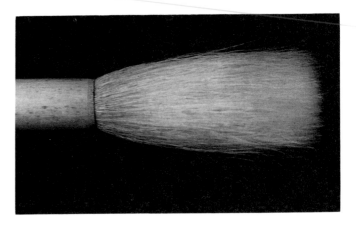

Detail of a brush made of goat hair and bamboo.

Lay several dozen hairs out on a clean piece of white paper on a flat surface. With a strong and direct light, some tweezers, and a magnifying lens select hairs that appear to have the same shape, texture, and, most important, taper. When enough of these hairs have been isolated, gently pinch the tapered tip with the thumb and forefinger and lift them off the paper. With the other hand slip a very small, thin elastic band over the opposing end of the hairs. Release the band about 1/3″ down the gathered hairs. This will temporarily hold them together until they are placed in the ferrule for a permanent hold.

The simplest ferrule to use with a brush of this type is a small-diameter metal tube, which can conveniently be cut to any desired length with a jeweler's saw or hacksaw. File the ends to remove any rough burrs. Draw the ends over a Carborundum stone to even out the metal before inserting the hairs. The dowel should be approximately 6″ long and should be sanded or filed on one end to a taper that can be inserted into the metal tube. The other end of the dowel should be rounded with coarse sandpaper, and the entire shaft should be given a final sanding with very fine sandpaper. Seal the wood if you wish to minimize stains.

Individual strands of fur are placed on a piece of white paper.

The furs are tied together with fine thread to keep them from slipping.

The tips of the fur are gathered together by size and shape and tied together as a bundle or small clump.

The thin thread must be tied securely around the hairs before they are placed in the ferrule.

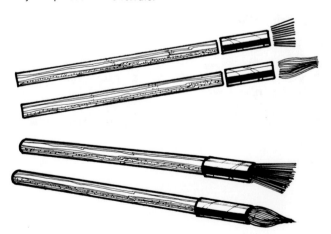

Once the hair is in place, glue is applied to the top end of the ferrule, cementing the bristles and ferrule together.

Carefully push the top end of the clump of hairs into the round ferrule. Coax the hairs upward to within ¼" of the rim of the ferrule. If the hairs resist sliding into the ferrule, remove and add a small amount of water mixed with liquid starch to the top portion of the hairs, taper, and allow to set. When dry, ease the clump into the ferrule. Pour a few drops of strong waterproof cement or glue into the top of the ferrule and allow to dry overnight.

The handle is now ready to be inserted into the other end of the ferrule. Again apply a small amount of waterproof glue, insert the handle, and allow to dry. For permanency rotate the brush and tap the ferrule where it meets the wood handle several times with a nail punch, forming a slightly depressed nipple in the metal. This will aid in clinching the metal ferrule to the wood handle.

Because the metal tube used as the ferrule for the brush is not tapered, you must take care not to allow pigment to work its way into the roots of the hairs. Keep the pigment well below the point where the metal brim and the hair meet. Wash the brush with lather and warm water after use. Shape and remove errant hairs with a pair of tweezers. Allow to dry in freely circulating air to prevent mold and odor.

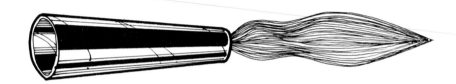

An enlarged view of the strands of fur as they are gently pushed into the ferrule.

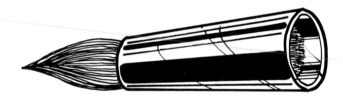

It is essential that the root ends of the fur strands do not extend beyond the edge of the ferrule. It is best to pull the strands within ¼" of the lip of the ferrule tube.

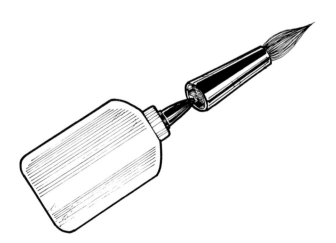

Bamboo and miscellaneous hairs may be combined in a simple painting brush. The brush does not have a ferrule—it is replaced by the hollow portion of the bamboo shaft.

Waterproof glue is applied to the inner hollow of the ferrule. A few drops should be sufficient.

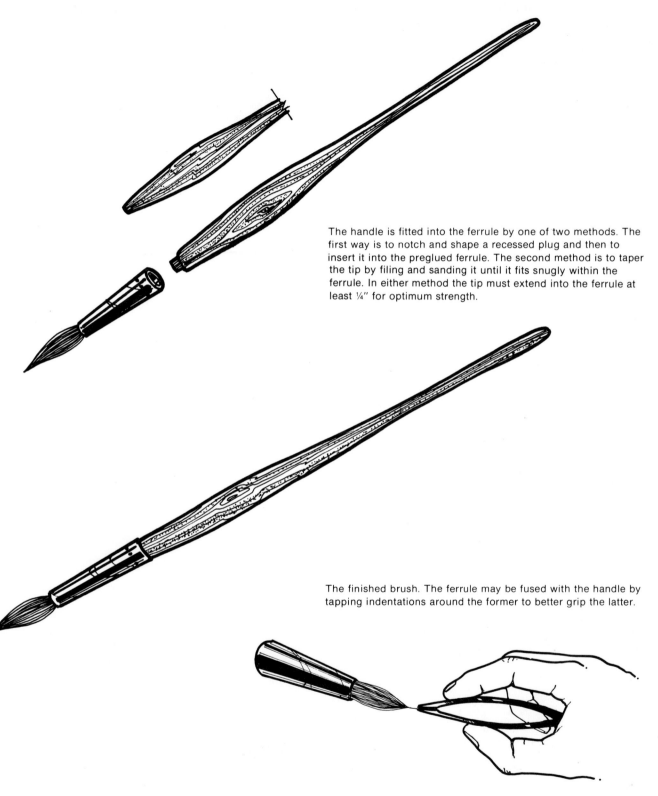

The handle is fitted into the ferrule by one of two methods. The first way is to notch and shape a recessed plug and then to insert it into the preglued ferrule. The second method is to taper the tip by filing and sanding it until it fits snugly within the ferrule. In either method the tip must extend into the ferrule at least ¼″ for optimum strength.

The finished brush. The ferrule may be fused with the handle by tapping indentations around the former to better grip the latter.

Errant strands of hair or bristle may be removed with tweezers.

When you feel that you have some mastery of this method of making brushes, you might want to make a finer brush, perhaps with a variety of hairs. Try to find tubes that taper in order to better hold and contain the hairs. For many years brushes were—and for that matter still are—made with quill ferrules from bird feathers. More recent ferrules have been plastic tubes that have the same texture but are more elastic for a better grip on the hairs. Brush handles can be filed and sanded to fit more comfortably in the hand or can perhaps be made longer to resemble an oil-painting brush. The method for making a more sophisticated brush and customizing its design is essentially the same as described above.

Do not feel limited to the use of rare furs. In many other cultures the hairs from many local and domestic animals are used to make brushes. Most animals lose their furry coats during the spring or early summer. These fallen hairs can be gathered and set aside for future brush making. Discarded animal pelts can be found in Goodwill and Salvation Army stores and can often be had for a pittance, depending on the condition of the piece.

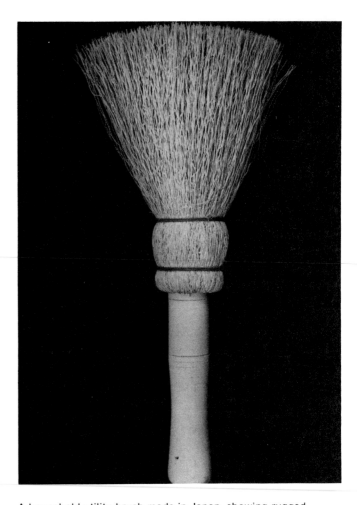

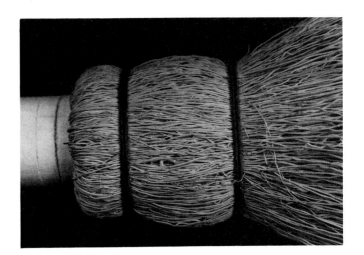

A household utility brush made in Japan, showing rugged, coarse, wavy strands of plant material. The strands are attached to the handle with bailing wire.

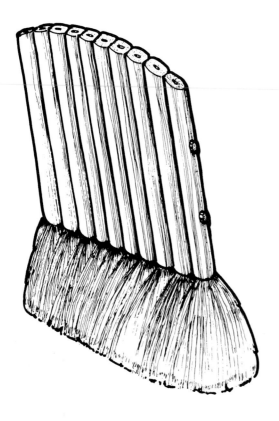

A version of the Japanese *hacke*, or background, brush can be made by laminating individual shoots of bamboo and pinning them together, with a dowel penetrating each shoot. Bristles are then inserted and glued in the tips of the bamboo. This is a useful brush for laying down large areas of wash.

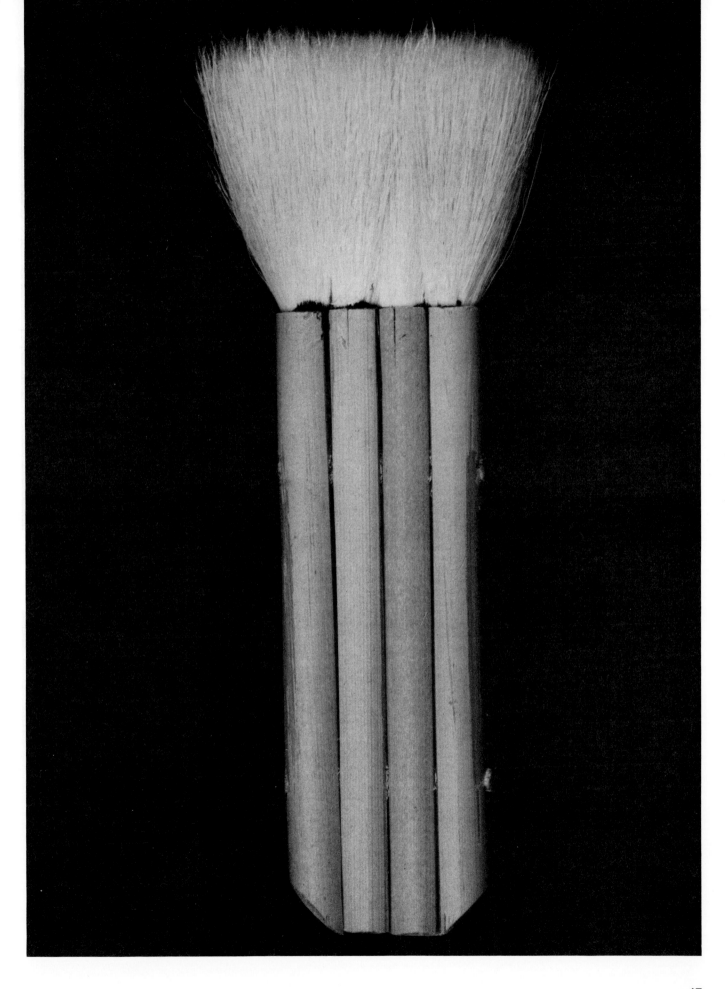

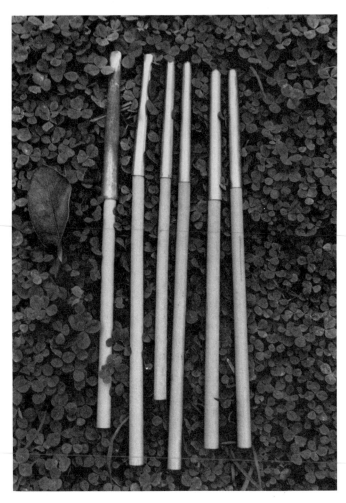

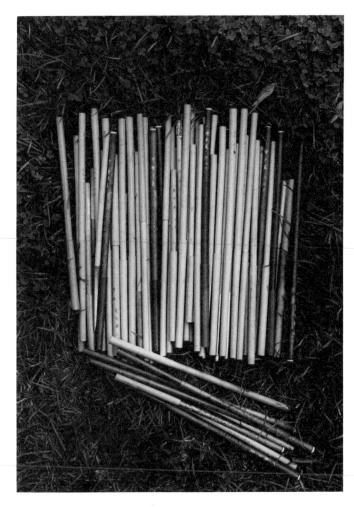

Oriental bamboo brushes made in the late 1800s. Instead of the bamboo cap now used to protect the bristles of the brush when not in use hollow metal caps were used.

A collection of late-19th-century *sumi* brushes. (Collection of E. Pong.)

A modern-day Japanese brush with bamboo cap attached.

A small strip of yarn or string can be affixed to the top of a brush. The brush is suspended from this loop in order to dry without disturbing the bristles.

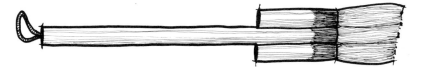

A unique brush made by gluing three pieces of bamboo together.

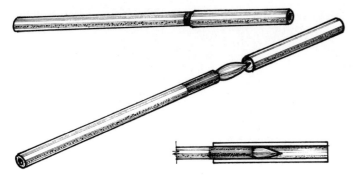

How the bamboo brush fits within the bamboo cap. The bristles must be shaped to a point before they are placed in the cap. A small amount of liquid starch is occasionally applied to the bristles, which are then shaped and allowed to dry. In this way bristles are not disarranged or spread as the cap slips over the tip.

Instead of gluing the hair to the inside of the metal ferrule you can substitute a plastic tube, insert the hair, and band the outside of the plastic with thin brass wire to hold the strands of hair in place. The plastic is elastic enough so that the end of a blunted pencil or dowel can easily be forced into place, effecting a surprisingly tight grip.

Synthetic Bristle

Synthetic fibrous material is often employed in the fabrication of experimental brushes. Strands of plastic monofilament, thin wire, bristles from existing house-painting brushes, string, jute, stiff cord and yarn, and strands from polyvinyl rope can all be used in provocative and challenging attempts to make unique brushes. Natural fibers such as grasses, long and thin twigs, leather, strands of papyrus, and reeds should also be tried to ascertain which are most suitable for the particular use.

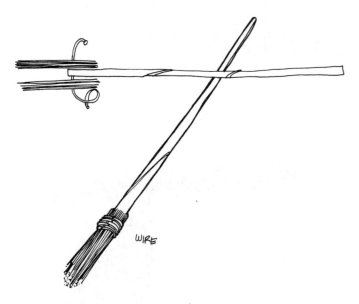

An experimental wire brush lashed to a handle made with ¼" doweling.

Another view of the quill-ferrule method of brush making, using a larger quantity of hairs to make a watercolor mop brush.

In this example the ferrule is made from a turkey quill. The quill is fastened to the wood handle with strong brass wire. This method has been used by brush makers for several centuries.

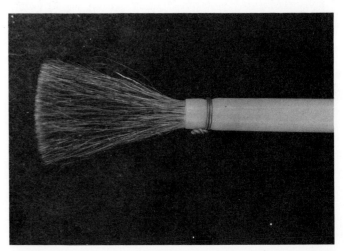

In place of a quill you may substitute plastic tubing with equal success. Use needle-nose pliers to bind the wire around the plastic ferrule. Whether you use the quill or the plastic tube, you must still apply a waterproof glue to hold the hair or bristle in place.

Bamboo

The bamboo brush pictured in the adjacent photographs was made by burying one end of a length of dried bamboo in the ground for several months until bacterial action broke it down into rough filaments. This is a remarkably simple procedure. The biodegrading action of the earth does all the work. Depending on the number of brushes you require, place a quantity of dried bamboo shoots of various diameters and lengths in the ground so that the shaft is perpendicular to the ground. The shafts are buried in the ground to a depth of anywhere from 2″ to 5″. Select an area of your yard or garden where moisture is frequently present. Earth that is continually soaked does not expedite the bacterial process; earth that is too dry, with little humus, likewise contributes little to the organic breakdown of the bamboo. Once the best location is found and the bamboo is in place, drive a stake into the ground a couple of inches away from the bamboo and attach some fine wire so that the two vertical pieces are linked together. This will help to thwart accidental toppling due to the elements or to the movements of animals and children.

After two weeks pull up one bamboo shoot and examine the tip. It will probably show little change but will give you a clue as to the nature and character of the biological activity taking place on the tip as it rests in the soil. Repeat this process every two weeks with one or two selected bamboo pieces until the brush is ready to be removed permanently.

Immerse the bamboo into a bucket of water, allowing it to soak for several hours. The water will loosen the dirt and other foreign material lodged in the fila-

ments. Agitate the water and bamboo every hour to remove the more steadfast particles. A small quantity of bleach liquor—3 tablespoons per bucket of water—will lighten the brushes considerably. If a coarse scrubbing brush is available, brush out the filaments as you would brush the fur of an animal—that is, in one direction toward the brush tip.

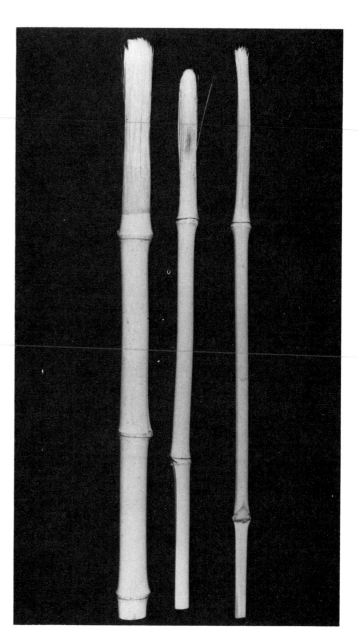

Three sizes of shredded-fibril-bamboo brushes.

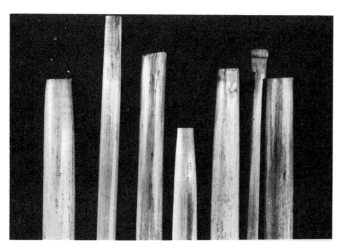

Swamp reeds can be used in place of bamboo for brush handles. They are lightweight, easy to cut, and hollow. Follow the same method as for bamboo.

50

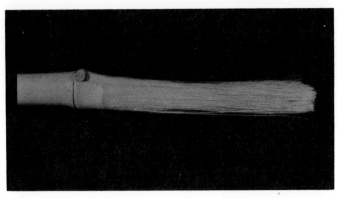

A closeup of the shredded-fibril brush, showing the proximity of the fiber strands to the node of the bamboo section.

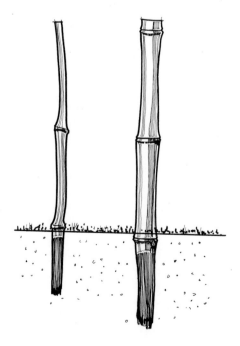

The manner in which the bamboo brush is held. The long strands allow for maximum ink absorption.

The depth to which the brushes are to be implanted in the soil. The soil must be kept damp and the bamboo held in place with an additional spike.

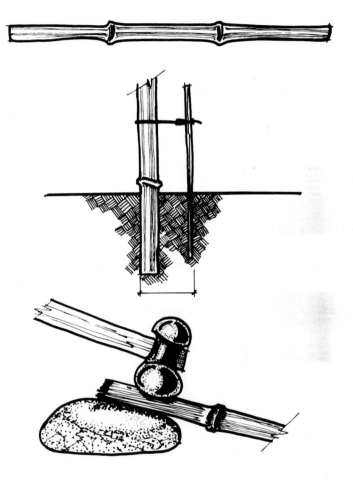

Once the bamboo has been removed from the soil (usually in three to five weeks), the buried end is hammered to break the long fibrils into discrete strands.

A wooden or leather mallet may be used to perform this step.

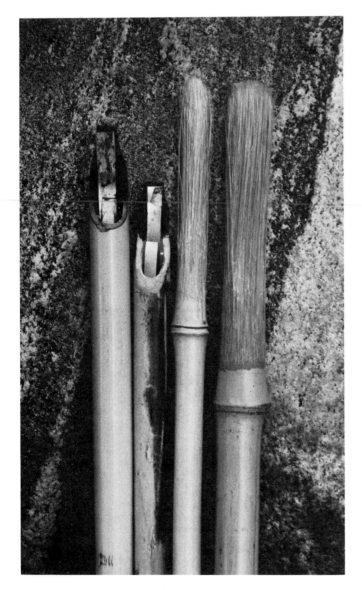

The inherent beauty and functional properties of bamboo are highly satisfying.

While the brush is damp, it is necessary to pound the flayed portion with a wood or hard rubber mallet. Place the bamboo on a table or log stump to support it as the blows are made. Approach this phase with care: a misdirected blow will splinter the shaft. As the brush is rotated, you will see the filaments start to appear.

Comb out the bristles with a wire brush to separate individual strands. The end should not need trimming: this would only form a blunt tip, which would ruin the characteristic slender, slightly tapering shape.

SPRAY DEVICES

Airbrush is a very popular technique today because of the subtle film of color that it imparts to paper and board. Dyes, inks, and diluted gouache provide a thorough array of colors from which the artist may choose. Although there are alternatives to the compressors (i.e., an aerosol can or prefilled tank), the pen itself is a costly little item that seems to be steadily climbing in price each year.

Most households have bottles of perfume, cologne, and aftershave lotion that come with a squeeze-bulb apparatus known as an atomizer. As the bulb is squeezed, air is blended with tiny particles of the perfume and expelled through the small aperture of the nozzle. The mist can be directed to any surface with excellent coverage. Once the perfume or cologne is exhausted, rinse the bottle thoroughly if the cap has a screw thread allowing it to be removed. If the cap and nozzle apparatus are permanently attached to the lip of the bottle, it is usually possible to immerse the nozzle in warm water and, by pumping the bulb, to alternately fill and expel the contents. The ink or dye substance is introduced to the bottle in the same manner. Of course, it is far more convenient to use a bottle with a resealable cap.

If the mist of color is too fine, widen the small hole on the tip of the nozzle with an awl. Keep a selection of these bottles handy and clearly identify the color contained in them if the glass is opaque. Also indicate the quality of the spray for each respective bottle to avoid inadvertent flooding of delicate artwork.

If you don't have any atomizers handy, you have a choice of resealable pump-spray bottles, which are sold new and empty in hardware and automotive-supply stores. As a result of the ban on certain aerosol devices more and more manufacturers are introducing their products in pump-spray containers. These can be washed and reused successfully.

Several brands of pump sprays have adjustable nozzles to control the spray or mist emitted. Avoid overly large bottles. You will probably not find it important or practical enough to make up more than a pint of ink or dyestuff at one time.

Small perfume atomizers can be used for airbrush techniques. Once the perfume or cologne has been exhausted, rinse the container with warm, soapy water. The bottle may now be filled with inks or dyes and the cap and bulb resealed in place. The opening in the tip of the nozzle may be enlarged by inserting an awl and rotating it with a little pressure.

Airbrush techniques may also be achieved with pump-spray bottles. These bottles may be purchased empty in variety stores. The nozzle is often adjustable for fine and heavy sprays. Windex and other cleaning solvents are sold in these bottles. Save them and put them to good use in your airbrush exercises.

KNIVES

Palette Knives

Palette knives are used to mix colors on the slab or palette. They are slender in shape, and the tang of the knife is limber. They are 3″ to 6″ in length and have both round and tapered tips. The jog in the metal prevents knuckles from getting in the paint. If you follow the illustration, it is simple enough to make a palette knife, provided that the raw materials are accessible. The chosen metal must be flexible and springy. Better yet, if the metal has previously been hand-tempered, the spring will already be evident. Handles for the palette knife can be fashioned from an old file handle or a piece of ½″ doweling. Drill a hole in the handle to hold the metal rod to which the blade portion has been attached by means of welding or liquid solder. Seal the handle to prevent paint from staining the wood.

Painting Knives

Painting knives are clearly different in shape and purpose from their close counterparts, palette knives. They are used for painting directly on the canvas. They can be used in conjunction with a brush. The blade is very fragile and thin and responds sensitively to the hand's movements. The handle tends to be longer than that of a palette knife or of a knife that is used for heavy-duty mixing and grinding. By trying different blades—long, short, wide, thin—with an assortment of handles you will eventually arrive at personal designs that complement your needs.

Painting and palette knives may be made from thin, flat pieces of metal, which are welded or soldered to metal rods. The metal rods may be shaped to fit the needs of the artist. Make the handles from ¾″ or 1″ dowels.

PALETTES

In order to mix paint easily, the artist should work from surfaces that are readily cleaned and occasionally from containers that can be disposed of when varnishes and other media accumulate, making the utensil worthless for extended use. Collect small tins and scour them ideal mixing cups: they are hard and plentiful and often fit well in the palm of the hand. Lightweight plastic and high-density foam dishes are expendable and worth saving for the purpose of mixing paint. Porcelain and glass trays, bowls, and plates can be purchased from secondhand stores at a fraction of the cost of artist's trays and palettes sold in art stores. Porcelain containers offer a wonderful surface for blending and dabbing paint. There is nothing quite like them for feel, hardness, and porosity. Save them whenever the opportunity presents itself.

PIGMENT CONTAINERS

Storage of small quantities of pigment, both wet and dry, can be complicated by the use of containers that do not fully seal off the air. Glass jars, with the exception of baby-food jars, are often too big for practical purposes and are cumbersome to store. I have found the plastic 35mm film canisters made by Kodak and other companies to be ideal capsules for preserving an assortment of paints. They are airtight, free for the asking at film dealers (they discard them anyway), and very lightweight for storing in the artist's paintbox. Medicine bottles and vials also meet this need. The brown glass helps to screen out the sun and further extends the life of paint and inks.

Porcelain plates make excellent palettes. They may be found in secondhand stores and are well worth the few pennies that they cost. Disposable plastic and high-density foam plates are also suitable for mixing paints.

Film canisters can be employed for storing inks, paints, dyes, water, and other solutions. They are airtight, do not leak, and are made of plastic or aluminum. They can usually be had for the asking at film and camera stores.

5 Tools For Lettering & Calligraphy

It can be safely said that one experience that is common to everyone is the act of writing with a pen or pencil. From grade school through our adult lives we use writing instruments practically on a daily basis. We write letters to friends, make grocery lists, sign checks, write stories, and doodle endlessly with the ballpoint pen. Everyone knows the frustration of having to search for a pencil or pen at desperate moments, only to find the lead broken or the cartridge empty. The writing tool signals to us a dependency that is hardly questioned. Everyone at one time has to handle a pen, if only to sign his name.

Today's writing tool is most likely to be a ballpoint pen, which came into popular use after 1945. Since that time it has become the ubiquitous pen, replacing the pen and nib, although the fountain pen is still in use and is popular among artists and designers. It is hard to imagine a time when these inexpensive, simple ballpoints were not around. For this reason most people are totally unaware of early writing tools—what form they took, how they were made, let alone how it feels to draw, letter, and write with them.

Ancient writing materials and tools. A and B: Papyrus is made by layering thin strips of papyrus reed at right angles and pounding them together. The sticky substance released helps to bond the material together. The papyrus is then polished with a smooth stone or shell. C and D: A wedge-shaped cuneiform tool and clay tablet. A stylus was impressed into the clay to form symbols. The clay was then fired and stored in archives.

Writing utensils from the early 1900s. Ink is drawn into the rubber bladder of the pen by means of a lever, which, when raised, creates a vacuum that draws the ink into the cartridge. The bottom pen combines a pen and pencil, one on each end.

THE REED OR CANE PEN

Man's first drawings were made by primitive artists on the natural rock of cave walls and ceilings with charcoal, some kind of coloring material applied with a skin pad, and several wood or bone tools. The veining of the cave rock often dictated the size and shape of the drawings: occasionally the contour of the rock conformed to the drawn image. Bison, mammoths, and other animals were depicted in whole and piecemeal form. Later picture stories or pictograms were developed. Animals were shown galloping, fighting, and fleeing from the hunter with his spear. Primitive man created the first narrative by visually recording, with the flimsiest tools, his observations of the earthly struggles for existence.

The Ideogram

In time the pictogram gave way to the ideogram, or ideograph. The ideograph is a definite picture, conventional and simplified, selected by agreement or custom from many experimental pictures. The chosen picture thus becomes a fixed pictorial symbol of its name. For example, the sun is depicted as a circle with lines extending outward from it to suggest its rays. This is a very common symbol known the world over for thousands of years and is accepted as a fixed picture or visual conception of how the sun appears to us.

The Egyptians

The Egyptians made an enormous contribution to the early beginnings of our alphabet. They were also instrumental in inventing the paperlike writing material known as papyrus. Papyrus, the plant, was most likely imported from what is now Ethiopia and raised on the banks of the Nile, which was quite fertile and compatible with the swampy, grasslike nature of the plant. Egyptian papyrus soon became the most widely used writing surface in the ancient world, supporting much commerce and exportation.

Along with the development and refinement of papyrus the Egyptians formed a writing tool from common swamp reeds that was the prototype for the reed pen used by students of lettering and calligraphy today.

They selected a reed, cut it to a manageable length, and set it aside to dry for a brief period. When ready, the end was frayed to make a primitive brush, with long tendrils of the plant used to hold the pigment. This pigment was a liquid similar to the ink that we use today. It was this tool that the Egyptians used to create the secret priestly writing of the Old Empire commonly known as hieroglyphics. In time the reed brush gave way to a square-edged nib made from the same material. This in turn directly affected the writing style of the early scribe.

The Greeks and Romans

The Greeks and Romans used the reed as the chief tool for their writing. The reed and the brush subsume the Roman alphabet and impart to the Roman letters an internal dynamic quality that can only be brought about by careful use of the reed tool.

There are good reasons for using the reed as a writing and lettering tool. Reed-written letters are far superior to pen-written letters. Reed strokes are crisper and sharper than identical strokes made with a metal pen. Each reed pen can be cut and sharpened to meet individual taste and requirements. As the pen becomes dulled by use, it is a simple matter to reshape the nib and to restore the original fine line made by this instrument. If one is left-handed, it is just as easy to carve an oblique nib to suit this particular need. The reed has a springlike quality that must be felt and hence is more sympathetic to ink and paper.

Other Countries

In other countries, notably the Middle East, Persia, and North Africa, special and unique materials were employed in the making of pens, each of which was endowed with significant symbolism. A marriage was sealed on wax tablets with a pen of red copper. To honor a comrade or friend, a pen fashioned of silver was employed. Pens from stork beaks were also used for special occasions. A pen made from a small branch of the pomegranate tree was used for conveying a message to an enemy.

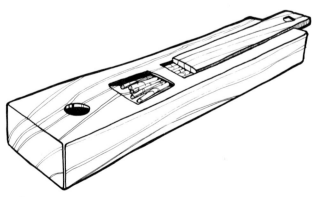

An Egyptian papyrus reed and ink box. The scribe used these instruments to record information and knowledge.

"On The Reed"

I was of late a barren plant,
Useless, insignificant,
Nor fig, nor grape, nor apple bore,
A native of the marshy shore;
But gather'd for poetic use—
And plunged into a sable juice,
Of which my modicum I sip
With narrow mouth & slender lip,
At once, although by nature dumb,
All eloquent I have become,
And speak with fluency untired,
As if by Phœbus' self inspired.

From the Minor Poems of William Cowper. Transcripsit W.M.Gardner.

A poem written with a reed pen about the reed as a writing tool. Scribe: W. M. Gardner. (From *Minor Poems of William Cowper*.)

Quid

Reed lettering showing the sharpness of detail and fluidity of line possible with a hand-cut tool.

Making the Reed Pen

Reeds (*Phragmites communis*) can be found near streams and marshes throughout the country. They occasionally grow up to 15′ in height. In Pliny's time (23–79 A.D.) tool technology was already beginning to develop, and he remarked that the ancients lavished so much care on reeds to be used for musical pipes that the modern use of silver is "inexcusable." The reed is indeed a highly useful plant and a delightful material with which to experiment in making lettering pens.

The reed is a lightweight, hollow stalk containing very little pith within the stem. The wall of the stem is 1/16″ to 1/8″ in thickness. The diameter averages 5/8″. When dried, the stalk is unusually rigid and able to withstand vigorous use. One complete shaft of the plant can ordinarily yield 10 to 12 pens averaging 6″ to 8″ in length. The craftsman will therefore have an abundance of material with which to work once a supply is discovered. Other hollow-stem plants can also be used. Bamboo is ideal and is covered in another section. Rushes (Junacaceae *Juncus*), cattails (Typhaceae *Typha*), and ordinary garden reeds are reliable materials for making excellent pens to form letters both large and small.

The wild reed plant, known biologically as *Phragmites communis*. Common swamp reeds may be found near the marshy banks of streams and lakes. They are tall, slender, and hollow and are good sources for pens.

In carving the reed it must be remembered that, as hardy as this plant appears to be, it owes its lightness to the lack of any internal substance, as is found in most tall-stalked plants. It can easily be crushed with the hands or with a knife used to sharpen the tip. The procedure for cutting a reed pen is as follows: choose a section of the reed measuring 7″ to 11″ in length. Any longer length is too topheavy and unwieldy in the hand. In many shoots, the desired length is the distance found between the knots of the plant. If the reed is too long, continued cutting and shaping will reduce the pen to a more manageable size. A small, inexpensive hacksaw (used because of its small teeth) is sufficient to cut through the joint of the reed without tearing and shredding the ends. Coarse-bladed tools should be avoided. When deciding which end of the reed to use for the nib, look for the more tapered portion. This is usually the best end because of the narrow contour of the shaft. It is easier to hold and feels more "natural" in the hand. Leave the other end closed (as in the drawing) in the event that you decide to insert fine string or colored braiding to hang the pen when setting it aside to dry. The closed end is also more attractive and maintains a small element of the beauty of the plant's growth pattern and nodelike structure.

When you have decided which end is to be carved, measure back from the blunt tip approximately 1¼″. This is where the first oblique cut with a very sharp knife is made. The objective is to make a clean cut halfway through the diameter of the pen. This is not always possible with harder substances but should present no difficulty with the swamp reed. A second cut is made in order to narrow the tip even further. This second cut is made approximately ¾″ back from the blunt end and should follow the same angle of the first cut. Note that these cuts are made with a slight scooping motion. This is achieved by initially rolling the knife blade, then flattening out the stroke as the blade continues its downward momentum. Make several passes with the knife until the cuts are even, smooth, and free of any rough or upstanding fibers. At this stage examine the tip. If the hollow remains, it is necessary to cut a bit more in order to make it smooth and flat. This must be done slowly and with great care. It is very easy for the knife to "bite" the reed and overcut the tip, spoiling your initial efforts.

When the tip is satisfactory, make a thin slit in the end of the pen by one of two methods. In the first place the sharp blade of the knife against the prepared blunt nib. The blade should be in the middle of the nib

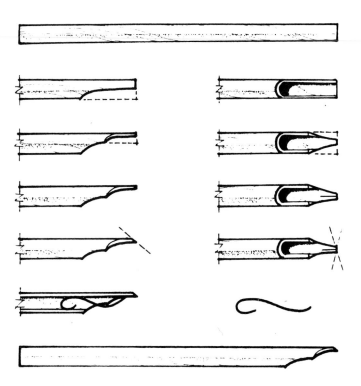

The cutting of a reed pen. The pen is shaped and nibbed, and the reservoir is added in the last step.

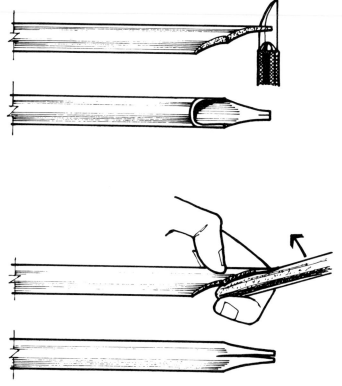

Twitching the reed nib. A fine slit is made in the protruding square-edged nib of the pen. The thin handle of a brush is then inserted into the hollow portion of the reed and gently lifted up. This causes the slit to travel another ⅛″ or so.

in order to divide the nib evenly. Gently press the blade so the slit moves upward about ⅝". If done properly, this maneuver will divide the nib into two lips—left and right. This slit will, according to the pressure exerted on the left or right lip or on both at the same time, provide a modulated line simply by the strength with which the pen is pressed down. The knife blade must be thin. If too wide, the blade will leave a notch in the nib and the pen will not make an even, uniform stroke. An X-Acto knife with a #11 blade is perfect for the job. A small penknife (pocketknife) ground down with a grinder or by hand on a hard, semicoarse Arkansas stone will make many useful cuts.

If you are uncertain about how to proceed with the first method or feel that you would like a simpler procedure, try this technique. Instead of positioning the knife blade against the nib simply position the tip of the knife on the top flank of the reed at the same location (⅝" from the nib) and quickly push downward. The cutting edge of the knife should face towards the nib. Grasp the shank of the reed. Guiding the blade with your other hand, pull to the side, simultaneously pulling the shank to the other side. This should immediately divide the nib into two halves, as with the first method. If the reed is truly dry, it will have a "memory" —that is, the right and left sections should immediately spring back to their original positions. You might need to do this a few times, but the balance of pushing while pulling is quickly learned.

After the slit is made, place the flat underside of the nib flush (dead flat) on a piece of acrylic (hard) plastic. To prevent the plastic from inadvertently slipping on the table, use a piece of acrylic approximately ¼" thick and measuring 4" × 6". It will be quite "beefy" in weight and will remain stationary when setting the nib. Bakelite or vulcanite, when available, also works nicely.

Cut the nib at an angle of 55° to 60°. This cut must be made firmly in one stroke, with no hesitation. It is best made with a sharp knife or #11 X-Acto blade. Closely examine the edge against the light with a magnifying glass to be sure that it is even and clean. No serrated edge should be observable. If the edge is slightly serrated, make a second cut perpendicular to the nib. Cut back from the nib only to the extent that a smooth edge is formed, not so far back that the nib is too blunt. If an oblique nib is required, simply cut to the desired angle with the knife.

An oblique nib can be cut by beveling the angle of the tip to the left or right of the pen's perpendicular edge. If you are left-handed, consider cutting an oblique angle to conform to your writing style.

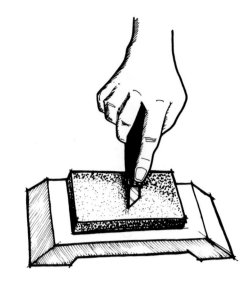

The cutting tool must be sharpened on a hard Arkansas stone. Do not use oil on the surface of the stone: instead add a small amount of liquid detergent and water. Wipe the blade before cutting the bamboo or reed. To keep a fine and keen edge on the blade, strop it on an old leather belt.

A standing magnifying glass is used to examine the nib of the pen. It is available in an assortment of sizes. This version allows the use of both hands when shaping the tool.

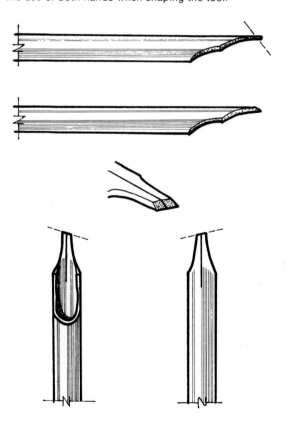

Making the Reservoir

The reservoir helps to control the ink flow and is an important feature of the pen. You must first determine the width necessary to fit within the reed. It should be slightly thinner than the nib and be capable of sliding into the inner hollow of the pen. I have used the following materials with equal success: brass shim stock measuring .005 in gauge, printer's zinc lithography plates, and aluminum soda cans. Brass is costly but has a nice spring or "memory" to it so that it creates few problems. It can be found in most hardware or auto-supply stores. Soda cans are certainly plentiful; shears are required to obtain the best strips. Printer's litho plates are best for very large reed pens (½" or more). Whichever metal is selected, it is spindled or shaped by quickly pulling it over the surface of the reed shaft to give it its cursive shape. Grab the reservoir halfway back and repeat this step (see the drawing). Insert the reservoir in the barrel of the pen and adjust to give best results.

The metal reservoir occasionally snags on the paper or vellum. Check to make sure that the metal tip has complete and firm contact with the nib. You may want to file the edges of the reservoir lightly on crocus cloth, a very mild abrasive that resembles fine sandpaper but lacks the sandy grit, which would quickly erode the metal. Crocus cloth is available in most hardware stores and can be used in finishing metal nibs.

Width of the Nib

The width of the nib is important in determining the module of the letter. Indeed, it determines the unit of proportion not only of the letter but also of all the other letters of each reed- or quill-written alphabet. It is therefore essential for the calligrapher to cut the point with precision and in accordance with the size of the selected letter style. The real advantage of knowing how to cut a well-formed reed, bamboo, or quill pen is that it allows the user to quickly adapt the tool to specific needs. Simply shape the nib to your own requirements. You may cut pens for Roman letters, uncials, versals, gothics, chanceries, and so on. The calligrapher, like the artist with his brushes, uses a number of pens, each with its own character and feel.

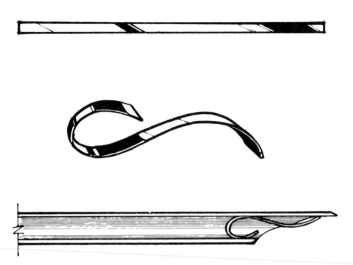

A thin strip of brass shimstock is used to make the reservoir of the pen. The reservoir is bent into an S-shape and inserted in the hollow of the bamboo.

Crocus cloth is used to buff the metal nib.

60

THE QUILL PEN

Background

The quill is still the best writing tool for the calligrapher. Wing primaries of turkey, swan, goose, crow, and raven are used. Making a quill pen is a skilled operation. Quills curve slightly according to whether they are taken from the right or left wing of the bird. The calligrapher must decide if he wants the quill to curve toward or away from the hand. Just when the quill came into use has not been fully ascertained, but literary references date from as early as the beginning of the 7th century A.D. Unfortunately, many artists forego the pleasures of writing with the quill due to ignorance of the methods of preparing and cutting this unique tool from nature.

During the last hundred years the quill has given way to the metal pen and for good reason. The metal pen is a ready-made item that provides the excellent thick-thin line qualities so desirable in good lettering. The quill softens in time with frequent use and must be replenished by constant dipping into the ink. Nonetheless, the quill has outstanding features that outweigh its disadvantages for calligraphers willing to locate a source of feathers and to learn how to cut the nib.

In England the goose was a primary source of meat, and bird feathers were plentiful. The importance of the village duck pond could scarcely be underestimated. Early English writing masters waxed ebulliently on the virtues of the quill and provided the reader with effusive and exacting procedures for quill preparation. An English writing master contributed the following piece to *The Dictionary of Arts and Sciences* in 1754:

> In order to harden a quill that is soft, thrust the barrel into hot ashes, stirring it till it is soft, then taking it out, press it almost flat upon your knee with the back of a penknife, and afterwards reduce it to a roundness with your fingers. If you have a number to harden set water and alum over the fire, and while it is boiling put in a handful of quills, the barrels only, for a minute, and then lay them by.

An early engraving demonstrating the procedure for carving a quill.

The various stages of quill preparation, shown with the knife used for shaping. (From *Libellus valde doctus* by Urban Wyss, 1549.)

An early illustration depicting a selection of penknives and their use with the quill. (From *L'Art d'écrire*.)

When it was published in Rome in 1540, Giovanni Battista Palatino's writing book entitled *Libro Nuovo d'Imparare a Scrivere* was the most comprehensive manual of handwriting of its time. A. S. Osley has translated this little masterwork into English; the following passage describes the method of preparing the quill:

> Quills for writing the chancery hand should be from the domestic goose, they should be hard and clear, and small rather than large, because thus they can be used with greater ease and speed. It does not matter from which wing they are taken, though some writers draw a great distinction here; those which are taken from the right wing should be broken off or bent above the barrel so that they do not twist when held in the hand; which is a serious impediment to rapid, even writing.
>
> Quills should be kept clean of any ink which remains after writing, because old ink interferes with the flow of fresh ink. They should invariably be kept in a vessel with just enough water to cover the part which has been cut to form the nib. A quill must never be allowed to dry out, because this makes your letters ragged and feeble, and it is extremely difficult to write with such quills. You should be careful not to rub quills with a cloth or put them under hot ashes, as many do to make them round.

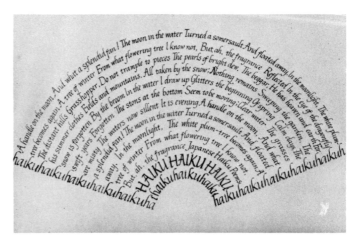

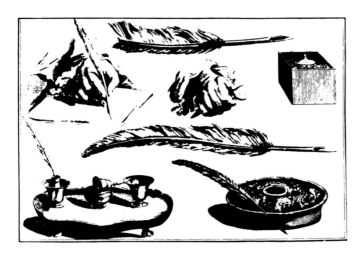

An assortment of writing utensils and implements from the late 18th century.

Examples of quill lettering by students of calligraphy. Each student composes his own formal solution to a given problem, demonstrating some mastery of calligraphic techniques and pictoral composition.

The quill can be made with a pointed nib as well as the broad nib used for italic and chancery writing or any other lettering requiring a square-edged end. If needed, a fairly fine point can be made and maintained. The quill pen is quite flexible and more delicate than the reed or bamboo pen, so care must be exercised in controlling the pressure. You will soon find the quill to be a very responsive lettering tool.

Making the Quill Pen

The procedure for cutting the quill is similar to that for cutting the reed, with a few exceptions. The quill is narrower in diameter, and thus the nib must be cut and shaped more precisely. Select a strong, sturdy turkey, goose, or swan feather. These birds are gallinaceous (in an order of birds that nest on the ground) and have the longest-barreled quills. In the case of the turkey and goose the outermost wing feathers are used for pen making.

Once the quill has been chosen, it must be cured for best results in writing. The feather consists of three main parts: the shaft, tube, and the feathery portion, which is made up of barbs and barbules. There are many exotic formulas and recipes for drying (curing) the quill to remove the greasy external residue or mem-

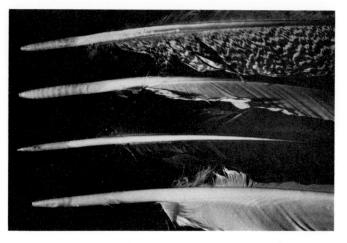

A selection of swan, goose, turkey, and raven feathers. Notice how the shaft of each feather is different.

A closeup of a turkey-quill nib prior to cutting.

The various sections of the feather.

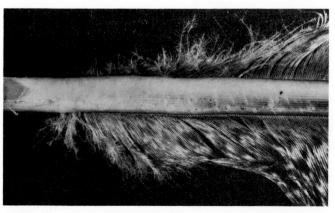

Detail of the turkey feather prior to removal of the feathery portion.

brane, but the following simple, effective method is sufficient. Strip the quill of the barbs and place the front shaft within 1½" of a coiled radiant-heat wire such as that of a hotplate or an electric heater. Be careful not to touch the wire. Slowly rotate the quill for approximately 30 to 45 seconds. This will soften the quill and shrivel up the internal marrowlike substance known as pith. If the external membrane of the quill begins to blister, move the tip back from the heat an inch or so. Once the quill has softened, quickly scrape the front shaft across the back edge of the small knife to remove the thin veneer of filmy membrane. Keep rotating the quill until you have come full circle. Closely inspect the quill tip to be sure that you have thoroughly removed all unwanted external material. When cooled, the quill is ready to be carved.

The dressing procedure is important. If quills are cut without proper curing, the pen will be serviceable, but quills cured by the above procedure are much harder and a great deal easier to cut. The material seems more brittle, and one is able to achieve a much sharper tip for lettering purposes. Another benefit is that less frequent sharpening or reshaping is required.

If you do not want to carve the pens but are merely preparing a batch for later use, it is best to wipe the surface of the shaft with a mildly abrasive fabric such as linen or sailcloth cotton, tie the quills in bundles of eight to ten, and set aside for future use.

For more exotic methods of preparing quills you may want to read the works of some of the Italian writing masters such as Palatino, Juan de Yciar, or Tagliente. The titles of these books may be found in the bibliography.

Cutting the Quill Pen
Once the barbs have been removed, cut the formerly feathered part of the quill down to 8" or 9". If you leave the feathers and length intact, the pen will be too cumbersome and awkward. Cut off the front tip, paying close attention to the angle of the cut. This will expose the hollow portion of the tube. Start a long cut about 1¼" back from the end on the underside of the feather. Square off the tip as shown. Clean out the pith with a long, slender tool such as a dental probe or tweezers. This material will only interfere with the flow of the ink and is undesirable.

Once the above cuts have been made, make a slit in the middle of the narrowed tip so that it extends back approximately 1". Do not force the slit if it refuses to part. Insert the end of a small brush handle into the hollow and lightly pull it up. This maneuver will twitch the quill nib and cause it to separate as you wish. If the twitching motion forces the slit back further than 1", cut the nib back further to accommodate the slit.

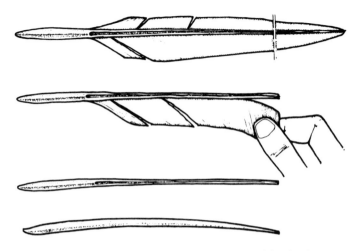

The stages of quill preparation. The top portion of the feather is cut off. The barbs are then removed by pulling them with the thumb and forefinger. After curing the outside membrane of the shaft its waxy surface is removed with coarse fabric.

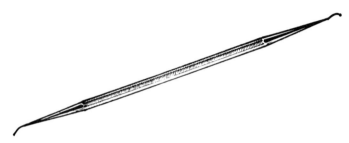

A dental probe may be used to remove the pith from the inside portion of the quill.

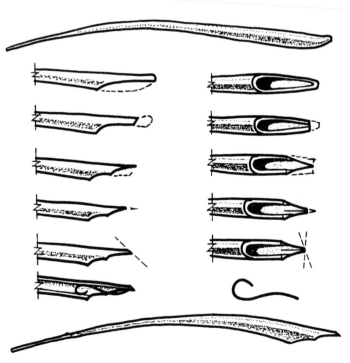

The stages of cutting the quill. Be sure that the reservoir is thinner than the nib as it is inserted into the pen. All cuts must be made with a sharp knife.

Narrow the nib by hollowing out the sides to form a symmetrical shoulder on both sides of the tip. The depth of the shoulder determines the line width of your lettering. Cut the edge of the nib vertically by placing it flat on a piece of flat plastic, as for the reed pen. This should leave a slit of about 3/16", which is ideal. This cut must be clean and smooth. As Edward Johnston mentions, "The thickness of the edge is so slight that it does not count as long as the true edge remains sharp (which sharpness is as necessary, and no more lasting in perfection in a thicker nib)." Your nib should resemble that shown in the illustration. You should now be ready to make the final slanted cut, which will impart the sharp edge necessary for fine lines.

This last cut is made at an angle of 60° to 65°. Notice that this little residue is easily cut away from the tip and that a slight popping sound is heard. Examine the tip under a small magnifying glass to ensure that the cut left the nib smooth and sharp. If so, the next step is to fashion a reservoir, as for the reed pen. Select an old watchspring or a piece of .005 brass shim stock, cut to a 1½" length, and form it into an S curve. Insert the reservoir in the tube of the quill, modifying its shape as necessary.

If the quill nib is too weak or flimsy, check to be sure that the taper of the tip is not too long. If it is too long, cut the nib back further. The brass tip of the reservoir should not extend to the edge of the quill nib. It will interfere with the fibers of the paper and snag. Move the reservoir tip back about 1/16". Dip the quill into ink, remove, and wipe the top portion of the nib with an old handkerchief or load (charge) the nib on the underside with ink applied by a brush and make a few preliminary lines or letters to check your quill. Does it sound or feel scratchy? If so, the tip is not smooth. Check to see whether your pen knife has a very sharp edge. Sharpen if necessary on a hard Arkansas stone with a small amount of water. (Oil will repel the ink if used on the stone.) Repeat the above steps, using a magnifying glass.

The quill should not require frequent sharpening. You will know when to reshape the tip. Letters will loose their hairline character, and the pen will begin to drag. After use gently wash the tip, blot with lintless cloth, and dry in freely circulating air.

Detail of a traditional penknife.

Two examples of the traditional quill knife or penknife. The raised blade at the tip of the knife is used to scrape the surface of the skin in the event of an error.

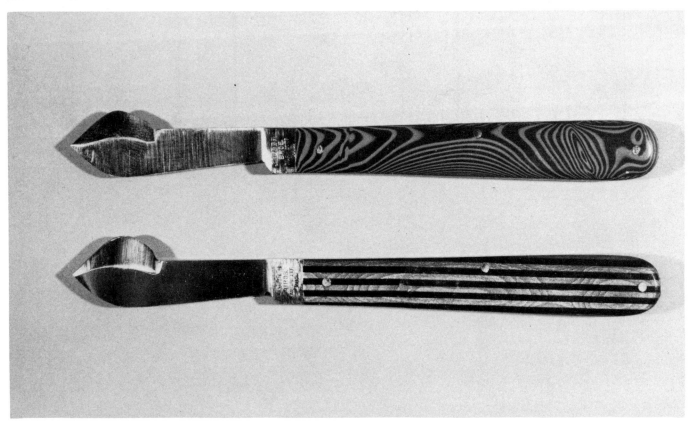

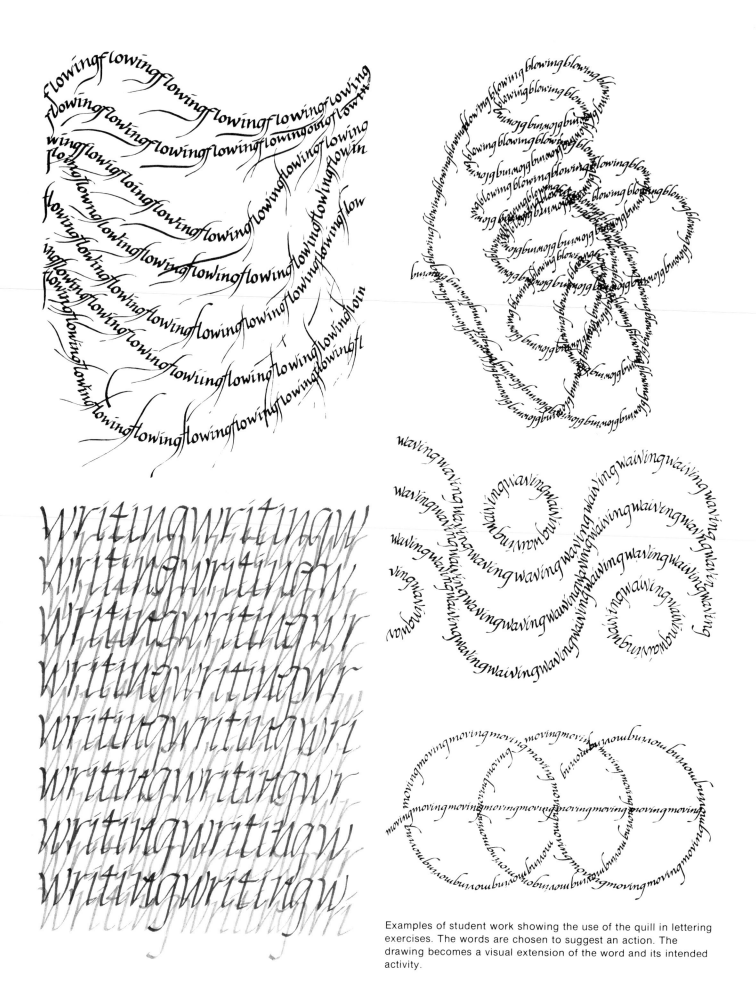

Examples of student work showing the use of the quill in lettering exercises. The words are chosen to suggest an action. The drawing becomes a visual extension of the word and its intended activity.

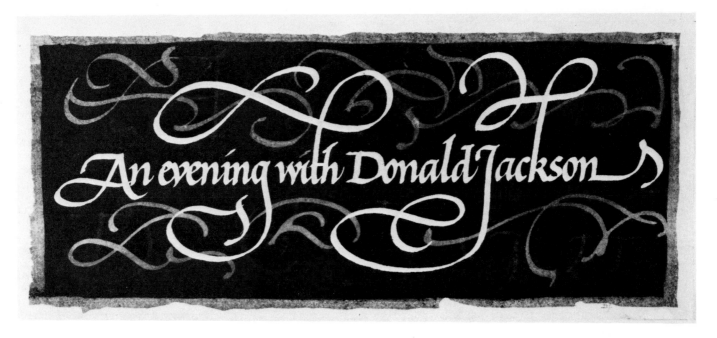

Calligraphy by the noted scribe Donald Jackson. The use of the quill in the hands of a real master can exhibit subtlety of control and mastery of letter forms.

A closer view of Donald Jackson's work.

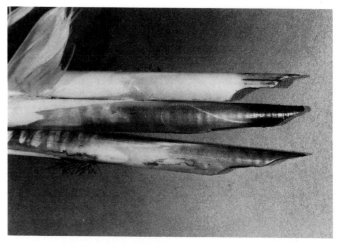

Detail of three quills after cutting.

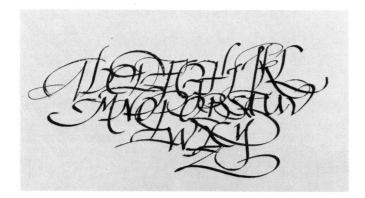

Free calligraphy executed with the quill, revealing flowing lines and unbridled movement. Calligrapher: Vance Studley.

BAMBOO PENS

Background

You will notice two major differences between the reed pen and the bamboo pen. Bamboo is available in larger and longer shoots and, when dry, tends to be much harder than reed. You may have a bit more difficulty in carving, but the result is more durable and capable of more aggressive lettering with less resharpening.

Bamboo is a very extraordinary plant. It is classified as one of the grasses and considered to be the fastest-growing plant in the world. Instances have been recorded of bamboo growing 4' in a single day! Bamboo also reaches its full growth in about two months and thereafter remains the same size as long as it lives. Ubiquitous, it provides shelter, food, raw materials, and medicine for the greater part of the world's population. A traveler of the Victorian era once observed: "What would a poor Chinaman do without the bamboo? Independently of its use as food, it provides him with the thatch that covers his house, the mat on which he sleeps, the cup from which he drinks, and the chopsticks with which he eats. He irrigates his field by means of a bamboo pipe; his harvest is gathered in by a bamboo rake; his grain is sifted through a bamboo sieve, and carried away in a bamboo basket. The mast of his junk is bamboo; so is the pole of his cart." A more useful natural material could hardly be found.

In the Orient the bamboo brush is used for calligraphy; in the West the bamboo pen sans bristles is used for calligraphy as well as for drawing. Bamboo and its relation to brushes are covered in chapter 3.

Cutting the Bamboo Pen

There is little difference in procedure between cutting the bamboo and the reed pen. With bamboo I have found the use of two knives to be indispensable. A larger pocketknife is used to make the first few cuts, a smaller penknife for the final trimming and truing of the nib. Once the nibbing operation is completed, the brass reservoir is inserted and minor adjustments made.

On the West Coast many species of bamboo are cultivated for various purposes, and practically all are suitable for pen making. The harder varieties offer a pleasing contrast to the softer reeds but tend to be heavier as a result of their size. Another advantage of the bamboo stalk is that practically all the stalk is usable. Each jointed section tapers towards the top, thereby providing upwards of 15 to 20 pens of varying size. On the other hand, the reed is strong only at its base, and its usefulness above the first few feet is questionable.

A brush rack can easily be improvised to store handmade bamboo tools. In this way the bristles are allowed to maintain their original shape.

A cluster of bamboo.

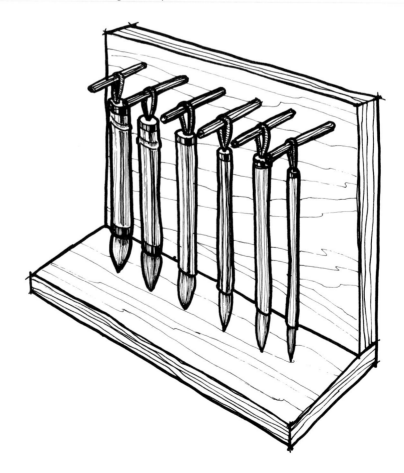

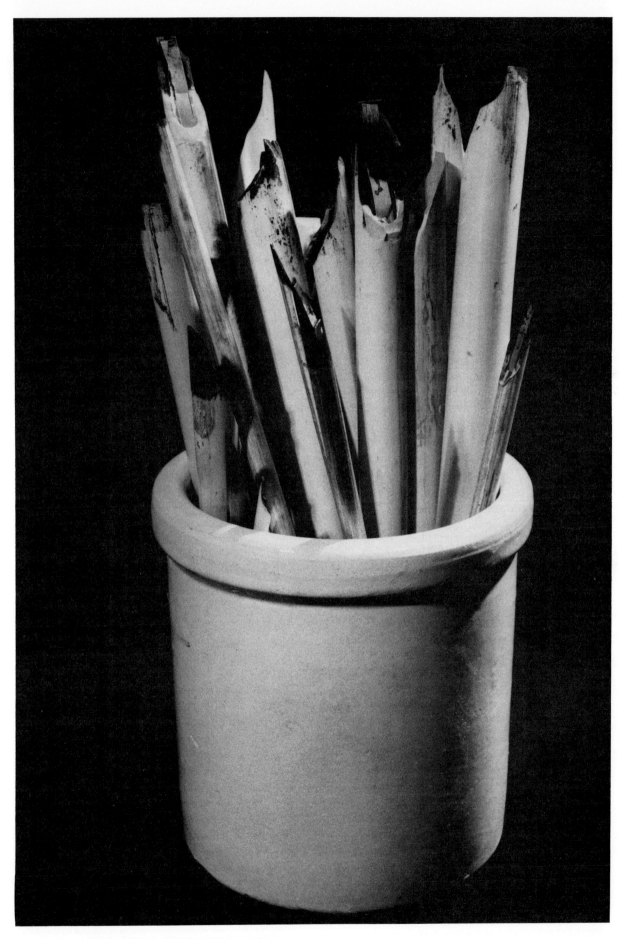

The author's collection of recently cut bamboo and reed pens.

After several long bamboo stems have been pro-
cured, set them aside to dry. This should take no longer
than a few weeks. The bamboo will turn light yellow or
golden tan, indicating that it is dry and ready to be cut.
With a small-tooth saw such as a hacksaw or electric
band saw cut the bamboo into lengths of 6″ to 8″. The
initial cut can be made through the joint as shown. This
will provide you with a pen that is sealed on one end.
If you wish to hang your pens on a convenient rack for
drying or display purposes, simply screw a small eye
hook into this end, attach strong thread or colorful
string, and suspend on a hook near your drawing
board.

Once the pens have been cut with a saw, select a
medium-sized shaft and carve the point as shown. Use
the larger knife (it must be very sharp) to rough out the
primary and secondary cuts. This saves your smaller
knife for the more critical use. Follow the procedure
for cutting reeds. Note that the split is easily made.
Because the bamboo is brittle, the split must be made
cautiously: it can easily extend more than the neces-
sary ½″. One simple way to avoid this annoyance is to
drill a small hole (1/32″) at the point where the slit is to
stop. The reservoir stock is best made with inexpensive
aluminum. Brass can be costly when used for larger
pens.

The bamboo pen is ideal for large, broad letters but is
not always capable of yielding fine arabesques be-
cause of its fibril nature. Even in the most skillful hands
extensive lettering and calligraphy will be interrupted
by flagging or loss of ink.

The bamboo pen, like the reed pen, should be

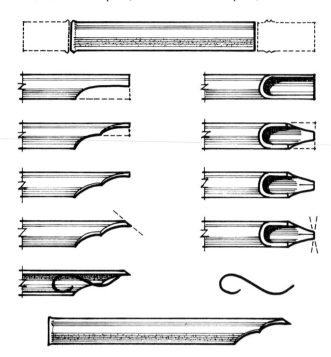

The stages of nibbing the bamboo pen. The brass or aluminum
used for the reservoir must be thin and have a springlike nature
in order to maintain its shape within the tool.

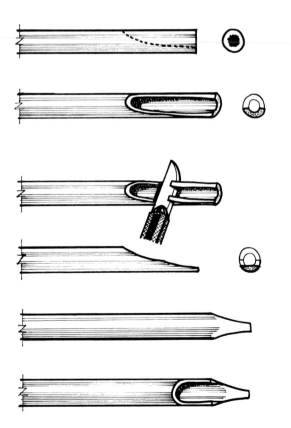

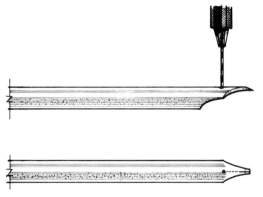

A small hole may be drilled toward the front of the nib to prevent
the slit from traveling too far.

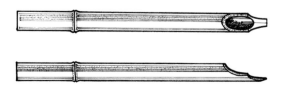

The stages of cutting the bamboo pen. Bamboo, because of its
hard constitution, requires the use of an extremely sharp knife.
The procedure for shaping the broad-edged nib is similar to that
for the reed. Bamboo is ideal for making large letters.

A view of the underside of the bamboo pen, showing the location
of the predrilled hole. The channel assists the flow of ink from
the reservoir to the tip of the pen.

cleaned with clear water, blotted with lintless cloth, and dried slowly. Accelerated drying tends to part the nib, necessitating the carving of a new tip. Regardless of how extensively the pen is cleaned, it is not a good idea to use a pen that has, for example, been dipped into black ink and later dipped into a lighter color.

There will always be some residual ink within the pores of the pen. This is loosened upon contact with other inks, and capillary action will draw the two together. Unless this is the objective, as with split-fountain or "rainbow" lettering, it is best to carve a different pen for each color that you plan to use.

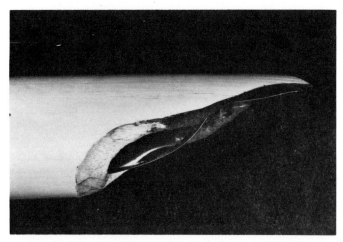

A side view of the cut bamboo pen.

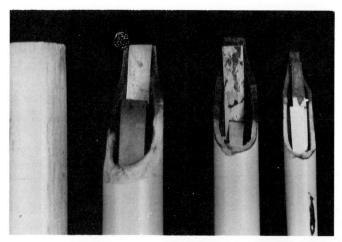

A selection of bamboo pens in assorted widths.

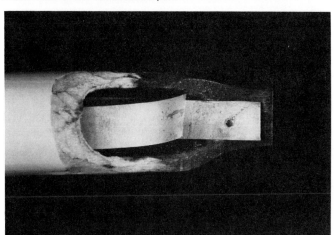

The underside of the bamboo pen with the reservoir in place.

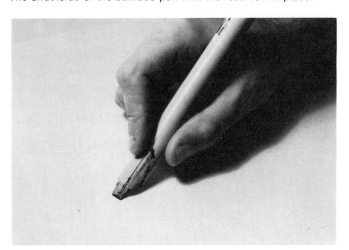

The position of the bamboo pen in the hand.

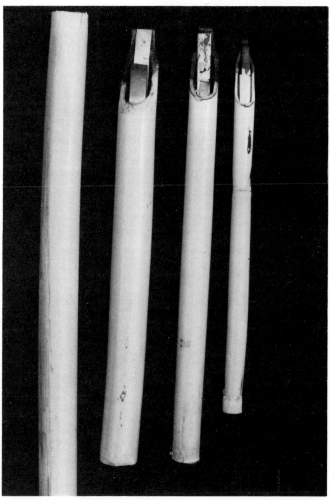

The same bamboo pens, showing the variety of thicknesses and widths available from one bamboo shoot.

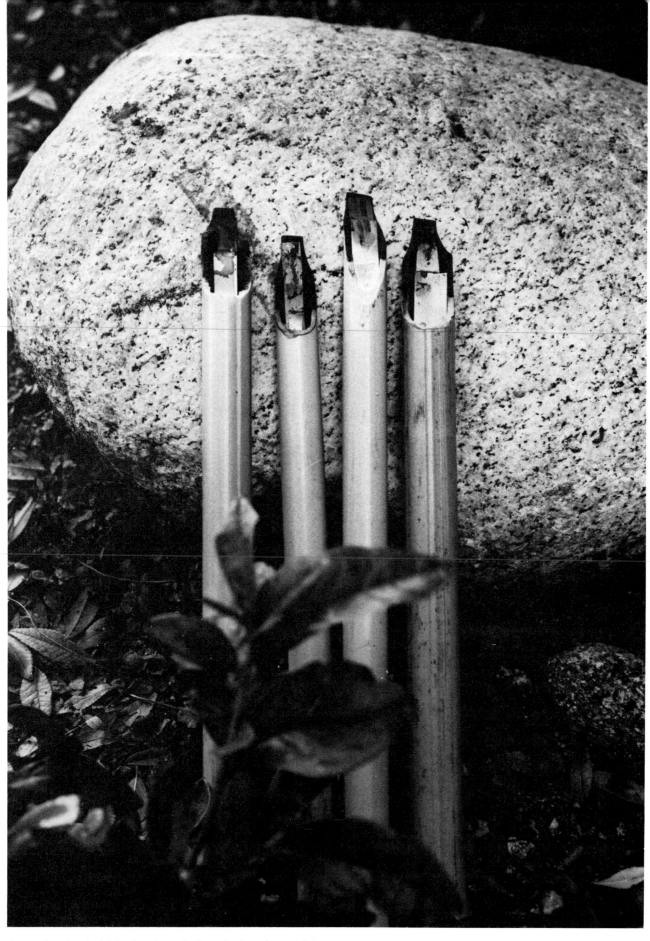

As a natural material the bamboo plant can be transformed into
a harmonious tool for the calligrapher.

FOUNTAIN LETTERING PENS

Fountain-pen lettering need not be done only with pens manufactured for italic and other broad-pen alphabets. Useful italic-lettering pens may easily be made from inexpensive fountain pens. There is a great deal of pleasure in cutting the chisel nib. It can be modified to suit your personal writing and is a handy substitute for a more expensive pen. Art-supply stores occasionally run out of Pentalic, Osmiroid, and Platignum lettering pens. The simple solution is to make your own! Try to buy the least expensive pen with a cartridge of ink. The cartridge is usually made of plastic and is available in several colors. When you run out of ink, use a syringe to refill the cartridge. Syringes used for this purpose are available from plastic-supply houses and hobby shops specializing in glues for laminating acrylic sheets together. They may be of the disposable type.

Brushes, pens, pencils, and other writing and drawing instruments may be conveniently stored in a cigar box modified for this purpose. The illustration shows where to attach two springs.

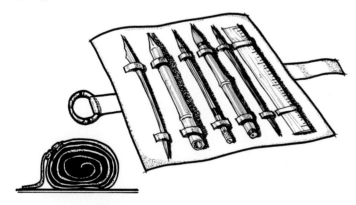

A portable tool holder can be made from strong cloth and a metal ring. When not in use, this carryall is rolled and stored in the artist's box of supplies.

ABCDEFGH
IJKLLMNOPQ
RSTUVWXYZ
abcdefghijklmn
opqrstuvwxyz&

ABCDEEFG
HIJKLMN
OPQRSTU
VWXYZ·&

1234567890

ABCDEFGHIJK
LMNNOOPQR
RSTUVWXYZ

Italic and chancery alphabets made with quill and reed tools.

73

UNCIALE

This word was drawn with a large bamboo pen.

Lettering performed with a lightweight quill pen affords the calligrapher a freedom unhampered by heavy and cumbersome tools. These exercises reveal a variety of possibilities for use of the quill.

Calligraphy is the dance of the pen

Materials

To cut your own pen, you will need the following materials:

- inexpensive fountain pen (average price $1.40)
- small wire cutters
- very fine Carborundum paper (#600)
- syringe (optional)
- crocus cloth (an abrasive heavy-duty cloth used for polishing the nib)
- cartridges (fountain-pen ink may be used in place of the cartridge—this is used in conjunction with the syringe)
- magnifying lens

Cutting The Nib

Begin with a dry pen. If it is filled with ink, expel the ink and blot the tip. With wire cutters snip off the front portion of the nib. Make this cut parallel to the tip. If an oblique tip is desired, angle the cut slightly to one side, either right or left. This initial cut is made just behind the ball of the pen nib. If done further back, you may cut into the working channel too close to the fluted reservoir.

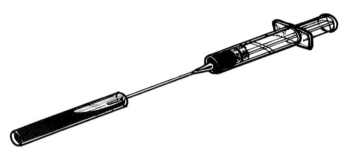

The cartridge of an inexpensive fountain pen may be refilled with ink by using a disposable hypodermic syringe. In this way different colors may be used with the same pen.

Cutting the nib with the wire cutters tends to pinch the metal, creating a sharp edge on the writing lip of the nib. To correct this draw the pen lightly across the Carborundum paper a few times in a perpendicular fashion. Even #600 Carborundum paper is an abrasive that will wear the tip down until it is useless. Examine the point with the magnifying lens. Does it appear to be even, not necessarily smooth but without a feathered edge? As with the quill, reed, and bamboo pens, it is necessary to bevel the top of the nib slightly. Draw the pen over the Carborundum paper in an even motion.

After three passes examine the nib once again. If it looks smooth and even, polish with the crocus cloth. The best way to do this is to draw imaginary letters lightly on the cloth. After forming several words insert the cartridge and wait for the ink to flow to the nib. On a piece of paper draw a few letters requiring four directional angles to test the smoothness of your nib. If it snags or tears the paper, slightly round the corners of the nib on the crocus cloth. Continue to do this until it does not scratch or drag on the paper. This may take a few attempts but persevere. The pen should be capable of rendering the fine lines that are necessary to constructing letterforms with thick and thin relationships.

You may want to make two or three pens with a variety of widths for different purposes. For the cost of one new commercial lettering pen you can make three pens with different-size tips.

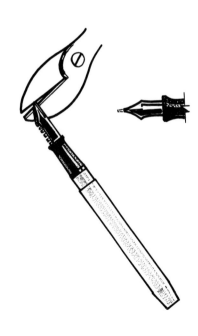

An inexpensive fountain pen is transformed into a broad-edged lettering pen. The tip of the nib is carefully cut with sharp wire nippers. The nib is then polished on the Arkansas stone. A final polishing is done with crocus cloth.

TONGUE-DEPRESSOR PEN

It is not unusual for calligraphers to use simple, make-shift lettering tools in order to demonstrate the anatomy of letterforms to students in the classroom. "Building" letters in front of an audience brings about a greater appreciation of the architecture of letters and their relationships to one another. The effect of seeing letters come alive on large sheets of white butcher-wrap paper in the hands of skilled artists is something to experience. The tools used in "letter chats" are often improvised on the spot and prove to be quite useful for the one-day or -evening workshop.

Large letters may be created with a Hunt's clip and felt, as mentioned in the following section. Another practical tool that you may make for demonstrations or may need when large letters are indicated can be made with a couple of tongue depressors and strong tape. Along with these items you will need some strong compressed felt, black tempera paint, a shallow dish, and water.

Ordinary tongue depressors are 1″ wide and made of wood. They come in large quantities for physicians' use or can be bought in paint stores, where they are wrapped in small quantities for stirring paint. These are usually "rejects" in that they are occasionally warped, knotty, or irregular. No matter—they are perfect for our makeshift tool.

Cut a piece of ⅛″-thick felt to a 1″ length and no more than 2″ wide. It may be narrower if necessary. Insert the felt between two depressor sticks so that it extends ¼″ beyond the tip of the wood. Tape the two pieces of wood together with strong plastic tape. Paper tape is too weak and will fall apart when dipped repeatedly in liquid. Dip the pen into a shallow dish of tempera mixed with water. The mixture should be somewhat more runny than usual so that the fluid will penetrate the felt, which usually contains a residual amount of lanolin, which resists absorption. Make a few letters on large sheets of white paper or newsprint. If you find the felt to be too flimsy, pull it back further into the wood depressors. This should give it greater rigidity and make it less likely to flap back and forth.

Tongue depressors, felt, and cardboard may be converted into lettering pens to demonstrate the anatomy of large letterforms. These devices, although far from permanent, are useful in the examination of oversized letters and their stroke sequence.

The cardboard or felt is placed between two tongue depressors and taped together to prevent the cardboard or felt from sliding.

String may be used in place of tape to bind the tool together.

Overly large letters may be made with this version of the clamp pen. The cardboard extends in width to within a small margin of the edge of the felt.

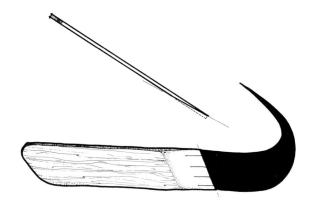

A simple lettering tool made from an ordinary tongue depressor.

If you need to make letters with strokes—say, 3" to 5" in width—the following is a passable way to augment the above pen. As illustrated, insert the felt between two pieces of sturdy cardboard that has been sprayed with plastic sealer on both sides and all edges. Then clasp the felt "sandwich" with the two tongue depressors and tape as described above. The cardboard should not extend to the edges of the felt, or it will interfere with the letter-making process. The cardboard should be as wide as possible without losing rigidity.

This tool is not made to be permanent. It is easy to put together, lasts for several hours of demonstration, and makes visually pleasing lines and forms that get your ideas across. Something more permanent may be made using thin aluminum lithographers' plates in place of the cardboard. This item should be rinsed after a session and wiped clean with a rag. If the tape gives way or the felt becomes tired, repair or throw away.

An inexpensive Hunt's clamp, combined with a dense sponge or compressed piece of felt, makes an excellent tool for letter demonstration. The sponge portion of this device is dipped into a shallow dish filled with ink or very dilute tempera paint.

FELT-TIP MARKERS

Due to the necessity of making letters for posters and signs, the design of felt-tip pens has become a pleasurable experience for scribes and lettering artists. Felt, in a highly compressed or woven state, offers the flexibility and resiliency that its counterpart, the metal sign pen, does not. If the felt is washed in a detergent solution prior to fabrication, it will be absorbent enough to soak up inks and dyes suitable for lettering and drawing purposes.

A simple felt pen may be constructed by clamping stiff felt in a Hunt's clip. The felt portion of the pen is dipped into ink or very dilute tempera paint. To clean the felt, simply remove the felt strip from the clip, soak in a detergent solution, and rinse. Another version of this tool can be created by crimping a flat strip of aluminum over a portion of the leading edge of the felt to provide a stiffer edge. The metal is placed on both top and bottom, and the felt "sandwiched" in between. Waterproof tape is used to bind the pen together.

A more sophisticated and potentially wider felt pen may be made with a worn-out paintbrush. With a pair of pliers yank the tired bristles from the ferrule of the brush. Into the ferrule insert a wedge-shaped portion of felt previously cut and shaped to the required size. If the felt moves within the ferrule, fortify the top and bottom of the felt with brass shim stock to take up the slack. On the top side of the felt tool insert a strip of metal: one end goes into the ferrule; the other is bent over the lip of the writing edge. This procedure will stiffen the tool and provide the required backbone for lettering on large paper or board. Working with a large felt-tip pen can provide the calligrapher with a more thorough understanding of letter construction and control. It is a counterpart to the diminutive letter made with much smaller pens.

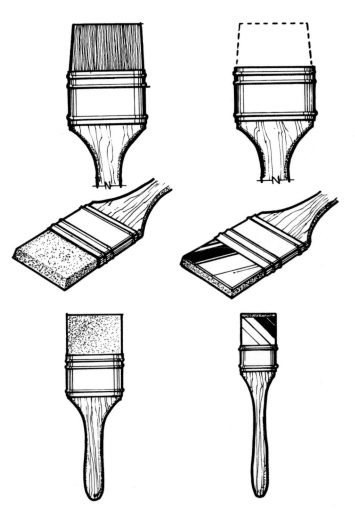

Felt pens may be fashioned from the handles and ferrules of old house paintbrushes. Remove all the bristles and substitute the felt pad. The pad may be made more rigid by adding brass or aluminum to the top of the tool. One end of the metal is inserted into the ferrule for additional rigidity. A thin piece of plastic may also be used in place of metal.

HACKE BRUSHES

Large brush letters can be made with the Japanese *hacke* brush. This type of brush is available in widths ranging from 1″ to 10″. It weighs little and feels comfortable in the hand. If the paint drips or runs down the paper, consider placing the large sheets on the floor. It is easy enough for your audience to gather around and watch as you demonstrate lettering and calligraphy on the floor. Oriental calligraphers have been doing it for centuries.

To my knowledge no stiff lettering tools capable of making letters larger than about 2″ are now manufactured on a large-scale basis. With the need to demonstrate letter making to an audience, tools such as these are indispensable.

The Japanese *fudemaki sumi* brush holder, composed of thin strips of bamboo, protects the hair structure when it is rolled up. The string binds the bamboo holder together once the brushes are in place.

A Japanese *hacke* brush. It is also used for making large brush letters.

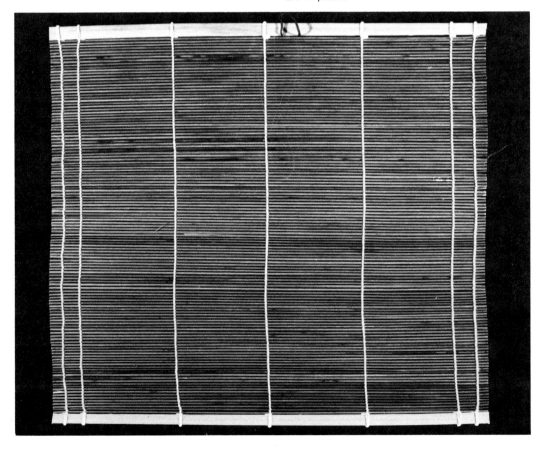

DRINKING STRAW PEN

Not long ago I was invited to give a brief talk on the chancery letterforms of the 16th century to a group that had little background in italic calligraphy. I wanted to illustrate the procedure for cutting a quill, the then prevailing writing tool. Upon opening my tackle box an uncut turkey quill for the evening's demonstration. I then found a plastic drinking straw, which I use for gilding. I produced the straw for all to see and proceeded to treat this innocuous little item as the substitute turkey quill. Though there is little resemblance in shape, substance, or form to the real thing, much to my relief it worked. After carving the "nib" of the straw, the pen made passable letters, and I was able to illustrate the method and procedure of quill preparation.

I produced the straw for all to see and proceeded to treat this innocuous little item as the substitute turkey quill. Though there is little resemblance in shape, substance, or form to the real thing, much to my relief it worked. After carving the "nib" of the straw, the pen made passable letters, and I was able to illustrate the method and procedure of quill preparation.

To this day I occasionally demonstrate quill cutting with a straw and ask lettering students to develop a sense of control and touch by practicing with straws. They are far cheaper than turkey or swan quills and are always accessible. They do not come within the pale of fine, natural quills but are nonetheless workable. Here are a few things to keep in mind when cutting and modeling a straw "pen." A sharp knife passes very quickly through the plastic. Cut with care and, above all, control. Do not make a thin, long nib. It is too weak to stand up to lettering. Instead make a blunt, broad nib and bring the split back a fraction of an inch. Carve as close to the hollow as possible without cutting through. There is no need (or room) to bevel the top

after squaring the nib. Use a thin metal reservoir, as with the real quill, charge the pen, and wipe as described in the section on cutting the quill. If you find the interior of the straw to be too slippery to discharge the ink properly, lightly spray the tip of the straw with a quick burst of plastic fixative.

Keep in mind that, if you find yourself in the position of instructing people in letter design or even a short italic-handwriting course, you should have the students bring a bunch of straws to whittle in order to get the feel of working with their hands and a penknife. It is a good icebreaker and a lot of fun.

PLASTIC-TUBE PEN

Plastic tubing is sold in aquarium and hardware stores, usually by the foot. I have experimented widely with an assortment of thicknesses and sizes to find those most practical for pen-making purposes. I prefer clear plastic with a ¼" inner diameter. The transparency allows me to see where to place the reservoir and what shape it takes once it is pushed up into the shaft. Plastic tubing of this type costs approximately 12¢ a foot, enough to make two 6" pens.

Shape the end of the tube in the same manner as for the quill pen. The plastic is softer and much easier for the knife to bite. Nibbing the tip will not produce the brittle snapping sound that you experience in cutting the quill. It is thus essential that you use a magnifying glass to scrutinize your finishing cuts closely in order to obtain the best possible writing edge. Insert the brass reservoir once the tip is perfected.

If you want to cap the pen, buy a piece of plastic tubing that will slip over the shaft. Cut to the desired length and plug the end with an equivalent piece of dowel. Glue can also be used to close the hole of the cap.

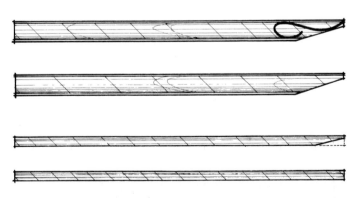

An ordinary plastic drinking straw may be converted into a simple lettering pen. If a reservoir is to be used, it is installed in the same manner as for the quill.

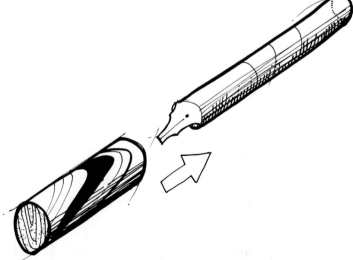

Plastic-tube pens are fashioned from flexible plastic, available in aquarium stores. The tip of the pen is made in the same way as for the quill. A large-diameter piece of plastic tubing may be fitted over the pen to serve as a cap.

LETTERING GUIDE

One often needs to position guidelines on paper, vellum, or other suitable lettering surfaces. These guidelines keep letters at their proper size and prevent sentences from riding up and down the page. Lines may be made with a ruler and a light pencil or with the aid of a blunt tool such as a dull stylus or the edge of the thumbnail. These scored or marked lines are sometimes left on the paper in informal works.

A T-square may also be used with a desk equipped with a true edge or rail along which the T-square travels. To ensure that the layout procedure goes more smoothly, however, you can make a plastic lettering guide to plan your line heights. This is a small device that may be conveniently stored in the artist's toolbox and used on occasions when ruled lines are essential. The raw material is a piece of thin, clear acrylic plastic (1/16" or 1/8" thick × 3" × 5").

Determine several line heights that you are likely to use. With a ruler and pencil draw straight lines across the paper, measure and mark vertical margins, and tape the paper to the underside of the clear acrylic sheet. With the aid of an electric drill (a manual hand drill also works well) fitted with a 1/16" drill bit, drill through the plastic at the marked intersections of the horizontal and vertical lines as illustrated. Make sure that the bit passes completely through the plastic. Lightly sand any burrs on the underside of the acrylic. This enables the guide to lie flat on the paper surface, which is essential for accuracy.

Repeat the drilling process at predetermined intervals. Move across the plastic sheet from left to right for each series of increments. The pointed pencil lead should penetrate the holes and leave a light dot on the paper. Using a step-and-repeat procedure on the left side of the page, move the tool down the paper. Line up a T-square with the series of dots and mark the ruled lines across the surface. If you do not have a T-square, simply repeat the above procedure on the right side of the paper, then connect the dots with a long ruler or yardstick.

In order to keep track of the intervals between the holes, mark the dimensions with a black laundry pen on masking tape and affix to the top surface of the ruling guide. Make several ruling guides, wrap them with a rubber band, and store in your supply box.

The paper is scored by means of pulling the thumbnail lightly across the surface, using a T-square as a guide. An invisible guideline helps the lettering artist to maintain straight lines.

With the aid of a hand drill or drill press premeasured holes are drilled into this small sheet of clear plastic. This device serves as a lettering-line guide by marking the paper with small dots to which the parallel line are connected.

The predrilled plastic sheet is now ready for use. The increments between the holes are arranged to give a variety of possible line combinations.

TOOL STANDS

Plastic tool caddies for designers, illustrators, and other artists are expensive for what they are. Two simple tool stands may be made with a few dollars' worth of raw materials available from your local hardware store. They work as well as if not better than the revolving kind that costs upwards of $10. You will need clothespins, a wire spring, some small scraps of wood, small finishing nails, drill, bits, and glue.

Wire-coil Tool Stand

The finished project should resemble the illustration. Cut three pieces of wood to the following dimensions:

 one piece 4″ × 8″ × 1″

 two pieces 1″ × 1″ × 6″

Glue and nail the underside of the large, flat base to the two wood strips, spaced 5″ apart. When the glue has dried, stretch a section of spring between the two posts and attach with brads. Attach pens, pencils, brushes, lead holders, and other tools to the spring by pushing into the wire coil. If the tool stand becomes too top-heavy, clamp a small C-clamp to the edge of the drawing table or worktable.

This device is also excellent for drying brushes after the bristles have been shaped. Place a small piece of tinfoil shaped like a shallow box underneath the brush to catch any dripping water. You can also use this procedure with a charged brush rather than placing it on the worktable. Drafting tables with inclined surfaces always seem to make wet brushes and pens roll off, leaving a little trail of color behind them; invariably the path is across precious artwork.

Clothespin Tool Stand

In addition to the above three pieces of wood you will need six clothespins, a piece of metal rod 1/16″ thick by 8″ in length, and two drill bits, one 1/16″ and one 1/8″. Prior to assembling the wood as described above predrill two holes in the posts as illustrated with the 1/16″ drill. Then drill holes in the clothespins with the 1/8″ drill. String the clothespins onto the metal rod and insert the rod into the post holes. Glue the ends with a drop of white glue to seal the holes. The clothespins will clamp your pens, brushes, and other tools until needed. Seal the entire stand with varnish or other wood sealer to make it impervious to stains. As with the first tool stand, use a C-clamp if the unit becomes too topheavy, which is likely to occur if long brushes or thick pens are used.

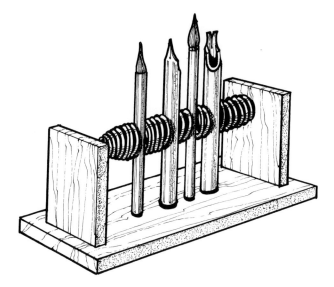

A tool stand that you can make with raw materials usually found in the home.

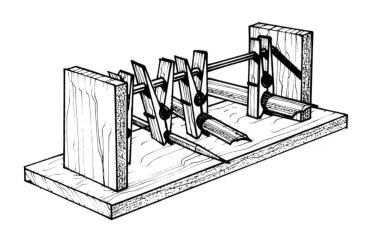

Another tool stand. This one utilizes clothespins and a metal rod to hold the drawing and painting instruments.

An ordinary test-tube rack can hold several tools in an upright position. A pipe stand will do the same.

SCROLL PENS

A scroll pen is capable of making two or more lines simultaneously on paper. It may be used for freehand drawing but is most commonly encountered in calligraphy. The lines may be of equal or unequal width. Wood pen holders can be equipped with scroll nibs capable of making five lines at once. Any of the above broad-edged pens can easily be transformed into scroll pens by adding additional slits and notching the writing edge. This is most readily accomplished with the bamboo pen. Bamboo pens are usually much wider than others and, as a result of their natural fiber, easier to carve and notch. In addition to ruling lines with the scroll pen you may want to create decorative letters to add contrast to other handwritten letters.

The technique for making a scroll pen with cane or bamboo is illustrated. It is entirely possible to make a scroll pen from the larger turkey quill. The splitting of the tip requires a sure hand capable of exact moves. One reservoir, regardless of the number of slits and notches, is all that is needed. The reservoir extends to the full width of the hollow of the quill or bamboo and feeds all the channels. Note the width of the space between the tips of the pen. These intervals determine the distance between lines.

As with any pen-making procedure, the knife used should be as sharp as possible. The scroll pen offers a refreshing change from the standard pointed and broad-edged tools. You might experiment with blends of inks or charge a watercolor mop brush with a rainbow of colors selected from cake watercolors, load the pen, and scribe vigorous letters with carefree arabesques. Scroll pens offer no resistance to spontaneous lettering, as does a metal pen. The bamboo or reed pen glides over the surface of the page. It is my opinion that a blend of natural and organic tools creates a harmonious marriage between writing implement and writing surface. Handmade paper, which is covered in chapter 9, is a visually pleasing and complementary material that can be used as an adjunct to the scroll or any natural tool fashioned by hand for expressive purposes.

An instructor who works with letters would do well to illustrate the relationships among outer contours with outlines rather than with heavy, wide black lines. The observer sees two sets of information: the outer linear edges (contour) and the wide line as a mass (shape). The active and passive areas are clearly enlivened with lines that demarcate space and breathe life into the path of the moving hand. One of the most difficult lessons to convey to students of lettering as well as other art studies is that letterforms demand concentration and manual discipline. The organization of space, the direction of forces, the use of composition and letter articulation are more quickly grasped when the student actually sees the process of making letters, words, and sentences take shape. For this reason I feel that it is very important to use a variety of tools to bring greater focus on specific aspects of letter design that might under ordinary circumstances pass unnoticed. The tool described herein is used specifically for the purpose of demonstrating how two parallel lines can at one point remain on equidistant paths and then change abruptly and immediately converge. This is done, of course, to show the dynamics of line quality.

Harmony in line invariably tantalizes the eye and can be rich with meaning even to the untrained viewer. Contrary to widespread belief lines in calligraphic forms do not always remain passive. They can dart, descend, flow, and twist with spiraling finesse. This is what helps to make letterforms so attractive to the eye and hand. The difference in line quality between Matisse and Giacometti is great. Each is a master of lines, suggesting at the same time human flesh and unbounded deep space. This is not quickly learned but is acquired through much study and the sheer act of making controlled movements with pen, brush, and charcoal on paper. To what length the artist goes in establishing new avenues of expression supported by items made for specific purposes is something that each of us at one time or another considers. Improvisation with pencils, chalk, crayons, marking pens, and other readily available media can create sparks within the classroom. Chalk is one way to build a letter. The pencil scroll is a helpful complement.

To make a pencil-scroll tool, you will need two well-sharpened pencils, masking tape or rubber bands, and a piece of pine or other softwood measuring 1" square by 6" in length. Lash the pencils to both sides of the pine strip, which should be lightly sanded on the edges for a more comfortable grip. The pencils extend beyond the tip of the wood 2" to 3". A hard lead requires less frequent sharpening, but the lines tend to be light. A plastic pencil sharpener can be used to sharpen the pencils as they wear down. Both pencils should match in length and be perfectly aligned so no one side of the tool is biased.

The pencil scroll is not meant to be held as one normally holds a pen or pencil. It must be grasped as if in a handshake. Several exploratory lines drawn over the surface of large sheets of white butcher wrap quickly introduce your hand and eye to the tool. There is a feeling of inordinate freedom in making such overt lines and in being allowed the kind of expression normally reserved for brushes. Note that in making true italic letters the tool is cocked at a 45° angle to the writing surface. In other words, the pen angle is 45°. The angle of the pen nib is also at 45° to the surface of the board. Try to make a few chancery-italic capitals. Note the intersection of the lines. A few sample letters reveal the underpinnings of the letterform.

Instead of pencils experiment with two felt-tip markers with stiff points. For blackboard demonstrations substitute two long pieces of white or colored chalk,

using rubber bands in place of the masking tape. The illustrations show the optical and rhythmical organization of the pencil-scroll line used to accomplish conscious control of the tool and mastery of letter design and execution. A uniform change of pressure also imparts line modulation to the letter and its basic strokes. The lines may achieve symmetry or be totally asymmetric in their configuration, thereby lending variety and character to the word or phrase.

A chalk scroll pen made by tying two pieces of chalk to the sides of a thin strip of wood. Rubber bands may also be used.

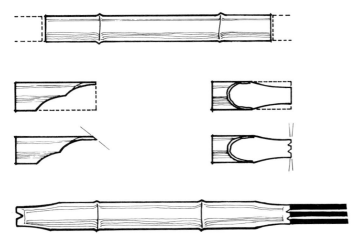

A scroll pen made of bamboo. The broad-edge nib is notched to make the individual lines.

A pencil scroll made in the same manner as the chalk scroll pen. This tool, when used in lettering demonstrations, shows how parallel lines combine in letter construction.

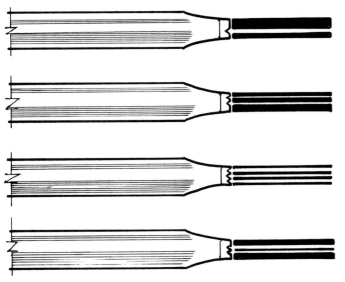

Several suggested line combinations.

6 Crayons & Pastels

CRAYONS

The Greeks and Romans employed a metal lead to make lines on papyrus for lettering purposes. At a later time the lead was encased in a wood shaft, becoming the first prototype of the wood pencil that we use today. In 1564 a large deposit of graphite or black carbon was discovered in England, and it was found that this substance made a lustrous black line. The chunks of graphite were wrapped with cord to keep the fingers clean and were considered scarce items for many years until modern technology was able to prepare and manufacture pencils using refined graphite, ball clay, and water.

The crayon, used for centuries as an art medium, is made of hard chalk pigment mixed with an oil or wax and molded into sticks. *Crayon* is the French word for "stick" or "pencil," which is confusing, since pastels are sometimes called crayons. Due to their waxy nature crayons do not smudge easily, making them ideal materials to use when color brilliancy is required without the usual dusting problems so often encountered in traditional chalks and pastels. Artists such as Seurat, Matisse, Toulouse-Lautrec, and Delacroix used crayons to achieve notable imaginative effects, yet the crayon is one of the most underrated materials of its time. In many ways it is an ideal drawing and coloring tool.

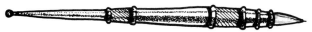

The top illustration shows a small brush used by the Romans for lettering. Beneath is a writing rod of thin lead encased in a 14th-century wood shaft. The lead disk was used by the Greeks and Romans to rule guidelines on papyrus in order to keep the lettering even.

Top: Solid graphite ore wrapped with string formed the first graphite pencil. Middle: A metal holder for graphite, used in the 18th century. Bottom: In early pencils the graphite was sawed into a square shape and encased in wood.

PASTELS

Pastels in their present form have been in use for the last two hundred years. They are one of the simplest and purest media available, since they contain little binder or vehicle substance—just enough to hold the pigment together and give the necessary rigidity. Provided that only the purest colors are used, the pastel can be a very permanent medium. True pastels lend themselves particularly well to very light tones, but the range of color in this medium is exactly the same as in oil, watercolor, tempera, and casein paints. There is one major difference, however: in pastel painting pure pigments of a great many shades are prepared in the form of sticks. Any mixing or blending of colors is done directly on the paper.

The word "pastel" is derived from the paste into which pigments are compounded before the sticks are molded. Pastels can be made in a variety of hardnesses and are relatively easy to make at home. For that matter homemade pastels tend to be a more perfect medium, superior to their commercial counterparts, because the artist is capable of controlling the ingredients. Fillers and extenders can be minimized,

and there is great leeway for experimentation with strength, shade, and hardness.

Any manufactured or handmade paper with tooth will hold the powdery substance. The finished pastel painting can be lightly sprayed with fixative to add a modicum of permanency to the surface. Too much fixative, however, destroys the refractive character of the whites. This can be offset by making pastels with a higher percentage of titanium white. Rough handmade papers give pastel paintings a loose, vibrating effect and are soft enough to accept the powder without acting as an unpleasant surface abrasive. Papers made or purchased in a wide range of colors and shades also serve to complement the effects.

Stumps or smudging tools can be made of spindled rag paper with a soft finish. The shape of the stump can be made to fit the occasion, and enough can be formed at one sitting so that some will always be handy. Of course, you may want to use soft flannel, terrycloth, or other such fabric for blending purposes.

Woman Drying Her Hair. Edgar Degas, pastel on paper, 24½″ × 28″. (Courtesy of the Norton Simon Museum.) Degas was a master of pastels. His subtle, delicate draftsmanship raised pastel drawing to a new dimension in impressionist art.

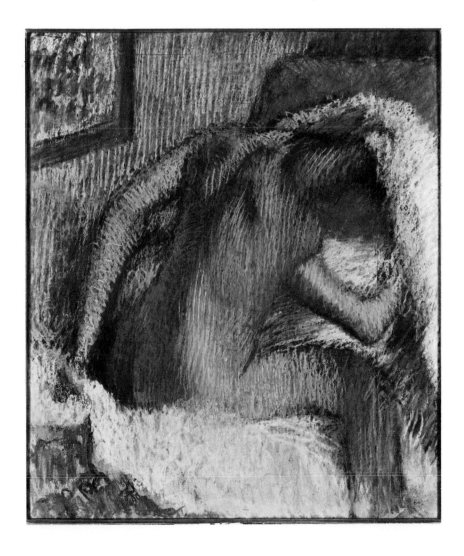

MAKING WAX CRAYONS

You will need household paraffin wax, several colors of powdered pigments, and a few small aluminum tins such as clean tunafish cans. The powdered pigments should be of the pure variety made by reputable color chemists, which are available in most good art stores. Be sure to buy only colors whose hue is accurately designated: i.e., ultramarine, cobalt blue, yellow ocher. Avoid pigments with nongeneric names such as sunrise yellow, dawn gray, passionate fuchsia, and so on. Tempera powders may be used in place of pure powdered pigments, but the color strength will not be as saturated and intense. Tempera powders, however, are far cheaper, and provide an interesting range of paler and more subdued colors, which I personally find attractive when used with the more brilliant colors.

Heat ½ pound of the cake wax (half a standard-size box of supermarket paraffin) on a low flame until melted. Pour a small amount into a small tin. The amount is determined by the size and number of crayons desired. You will know the range of the material after some experimentation. Start with 3 to 4 tablespoons for each medium-sized crayon. Mix 1 to 3 teaspoons of pigment depending on the intensity of color that you want the crayon to have. For example, 3 teaspoons of ultramarine will give you a crayon with a deep and fully saturating blue. Stir the pigment and wax quickly before it begins to set. To shape the crayon, pour the mixture into a paper cylinder made by rolling a piece of paper 5″ square into a tube and taping one end closed. The side of the paper tube is also taped to prevent wax from leaking out. Other containers to consider are plastic or wax drinking straws, which are slit down the side when the crayon is dry, and an old cigar or chocolate mold, which is coated with a small amount of vegetable oil for easy crayon removal. For interesting shapes you may want to pour the wax into assorted molds such as cookie molds or muffin tins in the shape of animals or other such subject matter. Crayons made in these molds are quite hefty and go a long way. The most obvious feature of a homemade crayon is that little drawing is necessary to bring out a bright and full-range color. If you are accustomed to using commercial crayons, this experience will be a pleasant surprise.

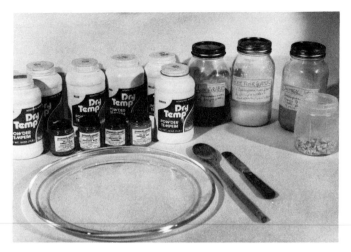

An assortment of pigments and tools for making crayons and pastels.

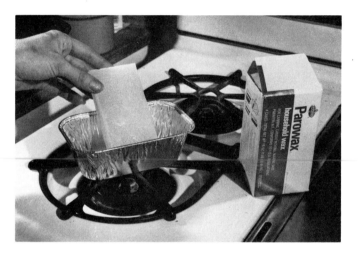

A block of paraffin wax is melted in a tin over a low flame.

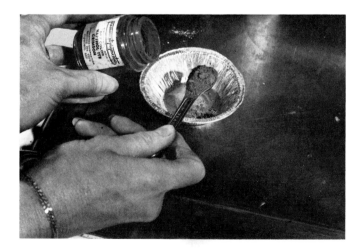

Pigment is added to the molten wax before it is allowed to cool and set.

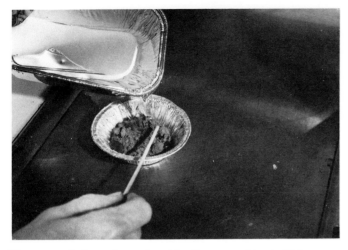

The wax and pigment are stirred for the proper blend. All traces of the dry pigment must be thoroughly mixed with the wax.

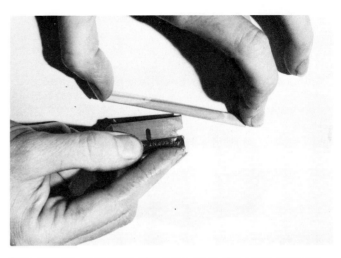

Care must be taken when slicing the straw. The blade must not be allowed to cut the crayon, which would weaken an already fragile tool.

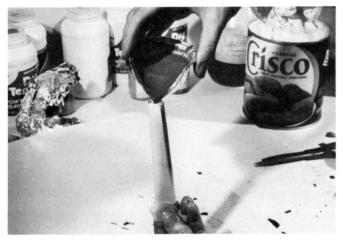

The blend is poured into a rolled paper tube and allowed to set until dry. When dry, the paper is peeled away from the crayon. Air bubbles may be eliminated after the pouring process by gently tapping the encased crayon on the work surface.

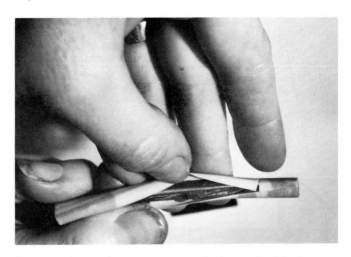

As you peel away the straw paper or plastic, gently slide the crayon out without breaking.

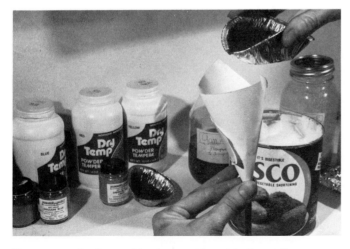

Straws may also be used to shape and contain the molten mixture. When dry, the straw is slit down the side with a single-edge razor blade.

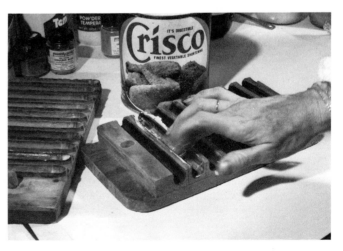

When using a cigar or chocolate mold, the inside of the mold must be coated with vegetable shortening for easy crayon release.

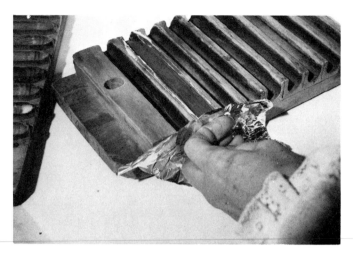

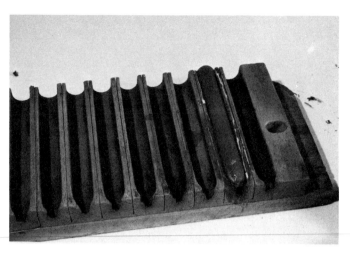

The ends of the mold must be capped with foil to prevent residual wax from spilling out. The foil is kept in place until the wax has set.

The crayon is ready to be removed from the mold and used by the artist. Paper may be wrapped around it for added convenience.

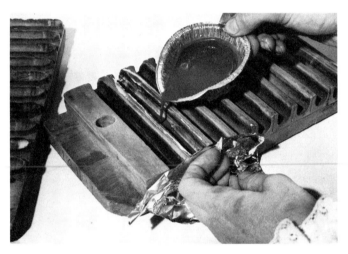

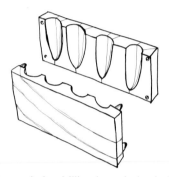

Continue to pour the wax into the individual troughs while the tin foil is in place.

Molds may be made by drilling large holes in 2″-×-4″ wood blocks. The block is then cut in half lengthwise. Although this procedure will not give you a totally round crayon, its design and simplicity are well worth this small inconvenience.

The mold as it appears in the closed position. Dowels may be used on the inside of the mold to connect the two pieces and to prevent the mold from slipping when the wax is in place.

The top is positioned over the mold containing the liquid wax. The crayons should be allowed to dry for 1 hour at room temperature before the mold is separated and the crayons removed.

Variegated crayons may be made by melting odd remnants of colored wax crayons. Pour the blend into the mold and allow to dry.

Crayons reduced to impractical sizes through use or breakage may be lumped together in a small tin and heated until melted. At the moment of melting remove the tin, pour into an appropriate container, and allow to cool. Peel away the container, and you will have a rainbow crayon with mixed aggregates of colors swimming throughout the wax. If the crayon wax is allowed to melt too long, the colors will bleed into one another and drastically change the hues, probably forming a grayish-brown color. Another procedure to try is to melt clear wax in the tin and sprinkle ground-up crayon chips of various colors into it. Quickly pour the crayon into the mold and allow to settle and cool. The result is a confetti-colored crayon capable of laying down many colors simultaneously.

Air pockets occasionally form during the process just outlined. To obviate this problem, gently tap the mold on the table a few times after the wax has been poured into it. This serves to bring the bubble to the surface, thereby eliminating trapped air pockets. In any event the air pockets are small and are no real bother to the user.

To keep particles of the color crayon intact, ground-up chips are sprinkled into the already molten paraffin wax. This prevents the color chips from bleeding into one another. As the wax cools down, the chips will remain in place.

Two crayons after the paper has been removed.

Detail of a waxed crayon after it has been removed from the cigar mold.

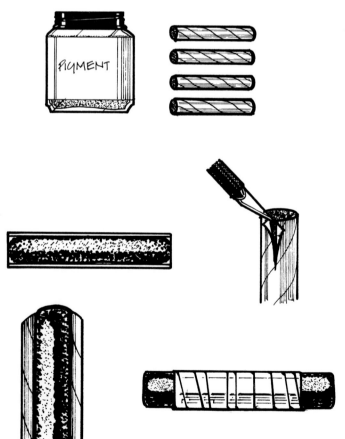

The variegated crayon chips may also be poured into a straw. The straw is then slit as above and the crayon removed. The crayon may also be wrapped with paper.

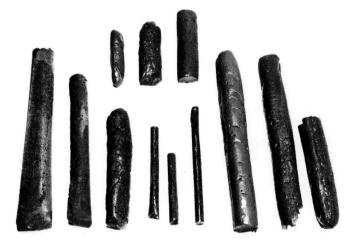

An assortment of small and large multicolored crayons made in the studio during a morning workshop. The colors and intensities are far superior to commercially made crayons.

MAKING PASTELS

Like crayons, pastels are as strong and vivid in color as the percentage of pigment will allow. The proportions given are recommended for the first examples of pastels and have been found successful over the years. It is important that you keep notes of percentages, proportions, and procedures for future reference. In order to keep pastel making a lively experience, you have to be something of a "chef" with a creative hand, seasonings and all.

Procedure

Start by placing the following items on the work surface: mortar and pestle made of glass or porcelain, binder (given below), talcum powder (baby powder or unscented talc), pigments, preservative, several sheets of white paper, and some thick plastic wrap.

Before working with the pigment prepare one of the following binders.

1. Gum arabic:
 3 teaspoons powdered gum arabic
 16 ounces water
 ½ teaspoon preservative (formalin or beta napthol)

2. Oatmeal water:
 1 tablespoon oatmeal powder (finely ground)
 16 ounces water
 ½ teaspoon preservative

3. Rice-flour binder:
 1 tablespoon rice flour
 16 ounces water
 ½ teaspoon preservative

Regardless of the binder you choose, it must be simmered on a low flame with occasional stirring. The gum-arabic solution must be boiled until the fine gum particles have completely dissolved. Store the solutions in glass mason jars and clearly label the contents, noting volume and strength, on a piece of waterproof tape affixed to the bottle. Use an indelible marker so that notes on the bottle do not bleed when touched with wet hands.

Begin by weighing out 4 ounces of talcum powder on a glass sheet or porcelain mortar. Add 1 ounce of powdered pigment to the talcum and stir the contents together. Measure out ½ teaspoon of prepared binder solution and pour into the mortar. Grind the contents with the pestle until a doughy texture is achieved. It is essential that you press the pestle down as you grind in a swirling motion in order to make a colloidal solution in which the particles are in suspension with the surrounding medium. Scrape the contents out of the mortar with a spoon or knife. Roll into sticks, carefully kneading the mixture with the fingers. Form into the desired size and shape on the plastic wrap. Flatten the ends with the side of the knife blade.

Gothic Visage. Vance Studley, 1969. A large drawing done with handmade pastels.

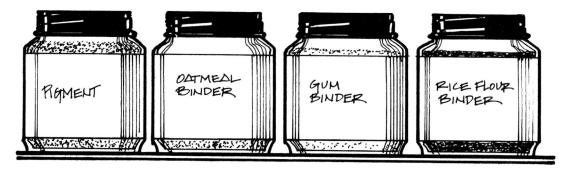

Three binders and a jar of pigment may be used in making pastels. The gum and oatmeal binders usually outperform rice flour. Rice flour does work and should be used if the other two binders cannot be made or if the raw materials are unavailable.

Binders can be stored in mason jars, which are available in supermarkets and hardware stores.

If more powder or pigment is necessary, add at this time.

In order to make pastels, talcum powder is placed on a glass plate or in a mortar. To it is added a small amount of pigment. The pigment may be permanent or powdered tempera. Adjustments must be made for the strength and formula of each colorant.

Add a small amount of binder to the mix.

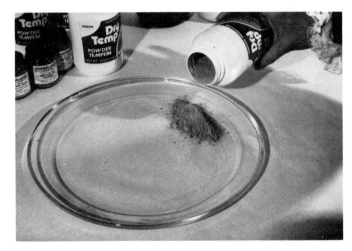

The talcum and pigment are mixed together evenly.

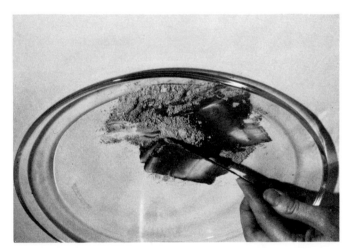

Stir and grind all ingredients thoroughly to ensure even absorption. Do not hurry this step.

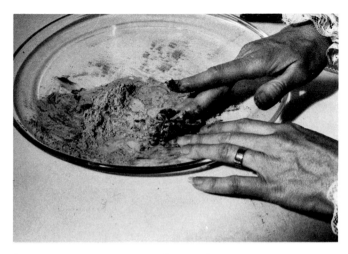

Once the mixture has a doughlike consistency, the contents are isolated and rubbed further.

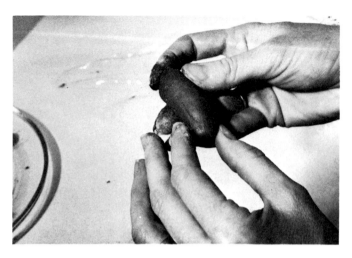

The thumb and forefinger are used to smooth the outer surface.

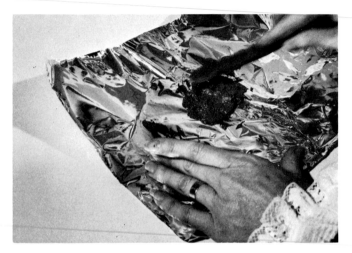

Place the doughy substance on wax paper or plastic wrap and begin to form the stick.

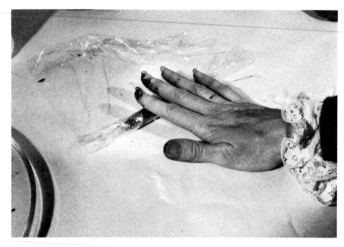

Further definition and final shaping are effected by rolling the stick on plastic wrap. When the pastel is even in size, it is removed from the plastic wrap and can be placed in the oven for drying. Only the heat from the pilot light must be used. If the heat is turned up, the pastel may flake or explode.

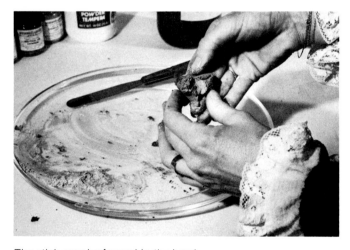

The stick may be formed in the hand.

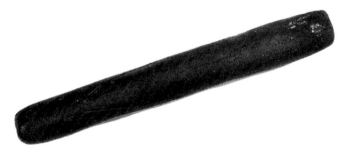

The dry pastel should resemble the one pictured here.

The pastel can be left to dry in the studio or placed in the oven on a cookie sheet and dried with only the pilot light. Turning up the heat will probably cause the pastel to explode or to flare when used. It will ordinarily take an hour or more for the pastel to dry. When it has been in the oven for a sufficient period, remove and allow to cool to room temperature. Prepare a sheet of paper and make your first marks. I am confident that you will be very pleased with your results.

Color Gradations

To make a series of gradations of color, pour out a larger quantity of the talcum powder and form into a mound. Start by adding a little colored pigment to a dimpled depression on the top of the mound. Mix dry ingredients together. Separate enough of the blend to make one pastel and add more pigment to the talcum mixture. Once again, separate enough to make one pastel. Repeat this process over and over, and you will soon have a series of tinted pastels in one color. Keep notes as you go along.

The pastels can be kept clean, orderly, and whole by placing into boxes with separate compartments such as cigarette cases, both cardboard and metal, or small boxes for each respective color and its tints, tones, and shades.

In order to prevent the pastels from breaking when not in use, store them in a small box such as a cigarette case.

7 Measuring Devices

By virtue of the tasks they perform measuring devices serve the artist in countless ways. Multiview drawings, perspective studies, orthographic projections, scale drawings, and simple forms of measurement require tools that are consistently accurate and designed to facilitate drafting and freehand-drawing techniques. The graphics of measurement and the tools required can necessitate the use of relatively sophisticated materials, but the job can often be done with much less. The purpose of this section is to demonstrate how a few rulers, guides, and templates can be made to serve the artist.

It would be very difficult to deal here with how to measure increments on rulers and how to transfer complex scales to improvised rulers. This is a job best left to manufacturers of professional tools with demanding standards of universal measurement. In a pinch, however, plastic materials can be scribed with a stylus and can often get the job done. T-squares rarely have inches marked off along the ruling edge.

Drafting tools from the late 1800s. These items are made of solid brass and ivory.

A collapsible yardstick made in 1888 by the Stanley Tool Company.

A detail of the yardstick hinge mechanism. Combining function with simple material, this ruler has outlived many of its contemporary counterparts.

The purpose of the T-square is to aid the draftsman in making parallel lines and to serve as a base for the use of triangles and other drafting and ruling paraphernalia. French curves, ship's curves, and ruling templates can be made from thin sheets of acrylic plastic with reliable accuracy.

Several sheets of clear plastic scrap ⅛" thick will be needed along with some hand tools. Access to a bandsaw or jigsaw would also be helpful. Schools invariably have a shop housing these larger pieces of equipment. Enrollment in an evening class will perhaps afford you the opportunity to make a complete set of plastic guides and templates if you are not already a student.

T-SQUARES

Of all ruling devices used by artists and designers the T-square, next to a common ruler or yardstick, is the most widely used tool. Yet I am always aghast at the prices charged for even simple squares made of plastic and wood. What is more surprising is that consumers do not realize that they can be made to look attractive and personal in a short time by combining ordinary materials. More exotic T-squares may include rare woods and smoked plexiglass for more sparkling effects. Of course, this raises the cost. Standard lengths of T-squares are 36", 42", and 48". Requirements are simple. The edges of the plastic strip are to be straight, parallel, and smooth, with no coarse sawblade cuts.

The sliding T section of the square can be made from another piece of plastic, hardwood, metal, or rare wood. The procedure is as follows. Determine the overall length of your T-square. Average the raw materials on the table and, with a freehand sketch or another straightedge, work out the mechanics of where the materials will be fastened together. The stock end and the parallel guide blade can be joined in key spots with several flat-head screws to provide stability and accuracy. Predrill holes using a slightly larger drill bit than the diameter of the flat-head screws. This allows the head to screw into the second material so that it is below the surface. The counter-sunk screw will not interfere with the hand as it grips the ruler to slide up and down the edge of the table surface. The configuration of the stock is not terribly important. The cursive form in traditional T-squares allows a comfortable grip and resting position for the hand. A customized grip to suit your hand would make an interesting departure from the usual T shape, but the mechanics of assembly remain the same. In order to determine whether your T-square has an accurate right angle, use a right-angle tool to adjust to the exact angle. Rulers are often necessary to make other rulers and guides. Once the correct relationship exists between stock and blade, tighten the screws in a diagonal pattern until the two are firmly joined.

The blade can be cut in one of two ways. Plastic stores will cut it to your specifications for a small fee. They are usually equipped with a special saw blade designed to cut only plastic. A rouge compound should be quickly passed over the edge to remove small burrs. This motion must not be labored or done unevenly: it will form low spots along the plastic edge, which negate the purpose of making such an item. If you wish to save a milling charge, check to see if the scrap bin holds the end strips of larger pieces. Scrap bins contain discards costing much less, since they are of dubious use and value. Bring a small ruler along with you to check whether the edges of the scrap are parallel. If you plan to hang up your ruler at the end of a work session, drill a hole (⅜") at the end and suspend the ruler from a peg.

T-squares may be made of plastic and assorted woods. They can be made in any length at a fraction of the cost of those found in the art store.

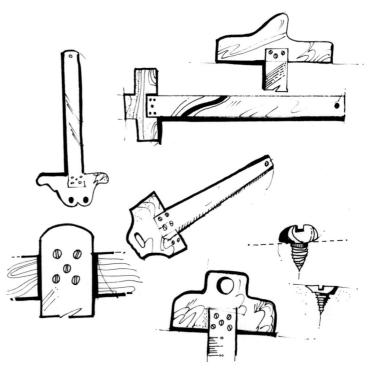

Grips of the T-square may be customized to suit the needs of the designer's hand.

TEMPLATES

A template is a pattern, usually in the form of a thin metal, wooden, or plastic plate, for making an accurate copy of an object or shape. The pattern consists of graduated circles, ellipses, or mixed shapes for indicating the profile or outline of physical objects. Many templates require special tooling apparatus to cut the required shape. A small circle template is one of the more frequent templates used by the artist. It may be used for drawing circles, adding a radius to a corner, or drawing concentric circles.

By selecting a series of graduated drill bits and a few small square or rectangular pieces of 1/8" clear plastic you can make a simple circle template. You will need a small hand or electric drill to drive the bit through the plastic at predetermined points. Keep the drilled holes in their proper graduated sequence. One hole occasionally looks no larger or smaller than the one adjacent to it and may cause an incorrect choice of circle sizes. Drill slowly when you begin. A piece of masking tape may be added to the underside of the plastic to prevent or at least minimize the occurrence of burrs on the plastic as the drill bit penetrates the bottom of the plastic. If you use a hand or electric drill, the drilling motion must be perpendicular to the plastic plate. This rules out the possibility of distorted shapes and sizes. Experiment with thinner pieces of plastic or metal. Templates of this nature may be used in conjunction with ruling pens, mechanical pens, or Rapidograph pens with extremely fine points, which can now create lines almost as thin as a strand of human hair. If a plastic burr results from the drilling process, use a piece of fine steel wool to remove the unwanted bits. A scouring motion will only scratch the plastic; a light pass or two usually does the job.

Experimental and assorted templates may be made in free designs by using scraps of clear plastic and cutting unusual shapes with a jigsaw. The jigsaw, if fitted with a fine-tooth blade, is capable of cutting plastic and leaving little if any irregular edge in its path. To acquire a feel for freely designed shapes, start by cutting into the plastic from the side and rotating the plastic stock as the blade cuts. When finished, turn the stock so that you remove the plastic by guiding the blade through the path made when entering. Once the template has been removed and examined, glue the initial cut together with acrylic or other plastic adhesive. This keeps the plastic template reasonably rigid.

If you want to avoid cutting the plastic from the side in order to reach the inner areas, predrill several holes in the plastic. By removing the jigsaw blade, inserting it through the predrilled holes, and fastening the blade once again, you are "locked" inside the plastic. Cut the desired shape and repeat the procedure for each hole.

Plastic sheets in various sizes, such as this one, are handy for making circle templates.

Drill bits in assorted sizes are used to drill holes in the plastic sheet. A circle template can be made with a variety of diameters and circumferences.

Free-form guides and templates are made with creative use of the band or jeweler's saw.

SHIP'S CURVES AND FRENCH CURVES

This type of ruler or guide, like the above items, can be made to conform to specified curves and angles. Some improvisational moves as the plastic stock is being cut will bring about interesting results. The above template-making process requires that the shapes be cut within a square or rectangular plastic form. Here the plastic is cut into a shape itself, which will serve as the guiding matrix for the lines to be made with its aid. In cutting the shapes it must be remembered that a slight hesitation may cause a dent or nick in the edge of the material. It is not necessary to race through the cutting process. An even cutting motion with graceful moves is all that is required. I made a complete set of oddly shaped curves, both French and free form, as a student in college. This was a mandatory project, and I was fortunate enough to have been guided by an individual who taught me that these items would prove to be indispensable over the years. I still use these shop-made guides today. It must be mentioned that these plastic rulers are not designed to be identical to commercially available models. It is difficult enough to make satisfactory shapes in a workmanlike manner without compounding the effort by expecting them to conform to mathematically precise angles. This approach allows the individual to create shapes at will rather than having to rely on finding an existing shape in the drafting department of an art store. The material is inexpensive, and there is no end to the number of angles, curves, bends, and shapes possible with this system.

Ship's curves and French curves cut from thin pieces of plastic plate. The cutting motion must be done without hesitation to give the ruler a smooth and natural contour.

MODIFIED CARPENTER'S SCRIBE

Several years ago in a secondhand store I found what is known as a scribing device for lumber used by carpenters and cabinetmakers. With a slight modification I transformed this tool into a measuring device that has made borders and lines for mat cutting a breeze. If you are fortunate enough to own a scribe of this type, the simple conversion illustrated is all that is necessary. If you plan to make one from scratch, you need the following pieces of hardwood such as ash, maple, alder, mahogany, teak, or oak: a piece measuring ½″ × ½″ × 8″, a block measuring 2″ × 2″ × 1″, and a 2″-long strip of round dowel stock ¼″ in diameter.

A modified carpenter's scribe is used for making lines on paper and boards. In place of the nail substitute graphite lead. Be sure to tighten the screw to clamp the lead tightly.

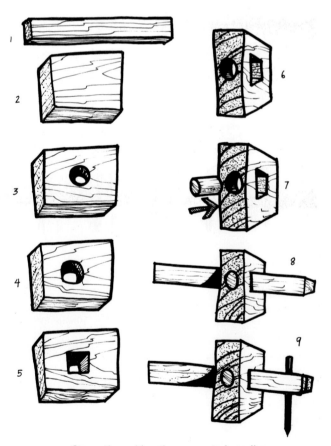

Stages in making the carpenter's scribe.

Drill ¼" holes in the center of the 8" bar every ¼". With the aid of a large drill bit, drill a hole in the center of the 2" × 2" wood block. File the inside diameter with a thin wood file to make a square large enough to accommodate the wood bar. The bar should travel freely up and down in the hole with no binding but should not fit sloppily. This would make the scribe too flimsy. On the side of the block drill a ¼" hole through the material. This should also be centered. This hole accepts the dowel, which keeps the bar in place. The last drilling takes place on the end of the bar. This small hole, originally designed to hold a sharp nail for scribing purposes, will now hold a mechanical-pencil lead. Instead of making a depression the tool draws a penciled line. Adjust the shaft of wood to the required length by pushing the dowel out with the back end of a pencil, moving the shaft up or down and replacing the dowel for a snug fit. Illustrated is the manner in which this device may be used for marking lines.

The scribe is adjusted for the desired measurement. A straightedge such as a table edge can be used as a guide for making straight lines. This device comes in very handy when marking mats for window cutting.

The scribing tool used in a practical situation.

PROPORTIONAL DIVIDERS

Proportional dividers help the artist to scale work for purposes of enlargement and reduction. Designers dealing with typographic measurement, sculptors enlarging features in clay from the maquette, model builders attempting to maintain proper scale all use some form of proportional measurement to assure the required ratio of change. What is essential to the divider design is that the two strips of wood, metal, or plastic be able to slide freely and be tightened once the size and adjustment have been decided upon.

An elementary proportional divider can be made with thin rectangular strips of sturdy material and a small nut and screw or carriage bolt and wing nut. The two strips of material, whether plastic, wood, or metal, require drilling and cutting to form an open and extended window or slit in the material, as illustrated. Follow the procedure described in the above section on templates. If you use wood, pare both ends of both strips so that they form a point. Insert the screw and tighten with a nut. Use a washer if the nut digs into the material. Loosen the nut for measuring adjustment. Proportional dividers can be fabricated in any size as long as this method is followed. I have found plastic and metal to be the more reliable raw materials. They assure longer use and are less likely to be nicked because of their hardness and durability. Other means of cutting and forming the sharpened ends must be used when working with metal or plastic.

Proportional dividers may be made according to the steps shown above.

8 Printmaking Tools & Materials

One of the first stages in the creation of a handmade print is to muse about what you want to say and what medium you would choose. The print often historically took the form of portraiture, landscape, and other recognizable images. A wealth of new techniques has recently appeared to augment the more traditional approaches. Etching, engraving, and lithography have been joined by screen prints, photolithography, and the collagraph (collage and graphics), extending the range of graphic possibilities to new and exciting dimensions.

A comfortable symbiosis between abstract form and print medium allows the artist to explore human emotion without the need to adhere to strict and conventional images. The handmade print may be one of a kind (unique) or part of a large edition. The artist usually determines the extent of the edition and how it is to be printed.

There is a very intimate relationship between hand and material. Noted wood engraver Fritz Eichenberg states: "The first cut made into the darkened surface of a woodblock, with the point of a steel blade or a burin, releases hidden forces which one can hardly gauge beforehand. The steel locates a spark, a source of light spreading slowly over the face of the block as the design emerges, white against black."

Plate 13 from *Los Proverbios*, *A Way of Flying*. Francisco De Goya. Etching, aquatint, and drypoint, 245 x 350mm. (Courtesy of the Norton Simon Museum.) Goya was one of the first artists to realize the importance of aquatint in printmaking media.

L'Esterel. Edgar Degas. Monotype, 11⅞" x 15⅝". (Courtesy of the Norton Simon Museum.) The monotype is a unique print. The artist applies washes of ink to the metal plate. Paper is then placed on top of the plate, pressure is applied, and the print is removed. The interplay of painting and the strictness often required in traditional printmaking make this work an exceptional example of how the two techniques may be poetically and visually combined.

Rising Moon. Vance Studley, 1973. The symbiosis between abstract form and nontraditional printmaking techniques exhibits an attempt to push the medium into new areas of greater expressiveness. The materials used in this collagraph include glue, cardboard, a tongue depressor, and modeling paste.

Aesthetic expressiveness can be enhanced by the knowledge that truth in material strengthens the artist's intent. Natural dyes, terracotta, hand-forged steel, the subtractive process of chipping away at slabs of white marble all contribute to the communion that the artist feels with his creation. No material is so precious, no tool so sacrosanct that an improvised and handwrought item cannot be considered as an improved substitute. A new brush is foreign to me. I would much rather use the one that is discolored and time-worn but whose bristles are still as reliable and springy as ever. It is not essential that we express the properties of materials but rather that we express their qualities. The former are objective and tangible; the latter are subjective and highly personal. To bring out the grain and inherent beauty of boxwood or the end grain of pearwood reinforces the internal and natural beauty as seen by the artist's capable and sensitive eye.

Dead Bird. Vance Studley, 1965. A linear study executed by incising lines into plastic following the intaglio technique.

Seismic Rhythms. Vance Studley, 1974. A sharpened dental probe was used to draw the fine lines and dots in this work.

Silver Trees. Vance Studley, 1975. A combination of the collagraph and etched-plate techniques.

Printmakers use a wide variety of hand tools to supplement purchased items. These tools may take mysterious form and are made of diverse materials such as wire, wood, metal, rubber, plastic, paper, cardboard, cloth, stone, and glass. They can be used in the techniques of drypoint, monoprint, engraving, and so on. Each tool makes a unique contribution to the printmaker's stable of devices for making marks. To help you in your search for interesting and novel supplies, consider starting with simple and basic items encountered within the printer's studio. The etching needle is the one tool common to most artists who explore the incising technique used in the intaglio process.

Cardboard plates are combined with a zinc plate, which has been photographically sensitized and developed to capture the focal point of a large flower.

Mystic Ascension. Vance Studley, 1974. Several improvised etching needles made from nails and scribing tools were combined to give this work a textured and ominous mood.

Metamorphosis. Vance Studley, 1970. A monoprint combining bamboo brushwork and washes of printer's ink.

Earth Strata. Vance Studley, 1975. Photoetching was combined with high-relief plaster molds in this work.

The Departure. Pablo Picasso, May 20, 1951. Color lithograph, final state bon à tirer, 22″ × 26″. (Courtesy of the Norton Simon Museum.) Picasso extended the frontiers of printmaking to show his compassion for human foibles and weaknesses. His work often revealed an artist with strong moral and ethical convictions.

Bust in Profile. Pablo Picasso, December 16, 1957. Lithograph, first state, bon à tirer, 25¼″ × 19¼″. (Courtesy of the Norton Simon Museum.)

347 Series, *Leiris #161.* Pablo Picasso. Aquatint, 13¼″ × 19½″. (Courtesy of the Norton Simon Museum.) Aquatint is used in an entirely different manner than in the work of Francisco Goya illustrated at the beginning of the chapter.

The Dove. Pablo Picasso, 1949. Lithograph, bon a tirer, 21½″ × 27½″. (Courtesy of the Norton Simon Museum.)

Lunch On The Grass. Pablo Picasso, 1962. Linoleum cut, 1 block, black, brown, beige, 21″ × 25¼″. (Courtesy of the Norton Simon Museum.) Picasso forces us to take a second look at the linoleum-block technique and brings out its inherent character.

Bacchanal. Pablo Picasso, November 27, 1959. Linoleum cut, 21″ × 25¼″. (Courtesy of the Norton Simon Museum.)

THE ETCHING NEEDLE

In etching a plate is bitten into with acid wherever the artist has drawn through an acidproof ground, which can be made of wax, asphaltum, lacquer, or other resists. The technique known as drypoint bypasses the acid process: the artist scribes directly into the plate with the etching needle in order to kick up a slight burr. The channel made by the needle and the subsequent burr hold the ink until the image is transferred to dampened paper, usually by means of the press, which exerts enormous pressure on the paper and plate. The drypoint process is not capable of providing a consistent and faithful multiple beyond seven to ten impressions.

In order to facilitate the drawing process, the tool used for making the lines should be strong and able to withstand much use and pressure, particularly if the drypoint technique is employed. Etching needles are sharpened at both ends to a pencil-point finish. Many printmakers find the tips too sharp for their purposes and alter the design slightly by purposely blunting them to make a wider line.

An etching stylus made by driving one or more nails into a slender block of wood. The heads of the nails are removed with metal nippers. This tool, especially the one with three nails, is used for incising parallel lines on the zinc plate for cross-hatching effects.

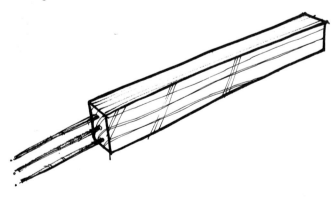

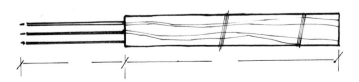

The nails may be driven into the wood at a diagonal angle.

Apocalypse. Robert Fiedler, 1974. Three states of the artist's proof showing greater detail in each successive image. Small, discrete lines are used in an orderly fashion to build masses of tonality.

Any hard metal rod can be shaped to resemble a commercial etching needle. This can be done by gradually grinding the tip of the rod to make a point that matches the need. Several needles can be made for a variety of purposes. Etchings made with a variety of line widths can be more arresting to study and offer the etcher a choice. Each end of the rod can be ground to provide a wide range of finishes. Tips may also be flattened by slightly hammering the metal on an anvil to extend the principle of different needles even further.

One of the most convenient tools that I have found for this purpose is the dental probe. The probe is made of durable surgical steel and has a grooved shaft for a solid grip, making it less likely to slip from the hand.

It is well balanced, easy to clean, and capable of many useful applications. Compared to the etching needle, the dental probe is usually a more expensive tool. However, all dentists use these tools and usually discard them once they have outlived their usefulness or have become unreasonably dull. A family dentist will most likely be glad to set a few of these items aside if you make previous arrangements with him. They are absolutely superior tools and well worth the trouble of obtaining them. If you are concerned about hygiene, ask your dentist to sterilize them for you. Another possible source is a military-surplus store. Many of these stores sell dental probes (government issue) at ridiculously low prices. They are available in many designs, some requiring no modification for your purposes.

If you want to change the existing tip, you will need to cut off the metal about ⅛" from the end. This is best done with a pair of wire cutters designed to cut strong material such as thin cable or electrical cord. It does not require much strength, just sharp metal. If cut properly, the tool will still have an obvious taper measuring about 1" in length. With the aid of a grinder or coarse Carborundum paper, begin to sharpen the tip by rotating the tool as you scrape back and forth in a side-to-side manner. This is slow going but essential to the formation of an even point. Stop when you think that the tip is formed. Make a few test scratches on a small zinc plate as if making a drypoint. Try the same tool on a plate coated with hard ground. Notice how it feels as it is drawn across the surface of the metal. Is it smooth and consistent with the tactile experience of drawing? I have found that this is the ultimate test of the point. I have always found the commercial etching needle to be anathema to the touch. It is like the iron lawn dog in the front yard, feigning a welcome greeting to the visitor. It is impersonal, aseptic, and without feeling. Those that you make will be a handsome addition to your box of artist's tools and will provide you with the exceptional quality that you would expect from a well-made tool.

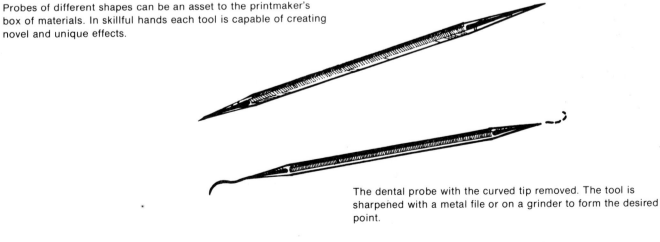

Probes of different shapes can be an asset to the printmaker's box of materials. In skillful hands each tool is capable of creating novel and unique effects.

The dental probe with the curved tip removed. The tool is sharpened with a metal file or on a grinder to form the desired point.

THE LINOLEUM BLOCK

Linoleum, like crayons, is one of those materials unfortunately relegated to students of grade-school age, hindering its acceptance as a serious art medium. Nonetheless, artists such as Picasso, Matisse, and other major 20th-century figures have used linoleum or linocut extensively. This fact should be enough to encourage artists to take a more serious look at this very accessible and inexpensive material.

Linoleum was invented by F. Walton, an English manufacturer, in 1863. It was conceived of as a hard, smooth, washable floorcovering made of a mixture of ground cork, ground woods, gums, color pigments, and oxidized linseed oil laid on a burlap or canvas backing. The type most preferred by printmakers is battleship linoleum, which comes in white, beige, and gray colors. Architects often use it on top of their drafting tables as a more durable surface that can withstand the rigors of compass points, calipers, and other measuring tools. Linoleum, if punctured, is self-mending to a degree. The material has a "memory" due to its rubbery nature, which makes it easy to cut with very sharp woodcutting tools or other tools capable of gouging the surface. Avoid linoleum that is patterned with flecks of color and covered with various designs for decorative purposes. The patterns may interfere with the plan and necessarily cost more due to the colorful designs.

Sheet linoleum is still plentiful and can be bought by the square yard. I have noticed a gradual decline in stocks of battleship linoleum in the larger floorcovering stores but always find a sizable cache of it in home-improvement centers. It may be worth the cost to buy a few square yards of linoleum and to store the unused portion for future use. The linoleum may be used as is or glued to a block of wood with mastic adhesive. The reason for the wood backing is to raise the linoleum to type-high measurement (.918") for use on the bed of the proof press. The block may also be locked up in the printer's chase for letterpress printing. If the linoleum is to be used with the adjustable etching press, wood backing is desirable but not essential to the pulling of a faithful print.

THE LINOLEUM AND WOODBLOCK FRAME

A frame such as the one illustrated here helps to keep the linoleum or woodblock from slipping under the hands of the artist as he works the surface. Although this device is not an original design, it bears mentioning because it is simple to make yet rarely stocked or used in the studio. It is one of those accessories that is difficult to improve upon and that does just what it is supposed to do. The measurements in the illustration are approximate. Increase or decrease the proportions depending on the size of the block that you intend to use. Any type of wood may be used. When rotating the linoleum or woodblock for carving curved lines, consider placing a quarter or a large metal washer under the plate to facilitate the revolving motion.

Sheet linoleum is an inexpensive printmaking material. It may be used in its natural form or glued to a block of wood.

A woodblock and linoleum holder. This simple device keeps the block from sliding on the work surface.

PLASTIC PLATES

Artists have recently been using hard acrylic or plastic plates to make prints. These materials have several clear advantages. They are transparent, which gives the artist a view of the underlying design on paper. They can withstand considerable pressure if used on the etching press. Although the plastic is hard, it has a consistent "feel" when cutting, unlike wood, which has both hard and soft spots. Acrylic plates are available in large sheets for spacious prints.

Tools used to carve or incise acrylic should be kept razor-sharp for best results. A small electric hand drill coupled with several bits such as burr wheels and tiny disk sanders make interesting lines and grated surfaces on the plastic surface. You may use engraving burins, gouges, etching needles, sandpaper, scrapers, or any material capable of altering the plastic surface. Acrylic is very sensitive in spite of its hard composition. The slightest scratch will show up in the print if the ink is not fully removed from it beforehand. The wiping process can be made easier with a small amount of talc. To store the plate, wrap in a piece of cloth and lay flat. The cloth prevents accidental scratches and nicks on the image surface.

A thin coat of water-soluble black ink may be applied to the surface of the plate with a wide brush to give an opaque appearance. I then place the plate on a large sheet of white paper or butcher scrap. Each time an incision is made, I can immediately see the nature and character of my line. When you are ready to make a proof print, wash off the water-soluble ink. Ink can be applied and removed at will with no adverse consequences. The printing ink should be finely ground. Any abrasive ingredients may scratch the plastic.

BRAYERS AND ROLLERS

An assortment of brayers is an indispensible requirement for practically all phases of printmaking. With brayers ink can be applied uniformly and evenly to hard-to-reach areas of the plate. They can be made in sizes ranging from the width of a rubber band to widths in excess of 6", depending on the rubberlike material selected for the job. Long ago I got into the practice of improvising my own brayers and rollers for inking collagraph plates. It seemed to me that brayers in unusual sizes were nowhere to be found. They were often not made to meet the specialized demands of some plates. These periodic futile searches led me to the conclusion that the only way to obtain specialized brayers was to make them to my own specifications.

A piece of clear plastic is used for engraving and drypoint.

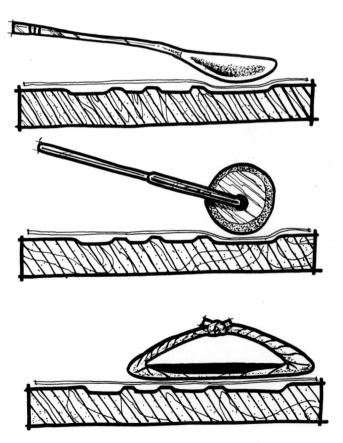

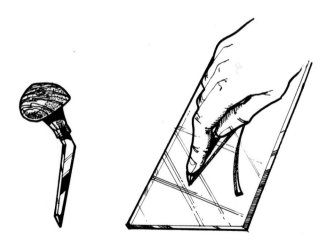

The technique of carving thin lines in the plastic sheet with the engraver's burin.

Three different ways of burnishing the surface of a woodblock print. The traditional Japanese *baren* covers the greatest area and does not force the paper into the valleys of the block.

At first I made rather elaborate brayers with fanciful metal handles that required welding for greater permanency. In time I began to use thin metal rods that could be bent with the aid of a vise and vise-grip pliers. I found this to be easier, more expedient, and just as fruitful as the welded version. For smaller rollers handles can be formed from coat hangers. Small-diameter brayers can be made from wood dowels, sheet rubber, and metal rods.

It must be determined beforehand precisely what function the brayer or roller will have and what part it will play in the inking process. The smaller brayer is used for inking tight and confined areas. It can also be used to lay down thin lines or bands of color on the plate. Large rollers are used for wider bands of color and for extensive surface coverage. The degree of rubber hardness is also important. Softer brayers are usually used to reach the more depressed areas of the plate. Hard-rubber brayers can be used to apply ink to flat surface areas of the plate, provided that the tool is not used with a burrowing force as it is rolled over the plate. The brayer core may be wide in diameter but narrow in tread. This allows a thin line of ink to be applied before the roller comes full circle and begins to repeat itself. At this stage most of the ink has been deposited on the plate, and continued rolling leaves a ghosted color as a result of ink depletion.

As you prepare to make brayers, place before you a few of the following raw materials, from which you may select as ideas occur. Obtain various diameters and lengths of wood dowels. Dowels rarely exceed 1½" in diameter, so larger shafts must be made from some other material such as stiff cardboard or plastic tubes. These are available in a variety of sizes from manufacturers of such goods. They are used in their original form for everything from mailing tubes to pipes for carrying all sorts of liquid and dry materials. Vendors are found in most large cities. A few inquiries to local merchants should turn up a reliable source. The ends of the tubes may already be capped. One end will invariably have a removable lid. You may want to leave this type of tube, usually made of cardboard, intact. When an appropriate rubber is wrapped around the tube, a brayer of this sort will be usable but far from permanent. In time solvents and water will decompose the cardboard, rendering the brayer useless. Hollow plastic tubes are far more durable and easy to clean.

In addition to the shafts you will need a selection of soft and hard, flexible and nonflexible materials to stretch and wrap around the cylinder. These materials hold the ink as it is picked up from the inking plate. I mention nonflexible materials such as leather, suede, and assorted vinyls simply for the reason that these goods fall into the realm of experimental, nontraditional tool design. Also, more importantly, they work. Handles for the larger brayers need to be made from wood, plastic, or metal. The weight and overall design of the brayer determine which material is more feasible for balance and support.

Begin by making a small ink roller. This will acquaint you with the procedure and provide you with the necessary experience before moving on to larger or more elaborate brayers. Cut a piece of dowel to 1" in length. The diameter of the dowel should be approximately the same. With an ⅛" drill bit drill holes in each end to a ¼" depth. Determine the circumference of the dowel and cut a piece of available rubber such as an old inner tube to match the circumference. The width of the rubber will need to be slightly narrower than 1". This permits the dowel to be exposed on both ends when the rubber has been properly applied by centering on the dowel. Apply a water- and solvent-resistant adhesive to the backside of the rubber and to the stock, provided that this is in accordance with the manufacturer's instructions. If you use mastic or contact cement, be prepared to work fast, as the glue sets quickly. Carefully wrap the rubber around the wood shaft, gently burnishing the rubber sideways with the thumb. This will force air pockets to the outside and ensure better adhesion.

You will note that, where both ends of the rubber meet, a thin line or depression occurs. If your initial cuts in the rubber were straight, this line will be marginal and will not depreciate your efforts. Allow the roller to dry by standing on end. Then bend a 10" strip of wire previously cut from a metal coat hanger to conform to the measurements and shape pictured in the adjacent illustration. Insert the wire prongs into the predrilled holes on the ends of the dowel. Roll the brayer back and forth on a piece of cardboard a few times to test the action and movement. The roller should not bind against the handle. If it does, reshape the wire so that freedom of movement is possible.

Leather is an ideal surface covering for rollers. Small scraps are inexpensive and run the gamut of softness and hardness. As with the above rollers, begin by making a small size in order to understand the material, its relationship to the tool, and how it performs on the plate. Sew the leather piece together first. This is a slow process somewhat akin to the cobbler's task in shoe repairing. Use a thin, sharp sailmaker's needle and fine linen thread. Small holes are made along the edge of the leather. The leather is then cupped until both edges meet. Sew the two edges together, making sure that no ripples occur along the seam. The leather, once sewn, is then soaked in a shallow tub for several hours or until the material is more supple and can be slipped onto the waiting dowel or tube. As the leather dries, it will contract and tighten around the shaft. Allow the roller to dry in a position so that no pressure is imposed upon any part of the surface. A roller cradle can be built for this purpose. If the leather has sufficient oil in it (i.e., if it feels soft and supple), coat it with

a thin veneer of mutton tallow and wrap in a plastic bag or aluminum foil. This will preserve the surface for future use.

If the leather is dry or stiff, it may be necessary to rub a small amount of soft lithographic varnish onto the surface and then to scrape it with a spatula, first against the grain, then with the grain of the leather. Then add a harder varnish (#5 or #6) and work the emollient into the leather with the hands. Roll the roller over a slab, preferably glass or marble, for 20 to 30 minutes, cleaning the slab every 10 minutes or so to remove small bits of leather nap. Thoroughly clean the inking slab and remove the excess varnish from the roller by wiping it once or twice with a soft, lintless rag. Apply a couple of thin beads of ink along the roller and once again roll out on the inking slab. Remove the last traces of ink and wrap in an appropriate covering. This process rejuvenates tired or dry leather and should render the roller useful once again.

If you look around, you will discover that there is a large assortment of raw materials that can be combined with the roller or brayer assembly. Upholstery webbing, the type used to support large cushions, is manufactured in several thicknesses of soft rubber.

It is available by the yard and can usually be purchased or ordered from an upholsterer. It costs a few dollars per yard and can be turned into a dozen or more brayers. A visit to a yardage store will turn up a few possibilities. Synthetic materials such as plastic are a good basis for experimentation in the roller-making process.

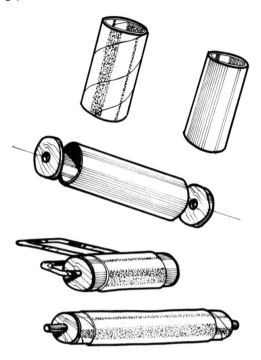

More elaborate brayers and rollers can be fashioned from plastic and cardboard tubes and cylinders. The ends must be capped with wood or plastic before the handles are installed.

A handmade brayer can be easily improvised using coat-hanger wire, doweling, and strips of rubber. It is ideal for applying inks to small areas on the plate.

Leather is wrapped around the cylinder to provide a professional roller surface. Consider using the handmade roller in the lithographic technique.

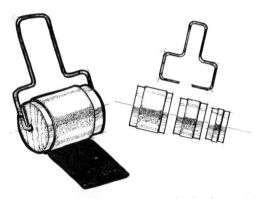

The shape and dimensions of the brayer handle.

109

BRAYER STORAGE RACK

To extend the life of small brayers, it is important to store them so that they hang freely from a hook. A rack can be improvised to hold several small rollers or brayers. The entire unit is portable and can be placed in front of the immediate work surface. This gives the printer convenient access to the rollers as the need arises. There is no special trick to making brayer racks. Surplus scraps of hardwood durable enough to withstand continual use are suitable materials.

The overall dimensions of the rack can be determined after deciding on the number of rollers that it is to support. Allow a little space between each roller for ease of movement and for air circulation to facilitate drying. Measure the width of each roller, allowing a ½" space in between. This will give you the total width of the back board that is to support the pegs used to hold each tool. The base is to be as wide as the back board and should extend far enough to counterbalance the weight of the board and tools. For example, thick pine or hardwood backboard measuring 8" (wide) × 7" (high) × 1" (thick) would call for a base measuring 8" (wide) × 4" (deep) of the same stock. Dowels to be used measure ⅜" and are inserted into predrilled holes at regulated intervals along the top portion of the board, as shown in the illustration. Seal the entire project with wood stain and sealer. Ink will then be easier to remove from the rack.

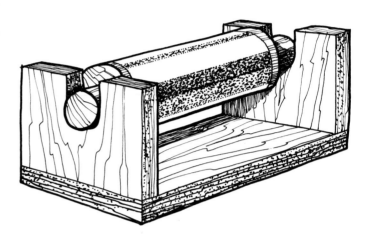

A brayer storage rack.

A storage rack for small brayers and brushes.

WOODBLOCK AND LINOLEUM PRESS

Although many artists prefer to hand-print their woodblock and linoleum plates with the aid of a flat spoon or bamboo baren, it is sometimes advisable to use a small press, which can easily be made with two sheets of ¾″ plywood and four carriage bolts with washers and wing nuts. The illustrations show how these materials are assembled to form a workable, portable press capable of exerting considerable pressure on the block. In theory the spoon or baren principle allows the contour of the tool to print the many raised points of the block, but with the aid of a couple of thin felt blankets the clamp press described here can print small plates with surprising quality and evenness. The felts help to cushion the hard surface of the wood as it comes into contact with the paper resting on top of the inked plate.

The traditional Japanese *baren* made from the bamboo plant. The inside of the *baren* contains a coiled rope over which the bamboo leaf is stretched and the ends tied in a knot. These *barens* are very reliable and can be made in the studio in a variety of sizes. The detail photographs show the manner in which the knots are tied. (Photos continue on pages 112 and 113.)

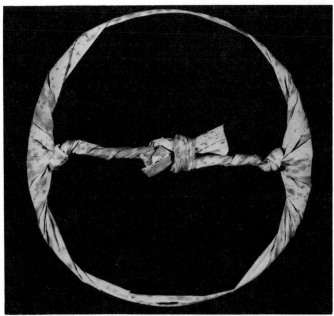

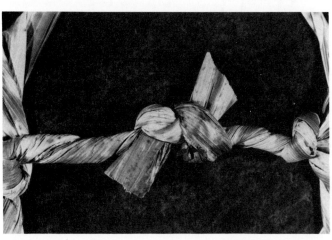

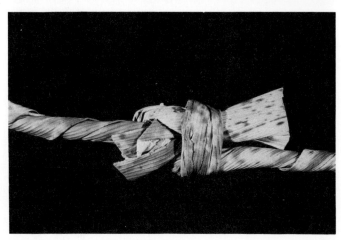

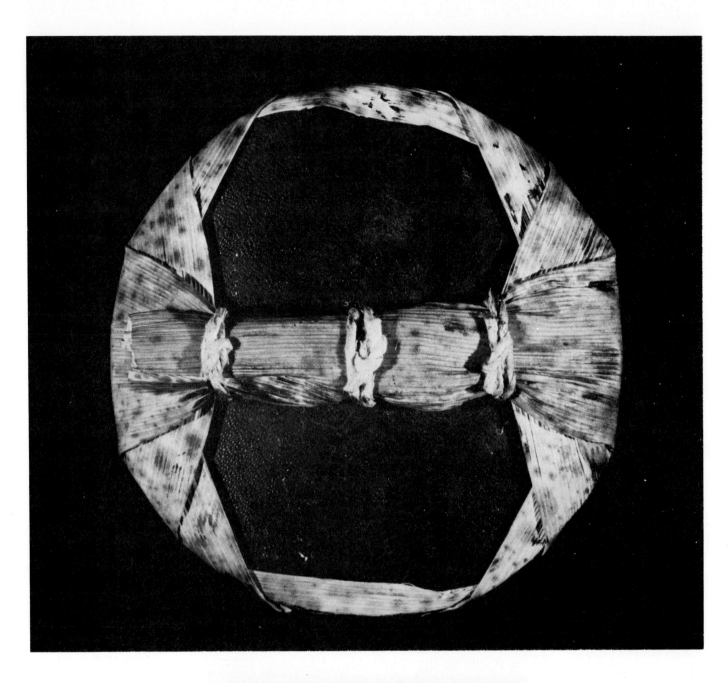

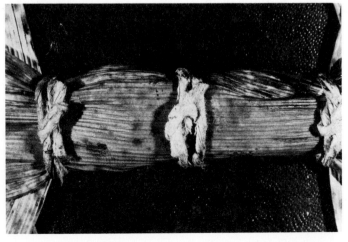

The press is made by drilling a hole in each corner of the two plywood panels. The panels are to be 1" or 2" larger than the felt, paper, and plate. The plywood should have no knotholes on the two opposing surfaces. The wood should be sanded and sealed with the appropriate wood sealer. Four ⅜" carriage bolts are inserted into the holes and serve to fasten both boards together as the wing nuts are tightened.

To effect a print with a clear and full image, it is necessary to turn the wing nuts quite hard. Once this is done, the wing nuts are loosened and the top panel and felt removed. The print is then peeled off the plate by gently pulling diagonally from one corner of the paper. Examine the felt to be sure that no ink has penetrated the paper and been transferred to the felts. This accident commonly occurs with thin papers if there is either an excessive amount of ink or an overtightening of the wing nuts. A press of this nature is best used for plates not larger than 14" × 17". Larger images require substantial pressure beyond that of which the plywood press is capable.

C-CLAMP PRESS

A variation on the plywood press is the C-clamp press, which requires two clamps for small prints (no larger than 9" square) or four clamps for larger plates. The plywood thickness remains the same (¾"), and the clamps are spaced in an equidistant arrangement around the edges of the two boards. Tighten in a clockwise manner, making sure that the pressure is evenly applied. Overtightening of one corner can result in uneven coloring. Long throat clamps can be used in conjunction with the C-clamp to apply pressure towards the center areas of the plywood. This combination ensures that all areas of the press are under a relatively equal amount of pressure, which can be an asset when printing larger blocks.

Start to print with one piece of thin felt before using additional felt. Felting is available in yardage stores. Pressed felt is desirable. Woven felt can be too coarse and may have a tendency to impart a texture to the paper when pressure is applied.

The C-clamp press. The plate, paper, and felt are inserted between the two plywood panels. The clamps are then tightened to strike the required impression.

A simple press combining plywood and four carriage bolts and wing nuts.

BOOKBINDER'S PRESS

If you are able to locate a bookbinder's press, you will find a very useful but rapidly disappearing tool. The binder's press is capable of exerting an enormous amount of pressure and is sturdily built to withstand the rigors of daily printing. This press used to be common and could be found in secondhand stores for many years. However, its desirability has made it a sought-after item that, once found, can command a high price. It is practical not only for printing and binding but for papermaking. Bookbinder's presses are still manufactured in this country. A large library in your city is likely to use the services of this type of equipment. The binder's press works with a central threaded shaft attached to a platen. As the wheel or "bone" handle is rotated, the platen is lowered and pressure is applied to the object beneath.

HYDRAULIC PRESS

Another version of the bookbinder's press is the small hydraulic press, which can deliver up to 15 tons of force per square inch. Considering its capabilities, it is reasonably priced. It can be purchased from a large automotive-supply store. If it is not stocked, ask the personnel to show you a picture of this item and to describe its components. The basic differences between the hydraulic and the bookbinder's press are that the former is more powerful, usually stands on the floor, and works on the principle of air compression. I have found the hydraulic press to be a decided asset for my own use as a printmaker and papermaker. Michael Ponce de Leon, a noted American printmaker, has designed a hydraulic press for printing his three-dimensional constructions. A deeper and more permanent relief is achieved, and, when combined with wet pulp, the possibilities are numerous. Hydraulic presses are traded often enough to make a search for a used press worth your while. Check with companies dealing in the resale of commercial machinery. The savings can be substantial.

A bookbinder's press can be a useful block-printing press. It is becoming quite scarce, since so few are made today. Try to locate one in a secondhand shop or antique store.

The hydraulic press. This machine is capable of exerting 15 tons of pressure per square inch on the bed plate.

SOLVENT CONTAINERS

One of the more wasteful printmaking activities occurs when plates are to be cleaned before storing or between runs. Solvents are poured onto zinc plates, woodblocks, collagraphs, and other supports straight from the can in which the solvent is sold. Manufacturers rarely fit the orifice of the can with a small spout capable of being adjusted for desirable flow. The net result of this oversight can be flooding of the plate surfaces with excessive solvents, which run off into the sawdust or newsprint beneath. In the classroom I have seen students go through paint thinner, lacquer thinner, acetone, turpentine, and toluol, quickly exhausting gallons of material in the course of a day's printing. Fumes from the overflow of thinners soon weigh heavily in the air and can make conditions unpleasant. Gallons of appropriate solvent have become a very expensive commodity in the overhead of printmaking studios.

Prudent use of chemicals can be promoted by using small dispensers salvaged from other uses and clearly labeled as to contents. In the print studio at the university where I teach each student has a small area set aside for his or her own use. On a thin shelf above the plate-cleaning counter are stored several plastic bottles with spouts to be used at the appropriate time, usually at the end of the class session. Each bottle holds a pint or two of solvent and is easily and quickly refilled from the large five-gallon drum in which the bulk of the material is stored.

It was interesting to note that in a six-month period our expenses for solvents were halved when this simple procedure was used. Save soap dispensers, window-cleaning atomizers, plastic salad-oil bottles with adjustable spouts, skin-lotion bottles, and other such containers for this purpose.

Disposable plastic bottles should be saved for storing a mixture of solvents used in the studio. These containers help to cut down on wasteful and thoughtless flooding of solvents when plates are to be cleaned.

One word of caution: a few solvents will attack the plastic and very quickly eat through the bottle. Experiment first by pouring a small amount into the container and carefully observing the bottom. Some plastics are impervious to all of the above-mentioned chemicals and are therefore the best to save for this purpose. Use a grease-base marking pencil to label each dispenser.

INK APPLICATORS

Etcher's ink is applied to the zinc or copper plate with a dabber or cardboard chip. The viscous ink is forced into the incised or etched lines by the rubbing motion of the hand and tool. The ink applicator must not be so absorbent that it soaks up the ink nor so hard that it scratches the plate surface. Just how much ink should be laid on the plate is, as every etcher knows, a matter of judgment based on practical experience. Residual amounts of ink can be removed from the plate with a stiff plastic wedge, as shown here. The wedge is made from thin, soft plastic or rubber and performs quite satisfactorily. The same tool can also be used to apply the ink to the plate.

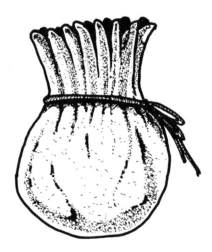

A leather ink applicator containing small particles of rag or cotton to give it shape. The applicator is used in a circular motion to drive the etcher's ink into the lines of the plate.

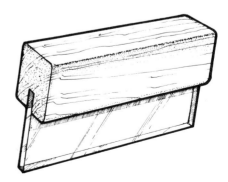

A simple plastic and wood squeegee can be used to apply ink to the surface of the plate.

There are certain drawbacks to the dabber, which is usually composed of a soft, bulbous wad of cloth covered with tarlatan or leather. It is flimsy, sometimes too absorbent, and often inadequate to force the ink into deeply etched or engraved lines. The cardboard chip, though expendable, becomes weak, and it seems that one is forever cutting the chips once the board has been found. Fragments of the board sometimes stray into the wiped image and show up on the freshly proofed print. For these reasons I have found the wedge applicator to be an ideal device for moving ink across and off the plate. I have also noticed that some printmakers prefer to use a window squeegee in place of the more conventional dabber. Provided that the rubber is soft enough, a large area can be inked with this item, and it may prove to be an advantageous accessory in the studio.

Dabbers, if used, can be made from nylon stockings. They are much softer than the tarlatan and are supple enough to work the ink into tiny crevices. The stuffing inside the stocking may be composed of cotton rags or other soft material. Whatever is chosen, avoid fabric that is likely to leave bits and traces of lint or other fine particles that could worm their way through the mesh of the nylon. A cleaner and more evenly inked plate will result from this seemingly insignificant step.

Distant Landscape. Vance Studley, 1974. Etching. The squeegee was also used to ink this print.

Untitled. Vance Studley, 1974. A plate as intricate as this one is easily inked by means of the squeegee device. Notice how the ink has effectively lodged in the very small lines of the moth.

Untitled. Vance Studley, 1974.

A drypoint study. The plate was plastic; the scribing tool, an improvised etching needle. The print was made on the plywood carriage-bolt press.

TWO USEFUL RESISTS

All printmaking books at some point cover the various uses and applications of resists to prevent the acid or other mordant from biting the zinc and copper plates. To this literature I would add the following materials, more for their expediency than their failsafe reliability. Both rubber cement and household masking tape perform so well that many printmakers use these materials for their own unique properties.

Rubber cement resists nitric acid. It is fluid enough that, when freely applied to the plate's surface, it can result in both flowing and abstract forms. It offers an almost calligraphic freedom that I find lacking in asphaltum or other traditional resists. It is available almost everywhere and is easy to remove. Use a brush applicator: one composed of pig bristle is well suited to cement.

Strips of masking tape may be applied to the plate both on the surface and around the edge to prevent the corrosive action of the acid. Whole images may be made with the imaginative use of the tape. Masking tape is available in rolls in several widths ranging from ¼" to 3" and can be found in hardware and paint stores. This tape should not be confused with drafting tape, which, though perfectly reliable, is more expensive. The tape should be cut before being applied to the plate. Any cutting on the plate may result in accidental lines, which, as in drypoint, will show up in the proofed print. Wide masking tape can be cut into shapes to act as frisket-paper shields similar to those so often used in airbrush art.

An ordinary squeegee can also be used to ink the plate.

Two useful resists. These materials are applied to the zinc plate to retard the bite of the acid solution.

119

9 Papermaking

BACKGROUND

Paper was invented by the Chinese over a thousand years before a German immigrant, William Rittenhouse, made the first piece of paper in the British American colonies in the late 1600s. In A.D. 105 Ts'ai Lun, a Chinese court official, mixed together the bark of mulberry trees, scraps of silk cloth, hemp, and worn-out fish nets and softened them with water. The materials were then pounded with primitive wooden mallets until the fibers were separated. The contents were added to a bucket of water and stirred until they were sufficiently blended. The whole mixture was then drained through a fine screen attached to a wooden frame. What remained was a sheet of matted material that was then allowed to dry in the sun.

Rittenhouse's technique differed very little from Ts'ai Lun's method. The main papermaking fibers used by colonial American craftsmen were derived from cotton and linen rags. These very scarce items were subjected to a fermentation process and then beaten with a stamping device to further reduce the material to a pulplike consistency. The pulp was placed into a vat filled with water, and, with the aid of a mold and deckle, the vatman formed his glistening sheet of waterleaf, the newly made sheet of paper.

The industrially produced paper of today tends to disappear as a form and to become indistinguishable from its function. Its being is its meaning and its meaning is to be useful. It is the diametrical opposite of a work of art. However, in the past few years there has been a revival of interest in the handmade-paper process and in handmade paper itself. The history and technique of the handmade-paper movement are more thoroughly covered in my book *The Art and Craft of Handmade Paper.* Readers are directed to this source for a more extensive look at the papermaking process. What follows are several approaches to making paper by hand and a description of the necessary equipment for making useful artist's papers.

An early antiphonal illumination on vellum. Vellum is made from calfskin, goatskin, or lambskin, usually the entire skin. Vellum may often be distinguished from parchment by the grain and hair marks, which produce an irregular surface.

MATERIALS FOR MAKING PAPER

The Vat

The equipment used in making small quantities of paper by hand is usually already contained within the home or studio. A few materials will have to be purchased to make the mold and deckle. A vat or tub can be improvised from any large, watertight container such as a busboy's tub, plastic litter box, or galvanized tub. A vat may also be made from plywood and sealed with resin or fiberglass to make it waterproof. A drain plug should be installed in the bottom of the tub to allow water to drain off after the paper-forming process is over.

The Beater

An electric blender will suffice for the beater. It need not be an exotic brand-name unit. A blender with a few speeds does an adequate job of reducing the fibrous material to a pulp consistency. By using small amounts of material in the blender the machine is not taxed beyond its capacity. The blender is also used to break down ready-made paper or paper that will be recycled into new sheets.

Felts

Felts or blankets are used to blot the newly formed waterleaf. They may be made of woolen blankets, compressed felt, cotton towels, or other suitable soft and absorbent material. The size of the felts should exceed the paper by a couple of inches on each side. A felt must be placed between each sheet of paper and the next and on the top and bottom of the stack.

A household blender is used to shred the plant material.

Compressed or woven felt similar to that used in army blankets may be employed.

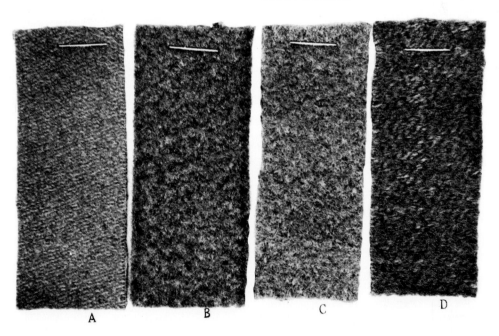

Four grades of commercial felt, available from Appleton Mills in Wisconsin.

121

The bookbinder's press is used to compress the felts and waterleaf in order to remove excess moisture from the newly made paper sheet.

Sizing can be made of alum, rosin, gelatin, or cornstarch. Coarse particles are finely ground with the mortar and pestle.

The Press

A pile or post of felts alternating with wet paper must be pressed by means of weight or pressure. A simple press can be made with two pieces of plywood connected by four bolts. Another press to consider is the bookbinder's press mentioned elsewhere in this book. It is ideal for pressing small sheets of paper. A third alternative to consider is the hydraulic press, which is the strongest of the three and also the most costly. if you think that you are going to make a lot of paper over the next few years, this would be the press to purchase. A hydraulic press capable of delivering pressure of upwards to 15 tons per square inch is sufficient.

Sizing

Sizing is accomplished with one of the following materials: alum, powdered rosin, clear powdered gelatin, polymer binder, cornstarch, or even white glue. Sizing is an optional procedure that should be considered and tried if only for the experience and the effect. A small amount of sizing, regardless of the ingredient that you choose, goes a long way and must be used with discretion.

Color

Paper is best colored while it is in the blender. This ensures even absorption and minimizes the risk of inadvertent contamination of other materials near the preparation area. I have used fiber-reactive dyes, procion dyes, inks, latex colors, and ready-colored paper. Each contributes a unique and characteristic quality to the handmade sheet. Apply the color in small amounts. This can be done with an eye dropper or a measuring spoon.

Coloring is added to the pulp while it is being macerated or beaten in the blender. It may also be introduced to the pulp when it is in the vat.

Mold and Deckle

The mold is a rigid rectangular frame on which paper is drawn from the vat. A wire, plastic, or fabric screen is stretched taut over the frame and allows water to drain from its surface. Molds may be made by sewing fine brass wire transversely across the frame, which is then fortified with thin struts or ribs. Make the frame from straight, good-quality wood for longer life. I have used fabrics such as burlap, linen, gauze, silk, and coarse sailcloth. Fiberglass screen-door mesh is a perfect alternative to the more expensive brass or copper-wire mesh. Mesh gauge for the fiberglass should average somewhere between 40 and 60 strands per inch. Apply the mesh with water-resistant brads, staples, or small tacks. You will find 1"-×-2" wood to be strong enough to withstand the wear-and-tear of the paper-making activity. A mold of the sewn-wire variety with wires averaging 22 parallel strands to the inch is termed a laid mold. A mold fabricated of the above-mentioned fabric or fiberglass is termed a wove mold.

The deckle is the wooden frame that fits over the mold when a sheet of paper is formed. Excess pulp is prevented from running over the mold by this device. The characteristic feathered or deckled edge seen on handmade papers results from this tool. The deckle can be made from inexpensive molding available from most lumberyards. Again, better-quality wood will create a proportionately more serviceable product. The deckle is mitered and assembled in much the same way as a picture frame. Use water-resistant glue and brass finishing nails to bind the four members together. The deckle must fit the mold tightly with no sloppy interplay.

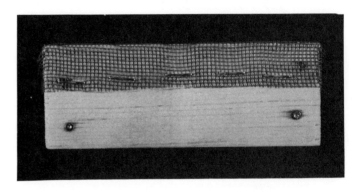

Coarse fabrics are stretched over wooden frames for simplified molds.

A side view of the mold.

The mold and deckle. Fiberglass is used as the screen to cover the mold. Brass staples are used to fasten the screen to the mold.

Pulp

The list of fibrous materials that can successfully be used for making paper is as varied and exhaustive as the plants themselves. I can safely say that paper can be made from jute, iris, gladiola, mulberry leaves, the thistle plant, bamboo leaves, cattail, ash leaves, bird-of-paradise leaves, cotton rags, linen rags, eucalyptus, straw, and many other readily available botanical materials. Growing things have a peculiar skeletal structure. This structure is the armature for the fleshy material of the plant. The boiling process so necessary to the breakdown of the plant will separate the two, leaving only the skeletal substance, which in turn is the very warp and weft to be transformed into the paper sheet.

Iris plants make ideal raw material for papermaking.

Wild thistles growing in nearby hills, if left to soak for a few days, can be transformed into coarse handmade paper.

The leaves of the mulberry tree, unlike the traditionally used bark, can be broken down into pulp. The final result resembles dark green paper.

A sheet of paper made by combining strands of thistle and cotton linters.

Matsumita paper.

This intriguing roughly textured sheet is the result of mixing jute, straw, cotton, and iris.

Paper made from the stalk of the cattail plant.

Decorative devices may be applied to the wet waterleaf after it has been couched on the felt. The items are gently embedded into the still wet sheet by patting with the hand or a wet sponge.

Flecks of sawdust were sprinkled into the pulp before the sheet was formed. Upon pressing the paper acquires an unusually rich and even surface.

A closeup of *gampi* paper.

Cornstalk leaves and strands were mixed with bamboo pulp, creating a very unusual piece of paper.

A delicate fern was gently introduced to the paper sheet upon forming. Once dry, the fibers contract, holding the fragile plant in place.

Long threads from the papyrus plant course their way through this handmade sheet.

Several sacks of dried plants are gathered and scissored into 1″ strips. They are placed into an enamel or stainless-steel pot in preparation for boiling. To this clump of plants are added several quarts of water and a couple of tablespoons of lye in flake form. Turn up the heat and slowly bring the ingredients to a rolling boil. Allow the mixture to simmer for 45 minutes to 1 hour. Remove the pot from the heat and pour off all the liquid. Rinse the plants by transferring them to a bucket and allowing water to play upon them. Repeat this process several times, place the fleshy plants into the pot once again, and repeat the first step. Go through the entire process at least twice. A particular species of plant can occasionally be resistant to the boiling procedure. It will invariably be broken down with a few additional hours of simmering. The pulpy substance remaining after the last boil is removed and sorted into small clumps, which can be shaped by squeezing a small handful of the plants. Each clump or bollus is placed in the blender pitcher with ½ quart of warm water. Blend the contents for 45 seconds to 1 minute. Pour the thick liquid into a mason jar or plastic tub until the paper is to be formed.

Raw materials to be used in papermaking must be scissored into 1″ strips, placed in a large aluminum or stainless-steel cauldron, and allowed to simmer for at least an hour.

An electric dough mixer can be used to macerate the raw material.

127

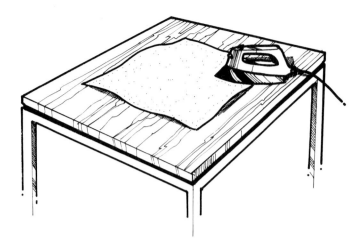

After the sheet is removed from the felt, a piece of blotter paper is placed on top of the newly made sheet. An iron, set at a low temperature, is used to further dry and flatten the handmade sheet.

In other cultures smooth stones and shells are used to flatten and smooth the surface of paper and bark.

FORMING THE PAPER

Make the paper sheet by first pouring a quart of concentrated pulp into the vat and adding six times as much water. This is enough pulp for about six 8"-×-11" sheets. Immerse the mold with the deckle in place into the pulp and allow the mold to sit briefly in limbo near the bottom of the vat. Slowly scoop the mold toward you and draw it from the vat, making sure that the mold is level with the ground. Once the mold is out of the vat, give it a slight to-and-fro shake to even out the fibers and to assist drainage. This is "throwing off the wave." Stand the mold with the thin stratum of matted fiber on end and allow more water to drain from the mold. Remove the deckle and prepare to transfer the sheet to the awaiting felt blanket.

Couching the Waterleaf

Felts and blankets must be wet to facilitate the transference of the paper. Couching, or transferring the sheet of paper from mold to felt, is accomplished by rolling the mold across the felt from one side to the other. Place the next flap of dampened felt on top of the sheet of paper and continue with the forming process. At first make a post or pile with no more than seven or eight sheets of paper and corresponding felts.

Pressing the Paper

Transfer the post to the press and squeeze out as much water as possible. Place a tin or other shallow tray beneath the press to catch the water as it drains off the press. It may be more convenient to place the press and post outdoors and carry on there. At this point the paper is still very damp and needs to be transferred to drier felt. By gently removing each sheet the paper may be restacked with slightly damp felts. On top of this second post place a heavy weight (50 pounds) to prevent the paper from curling and drying too fast. Every

If the new sheet is couched on coarse fabric or material such as burlap, terrycloth, or cheesecloth, a curious and varied surface can result when the paper is squeezed in the press.

two days change felts and examine to see if the paper is dry. The average time is three to five days, depending on the weather and the local temperature. Air is to circulate around the post for optimum drying conditions. Iron the sheets when almost dry to remove moisture. In the South Seas rocks and shells were used to flatten and smooth tapa cloth, a paperlike material.

Sizing

If the paper is to be sized, it is best to allow it to dry for at least two weeks before immersion in the sizing preparation. You will need a large, shallow pan or tray containing a quart or so of warm water. Add the proper amount of sizing solution and stir gently. Have ready several large sheets of clean blotter paper (enough so that the handmade sheets can be spread out to dry in a single layer).

Sizing formulas vary depending on the product selected for this purpose. For gelatin mix one packet with a cup of boiling water until dissolved. Add a tablespoon of this mixture to the water bath for each sheet of paper. (To size eight or ten sheets, add the whole cup of gelatin solution.) If you prefer to use cornstarch, use 2 teaspoons mixed in a cup of hot water and add as you would the gelatin. White glue or acrylic medium may be used by adding 2 drops of either to the water for each sheet.

When the sizing solution is ready, pass the sheets of paper fairly slowly through the sizing bath. I usually do this by holding the sheet in both hands and slipping it into the water, then removing it with the other hand from the opposite end of the pan. Some absorption is necessary, but you do not want the sheet to become completely soaked. The sized sheet is then placed on the blotter paper to dry. If you do not have ample space, the sheets can be hung from a line to finish drying.

Tub sizing is the traditional method, but you may want to experiment by adding small amounts of the above ingredients to the pulp during blending. If you do this, the felts will need to be washed after use to remove residual sizing.

Watermarks

The watermark was originally a sign of the papermaker. It is made by sewing thin brass wire in any chosen shape or configuration to the mold screen with fine thread. As the pulp is formed over the screen, the wire displaces the material, resulting in thinner paper at this point. Watermarks can play an important part in the overall effect of the paper and can be modified by using a design that is either larger or smaller than the traditional sizes used by paper manufacturers.

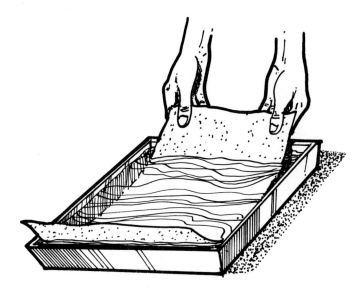

Sizing is accomplished by slowly immersing the handmade sheet in the prepared solution for a moment.

The watermark is made by sewing brass or copper wire onto the mesh of the mold. This design displaces the pulp and gives the handmade sheet its trademark.

Additives to the Pulp

An assortment of materials may be added to the pulp for greater surface and textural interest. Some examples are straw flowers, bits of thread and yarn, sawdust, leaves, wool, hair, rope, small pieces of confetti paper, and butterflies. Very minute pieces of rags can be used as pulp or added to the pulp but must first be boiled in a caustic-soda solution to weaken the material. Add these fragments of rags in small portions to the blender. Too thick a clump can result in a burned-out blender. The above additives may also be placed on the newly formed waterleaf and gently embedded into the paper with the aid of a damp sponge. As the paper dries, the fibers contract and capture the particles, making them part of the fabric of the paper sheet.

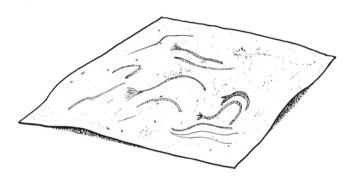

Decorative devices such as a butterfly may be designed into the paper sheet.

Strands of colored yarn, string, and filament can be sprinkled onto the surface of the paper before it is pressed.

Another example showing the relationship of small plants to the paper surface.

Leaves can become an integral part of the paper's surface and design.

By placing small, flat objects on the waterleaf and then forming a second sheet on top, an effect known as "pattycake" is created—i.e., applying or pouring pulp onto a surface and then patting it down with the hand or a sponge. The second layer of pulp is applied in this way, sandwiching the objects inside the finished sheet.

As with all papermaking ventures, each experiment brings to light some new technique or result that can excite the artist to push the medium even further for expressive purposes. From each of the many workshops I have conducted I inevitably have come away with something new learned from the fledgling papermakers. Handmade paper, whether it is poured, formed, embedded, or layered, crosses all the boundaries of various disciplines of art. Paper can be woven, painted and drawn upon, sculpted, torn, cut and collaged, printed, and pressed. And it is for these reasons and uses that handmade paper has a predilection for experimentation and ornamentation, not for efficiency but for pure pleasure.

Pulp poured over a loom weaving. After two weeks of drying the embedded form was pulled away from the weaving, revealing this faithful and textural work of art.

Nurses on the Beach. Edgar Degas. Oil on paper, 17½" × 23". (Courtesy of the Norton Simon Museum.) Degas thought nothing of painting on paper instead of on the more reliable and traditional canvas support.

Merz 289, Erfurt. Kurt Schwitters, 1921. Collage. (The Blue Four. Galka Scheyer Collection. Courtesy of the Norton Simon Museum.) Schwitters delighted in upending trash baskets in order to discover small and intriguing pieces of paper and foil to be used in his collages.

AL 3. Lazio Moholy-Nagy, 1926. Oil, watercolor, and shellac on sheet aluminum, 15⅞ x 15⅞. The Blue Four. Galka Scheyer Collection. Courtesy of the Norton Simon Museum.) If paper is well made and durable, it can withstand the application of mixed media and remain in good condition for many years, provided that it is framed and well cared for.

10 Miscellaneous Tools

There are many miscellaneous tools and artist's instruments that belong in no special category. They often consist of tools converted from other more typical purposes. With a little imagination they can be improvised or modified in the studio once the need arises. You will no doubt want to add your own ideas, as every artist has personal requirements and ideas for shortcuts to get the job done much more easily. Interesting transpositions of wire, wood, plastic, and bamboo objects may occur to you as you window-shop and brouse through art stores.

With metal or plastic as the basic material a very broad interpretation of the various toolmaking processes is possible. Techniques can be used to form a variety of items that serve more than one purpose. If you teach art classes, consider a two- or three-day workshop as a prelude to the class in order to introduce tools and techniques to your students. In this way students are exposed to many of the instruments needed to make artistic works. Some students will be more adept at working with their hands and will soon provide their own problems and attendant solutions, thereby rounding out their creative training and experiences.

The introduction of new processes and equipment, whether directly from the manufacturer or by the play of fresh invention upon a received idea, is an activity to which we are continually exposed. Some of these ideas are self-limiting, while others may have broad appeal. To this end I feel that, if you have crafted something to solve a problem at hand, the chances are that this same device may be of benefit to others who at some point might be struck by the same dilemma. By sharing your ideas and concepts with other designers, artists, and craftsmen you provide an enriching experience for all concerned. Most of the following suggestions for tools are made from materials found around the home. A few may have to be purchased but are modified to fit the proposed design.

ARTIST'S TOOLBOX

It is no longer necessary to trudge from studio to location carrying cumbersome and heavy wood tool caddies. With today's lightweight plastics boxes fitted with handles in an assortment of sizes can be purchased from sporting-goods and discount stores in all price ranges. Tackle boxes are designed for use by fishermen and outdoorsmen and come equipped with compartments, trays, drawers, and resealable containers. They are ideal for storing pens, nibs, erasers, brushes, oil paints, palettes, scrapers, markers, drafting sets, and other essential supplies for use on location. The same tackle box, when sold as an artist's tool carryall in the art store, is inevitably priced higher than the same item in the sporting-goods store.

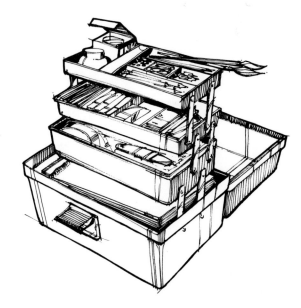

A sportsman's fishing-tackle box can serve as a useful artist's carryall. Many of these containers have drawers and compartments in which to store the many gadgets and tools used by the artist.

A SIMPLE WORKTABLE

Here is a table made from inexpensive 2 × 2s and particle board. Dimensions are chosen to fit personal physical requirements, and the table can be assembled in a day. Cover the top panel with cloth and use as a bulletin board. The panel is made adjustable by nailing two six-penny box nails through the vertical supports. All other members are attached with wood screws or appropriate finishing nails and carpenter's wood glue. The top of the table may be surfaced with linoleum or some other laminate.

WEIGHTS

An assortment of weights is always useful for drying paper, weighting newly bound books with binder's boards, or preventing paper from blowing off the table. Illustrated are two ideas. You can attach handles to bricks by means of strong glues or epoxy cements. To prevent scraping the knuckles, first glue down two small pieces of wood, allow to dry, and, with flat-head screws, screw the handle to the wood. The handles are ordinary kitchen-cupboard items that cost very little. To prevent the bricks from dusting, apply two coats of sealer or varnish on all sides.

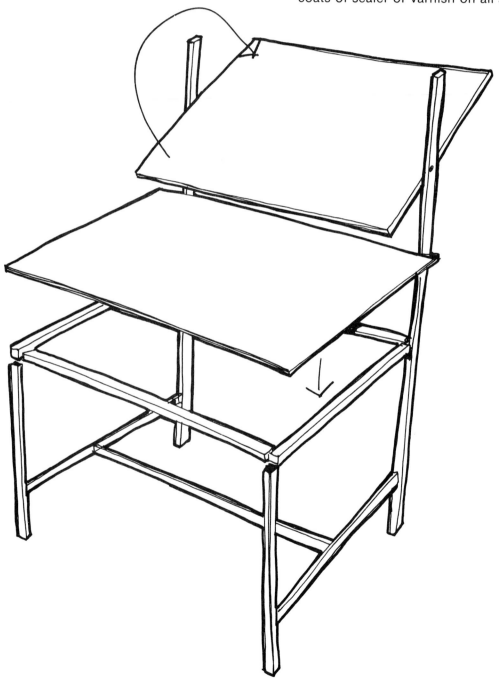

A functional worktable and bulletin board are combined in this relatively easy-to-build piece of furniture.

Plastic boxes are sold in variety stores equipped with the removable lids that fit by slipping over a recessed lip of the box. Fill the boxes with sand or coarse gravel, then glue the lids down for permanency. In order to keep track of the weight of each box, preweigh the contents and immediately label after the gluing step.

HUMIDOR

Many pens clog if left uncapped even for the shortest period of time. With a glass jar (a mayonnaise jar is fine), a piece of cardboard, and a bit of sponge you can construct an effective humidor to keep your pen points moist. Pierce holes in the cardboard to accommodate the pens, fill the sponge with water, place at the bottom of the jar, and tape the cardboard securely to the mouth of the jar. Change the water every few days. Periodically change the cardboard to maintain a rigid surface.

RUBBER-CEMENT LIFT

A traditional way of making a rubber-cement-pickup tool is to apply several coats of rubber cement to the outside of the cement jar and allow to dry. The vehicle for rubber cement is alcohol, which evaporates quickly. With the forefinger roll the rubber cement up and down until a ball is formed. Remove the ball and place near the gluing area of your worktable. This curious little bolus of glue has a natural affinity for excess glue on paper and board, and, when the ball comes into contact with dried rubber cement, it should swiftly lift it up and off the surface.

Weights are an indispensable tool for the artist's work area. These have been made from bricks and plastic boxes filled with sand. The bricks have been varnished to prevent dusting.

A humidor keeps pen points moist. A dampened sponge is placed at the bottom of a glass jar. Pens are held in place by cardboard. The sponge should be rinsed every few days and replenished with fresh water.

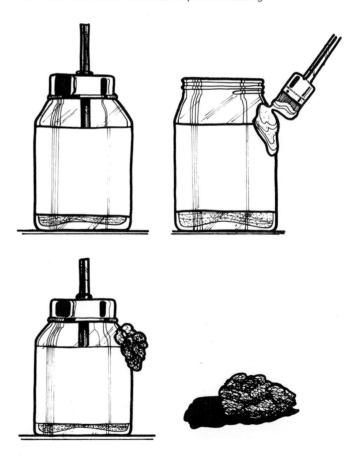

A rubber-cement lift is made by applying several coats of rubber cement to the side of the bottle and allowing them to dry. The cement is rolled up into a ball. Use the ball to remove excess rubber cement from artwork.

Lead sharpeners made by stapling sandpaper to tongue depressors.

LEAD SHARPENER

Pencil leads may be quickly shaped and sharpened by stropping the lead on a piece of sandpaper stapled to a tongue depressor. For a variety of grits use an assortment of sandpapers cut to fit the tongue-depressor blade. Staple at the top end. Tear off each layer of paper when it is no longer effective.

BOOKBINDER'S BONE

A binder's bone is used to fold and burnish paper with or without glue. The one illustrated here is fashioned from plastic by cutting it on the bandsaw or with a plastic handsaw. The tool should have a taper towards the front tip, with edges shaped like a blunt knife blade. This may be achieved by sanding with emery paper and finishing off with crocus cloth and plastic rubbing compound.

AGATE BURNISHER

Agate burnishers are used to burnish gold leaf to raised grounds such as gesso, size, modeling paste, and other appropriate supports. They are extremely expensive but essential to the gilding art. The agate must be without flaw, evince no pores, and be shaped to fit the interstices of the gold-leaf letter. By rummaging through a box of small agates found in stores selling lapidary materials you may come across several with slender tips of which one end can be fitted into a predrilled wood handle. The handle may come from an old brush, dowel, or piece of exotic wood hand-turned on a wood lathe. The agate itself may be replaced with hematite, which Graily Hewitt recommends in his book *Lettering for Students and Craftsmen.* Cennini also cites the use of dogs' or wolves' teeth in place of agate. The agate or its substitute must be firmly placed and glued in the handle with a strong cement such as epoxy or other catalyst-bonding agent.

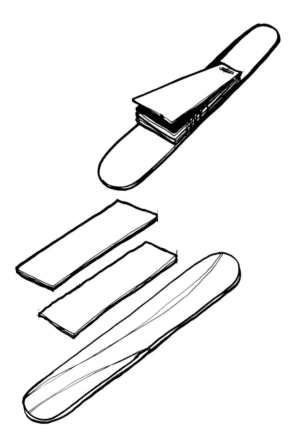

For varying degrees of coarseness staple different grades of sandpaper to the tongue-depressor stick. When the sandpaper is no longer functional, remove and discard.

A bone folder fashioned from a thin strip of plastic.

An agate burnisher is used in the gilding process. A hard, smooth agate, when properly set and glued in an appropriate handle, provides the illuminator with a useful tool.

MARKER HOLDERS

On the inclined drafting table it seems that markers are forever rolling into the lap of the designer. One way to prevent this nuisance is to place on the working surface a foam-seating material with overly large holes, the result of the manufacturer's design or the artist's skillful cutting with a knife. The holes nicely accommodate the markers, and the foam can be cut to size and shape. Inquire at a local upholsterer's for several remnants of this material. Use a pair of scissors or a serrated steak knife to shape the foam to fit the work area.

SHARPENING STONE

Arkansas and Carborundum stones can be glued to a block of rectangular wood, thereby providing a better base. When sharpening knives or pen points on a plastic countertop, the stone may scratch the surface. The wood prevents this unpleasant side effect, while at the same time it enhances the appearance of the stone.

WOOD MALLET

Limbs from hardwood trees such as oak, maple, alder, and ash can be cut into small sections to be used as wood mallet heads. This is an age-old tool for which many uses can be found. Hardwood mallets, unlike hammers fitted with metal heads, are kinder to materials such as leather, wood, plastic, bamboo, and soft metals and are considered to be an indispensible item for the workbench.

Predrill a hole large enough in diameter to accommodate the handle, which should measure 8" to 10" in length. Drill at the point where the best balance is likely to occur, apply wood glue, insert the handle, and allow to dry for 48 hours. Sure bonding of the two pieces is essential for safety and performance. The illustration depicts a mallet with the bark scraped back from both ends. You may wish to remove the bark. Sanding or sealing is not necessary, since this top membrane or surface of the wood is smooth and hard. Green wood should be allowed to sit for awhile until it is thoroughly dry. Keep moisture away from the wood, as this tends to create small cracks and fissures, thereby weakening it.

Wooden mallets can be made from strong, sturdy tree branches. This age-old tool is difficult to improve upon. The bark need not be removed unless desired.

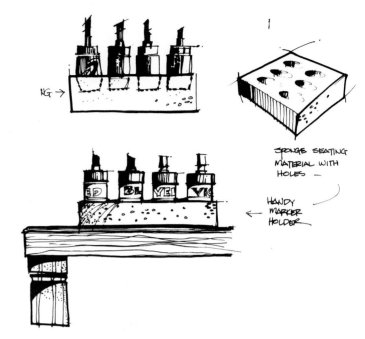

Sponge filler used in upholstery makes a perfect holder for marker pens.

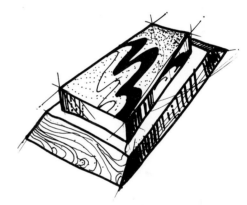

Carborundum and Arkansas stones are less likely to scratch the counter surface if they are glued to a block of soft wood.

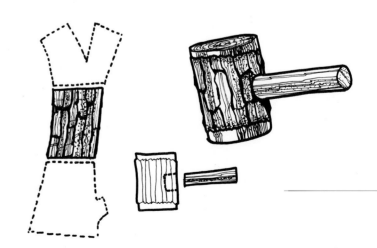

137

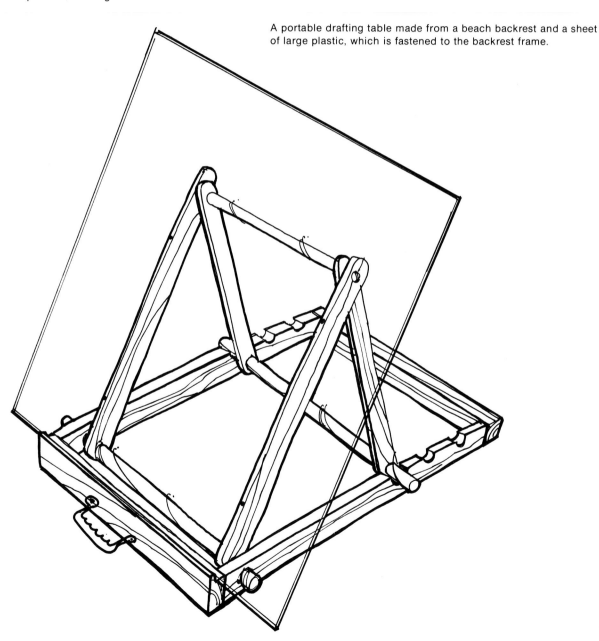

PORTABLE DRAWING BOARD WITH PAPER

This portable item can be made with a minimum of hardward and gadgetry. Obtain a flat piece of plywood with two good sides. Cut a sheet of linoleum and bond it to the surface with mastic. Burnish from the center outwards, forcing out trapped air pockets. Secure a collapsible handle to one end of the board with 1½″ flat-head wood screws. Screws provided with the handle are usually too short to stand up to constant use and weight. On the opposing edge glue a cardboard tube with at least one resealable end. Before gluing make a slit in the tube with an X-Acto or mat knife wide enough to allow the edge of a continuous roll of paper to pass through. Paper, in rolled form, may be of any grade or texture. Drafting papers are usually available in such containers. These tubes are ideal for the cylinder portion of this project.

A portable drawing table.

A portable drafting table made from a beach backrest and a sheet of large plastic, which is fastened to the backrest frame.

PORTABLE DRAFTING TABLE

Beach backrests can be converted into adjustable drawing or calligraphy tables by removing the canvas and substituting a square or rectangular piece of ½" plastic plate. The plate is fastened to the vertical struts with shallow flat-head screws from the backside of the supports. I recommend plastic because of its lightness and, more importantly, because with little extra effort a drafting lamp can be clamped to the top edge for illumination. The drafting lamp is flexible enough so that it can easily be turned to the underside of the plastic, thereby converting the surface into a light table. Opalescent plastic can be used for better light diffusion. When not in use the unit is easily collapsed, tucked under the arm, and whisked away. As with the portable drawing board, attach a collapsible handle for extra convenience. Locking clasps can be applied on both sides to prevent the table from unfolding while it is in transit.

This project is immensely popular with my lettering and graphic-design students. Beach backrests cost under five dollars and are more often than not made of sturdy oak.

BRUSH AND SOLVENT CONTAINER

Set aside a quart-sized coffee can and drill holes on two opposing sides. Into each hole insert a 4" strip of coat-hanger wire and bend to keep in place. To the two top ends of the wire attach a spring short enough to cause visible stretching or tension within the coils. Place brushes in the coils, allowing the bristles to extend into a can containing enough water or solvent to loosen dried particles of paint or varnish.

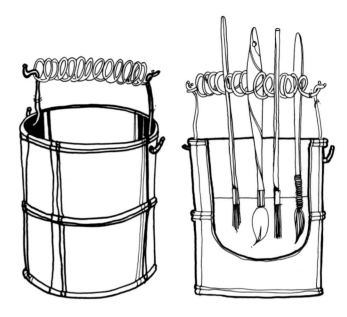

A brush-solvent container made from a coffee can, coat hanger, and screen-door spring.

To convert the portable drafting table into a light table, attach the drafting lamp to the top edge of the plastic. Turn the light so that it illuminates the underside of the plastic surface. For better and more even illumination use opalescent plastic.

Bibliography

Bridge, Paul and Austin Crossland. *Designs In Wood*. New York: Frederick A. Praeger, Publishers, 1969.

Constable, W. G. *The Painter's Workshop*. London: Oxford University Press, 1955.

Cox, Doris, and Barbara Warren Weismann. *Creative Hands: An Introduction To Craft Techniques*. New York: John Wiley and Sons, Inc., 1945.

Csoka, Stephen. *Pastel Painting*. New York: Reinhold Publishing Company, 1963.

Doerner, Max. *The Materials Of The Artist And Their Use In Painting With Notes On The Techniques Of The Old Masters*. New York: Harcourt, Brace and Company, 1949.

Gray, Bill. *Studio Tips for artists and graphic designers*. New York: Van Nostrand Reinhold Company, 1976.

Gray, Bill. *More Studio Tips for artists and graphic designers*. New York: Van Nostrand Reinhold Company, 1978.

Horn, George F. *The Crayon: A Versatile Medium For Creative Expression*. Worcester, Mass., 1969.

Hunter, Dard. *Papermaking: The History And Technique Of An Ancient Craft*. New York: Alfred A. Knopf, 1943.

Laliberté, Norman, and Alex Mogelon. *Drawing With Ink: History And Modern Techniques*. New York: Van Nostrand Reinhold Company, 1970.

Laliberté, Norman, and Alex Mogelon. *Drawing With Pencils: History And Modern Techniques*. New York: Van Nostrand Reinhold Company, 1969.

Laliberte, Norman, and Alex Mogelon. *Painting With Crayons: History And Modern Techniques*. New York: Reinhold Publishing Company, 1967.

Lamb, C. M., Ed. *The Calligrapher's Handbook*. New York: Pentalic Corporation, 1968.

Langer, Susanne K. *Feeling and Form: A Theory of Art*. New York: Charles Scribner's Sons, 1953.

Langer, Susanne K. *Philosophy In A New Key: A Study In The Symbolism Of Reason, Rite, And Art*. Cambridge: Harvard University Press, 1957.

Marzoli, Carla. *Calligraphy 1535–1885*. Milan: La Bibliobila, 1962.

Mayer, Ralph. *The Artist's Handbook of Materials and Techniques*. New York: The Viking Press, 1970.

Okakwa, Kakuzo. *The Book of Tea*. New York: Dover Publications, Inc., 1964.

Osley, A. S. *Scalzini on Handwriting*. Wormley: The Glade Press, 1972.

Paz, Octavio. *In Praise Of Hands: Contemporary Crafts Of The World*. Greenwich, Conn.: New York Graphic Society, 1974.

Petterson, Henry and Ray Gerring. *Exploring With Paint*. New York: Reinhold Publishing Company, 1964.

Pluckrose, Henry. *Introducing Crayon Techniques*. New York: Watson-Guptill Publications, 1967.

Pye, David, *The Nature And Art Of Workmanship*. New York: Van Nostrand Reinhold Company, 1971.

Ruffino, Carlos. *A Guide To Pencil Drawing*. New York: Van Nostrand Reinhold Company, 1969.

Studley, V. *The Art And Craft Of Handmade Paper*. New York: Van Nostrand Reinhold Company, 1977.

Studley, V. *Calligraphy: Appreciation And Form*. Dubuque: Kendal/Hunt Publishing Company, 1976.

Whalley, Joyce Irene. *Writing Implements And Accessories*. London: David and Charles, 1975.

Wong, Frederick. *Oriental Watercolor Techniques*. New York: Watson-Guptill Publications, 1977.

Yanagi, Sōetsu. *The Unknown Craftsman: A Japanese Insight Into Beauty*. New York: Kodansha International Ltd., 1976.

Yoshida, Toshi and Reiyuki. *Japanese Printmaking: A Handbook Of Traditional And Modern Techniques*. Rutland, Vermont: Charles E. Tuttle Company, 1966.

Sources of Supply

Yasutomo & Co.
24 California Street
San Francisco, Ca. 94111
Oriental artist's materials

M. Schwartz & Son
321–325 East Third Street
New York, N. Y. 10009
Quills—swan, turkey, goose

Gane Bros. and Co. of New York
480 Canal Street
New York, N. Y. 10013
Bookbinding supplies

Andrews/Nelson/Whitehead
31–10 48th Avenue
Long Island City, N.Y. 11101
Specialty papers

Plastic Mart
2101 Pico Blvd.
Santa Monica, Ca. 90405
Plastic, tubes, containers, acrylic

Tandy Leathercraft
3157 Wilshire Blvd.
Los Angeles, Ca. 90005
Leather goods

MacPherson Leather Co.
200 South Los Angeles St.
Los Angeles, Ca. 90012
Leather goods

Andrews Industrial Hardware Co.
1610 West 7th St.
Los Angeles, Ca. 90017
Hard-to-find hardware items

Appleton Mills
Appleton, Wisc. 54911
Papermaking felts

Griegers, Inc.
900 South Arroyo Parkway
Pasadena, Ca. 91105
Lapidary equipment, exotic stones

Index